LINOGLYPHIC ART:
the finger works

of

KEYES the Artist

Presented by

Bobby Keyes, PhD

Linoglyphic Art: the finger works copyright © 2015 Robert E. Keyes, Jr., PhD

DEDICATION

This book of artwork is dedicated to the glory of God, Lorbor W., and to the memory of Rembrandt van Rijn.

Introduction to Linoglyphic Art: the finger works

Linoglyphic art was conceived to employ the barest of materials, detail, and effort as possible to convey a maximum emotive response. Linoglyphs are line drawings with the addition of a topic word. The drawing and the word together inspire an emotional involvement with the art that not only holds a personal meaning for the artist but also profoundly speaks to the universal human spirit.

The simplicity of linoglyphic art lends itself to production by many different means and in many different media. Although originally conceived using a graphite pencil, KEYES the Artist found that the essence and expression of linoglyphic art could be expressed using a "pen" app on a touchscreen tablet device. The lines are less crisp and the linoglyphs less complex when rendered with a finger on a touchscreen compared to using a pencil on paper. Nevertheless, the results produced on the tablet device are startling and oftentimes more profound than if a pencil had been used. Thus, the subtitle for this volume of linoglyphic art is "the finger works".

The subtitle of this book contains a double entendre' in the spirit of linoglyphic art. "I will leave it to the viewer to decipher the double meaning contained in the subtitle," remarked KEYES the Artist.

Introduction from the original Linoglyphic Art book published in 2013

Linoglyphic Art was conceived as a response to a challenge to KEYES who had been struggling to recreate the insightful genius of Rembrandt. After displaying remarkable talent in the portraiture genre, KEYES was still dissatisfied. It seemed that he was merely restating the obvious. During a session of self-deprecation, a friend of the artist challenged KEYES to "just try painting what you feel".

Abhorring the fanciful vision of a tortured spirit splashing paint on the canvas and swirling the brush madly in tormented spasms of so-called creativity, KEYES was in a quandary. How does one paint a feeling? Later that night in the throes of a fitful night's sleep, the ghost of Rembrandt appeared to KEYES as if standing in his studio in Amsterdam. The ghost of Rembrandt hurled a pot of blue paint against the wall. The paint obliterated the studio and the ghost faded away wearing an impish smirk of defiance that taunted KEYES to become original. The message was clear: stop trying to be Rembrandt and start being KEYES.

The next afternoon, KEYES sat in his garage furiously smoking a cigar while pondering the dream. With a pencil, KEYES sketched out the first linoglyph "Dream". After "Dream" was composed, a string of spontaneously obsessive sessions led to the compositions found in this groundbreaking book.

"After I composed 'Dream', I searched the Internet on different ideas about line art, minimalism, and other associated ideas to see if I was subconsciously duplicated something I had seen before," said KEYES in a recent interview. "I discovered similarities of my

linoglyphs with the work of Pablo Picasso and Al Hirschfeld, but in no way was I copying these titans of the art world. I concluded that I had achieved originality as Rembrandt had challenged me. I dubbed my new art form *linoglyphs*."

Linoglyph is a hybrid word combining the words *line* and *hieroglyph.* Each linoglyph is accompanied by a word that merely suggests the cognitive connotation of the line drawing. Each linoglyph evokes a universal human experience. Although the words are English in this volume of linoglypghs, they could be translated to any other language without weakening the effects of the drawing.

Linoglyphs immediately penetrate the human psyche and resonate across cultures and space-time. "Linoglyphs are mesmerizing and unforgettable. They are spontaneous creations taking no more than a few minutes to compose," said KEYES. "Even I cannot duplicate one of my own linoglyphs. For instance, notice the difference in the linoglyphs for *hate* and *obese*. The present moment being experienced affects the cognitive state of mind and spawns unique results. This is the essence and power of linoglyphic art: the melding of spontaneous fleeting mental machinations with minimalist art techniques. Entirely different results occur under various psychological states."

Linoglyphs are not 'doodling', which implies vacuous idiocy. Linoglyphs are the spontaneous free flow of consciousness. The inner mind is linked directly to the point of the drawing instrument. The lines are drawn in response to a focused mental concentration on a thought, feeling, emotion, or idea. No preconception of the image occurs. The result is a unique image that cannot be recreated except by forgery or copying. A linoglyph is a visual artistic utterance of the sentient brain. A linoglyph is abrupt and unplanned. "Rarely do I erase the first effort of composing a linoglyph", said KEYES. "To erase the initial effort is to destroy the essence of spontaneity. I might not like how my linoglyphs look, but that is the charm of this art from. I do not expect or even care what someone else thinks about my linoglyphs. They are mine, and I am a genius, and this is what my genius looks like."

Most of the linoglypghs in this book were drawn with No.2 pencil on 8½" by 11" plain white copier paper. A few were drawn by finger on a touchscreen tablet. One was drawn using a brush pen with India ink. No attempt has been made to alter the linoglyphs from their original state by trickery with photo editing. The images in this book are as close to their genuine spontaneous nature as possible. "As each individual has an individual style of hand-writing, so it is with linoglyphic art. My particular style is evident in my works. Another linoglyphic artist's style would be different than mine. However, I invented this art form, so all others will be compared to my superior original style," said KEYES.

This introduction volume of KEYES linoglyphs is presented mostly in reverse chronological order of their creation. No meaning should be implied as to the order or sequencing of the linoglyphs. Indeed, such ordering is impossible because of the erratic and spontaneous nature of this art form. Each linoglyph should be studied in detail to discover the nuance of each line, swirl, swell, or mark. Some semblance to human form is apparent in the linoglyphs but is coincidental to the spirit by which they were created.

KEYES linoglyphs are available for licensing for imprinting on objects such as T-shirts, coffee cups, and other promotional items. KEYES might also consider commissioning of personalized linoglyphs or hand-signed reproductions of the originals. Contact the author Bobby Keyes at bobbykeyes@gmail.com for information about licensing reproductions of any particular KEYES linoglyph.

KEYES is a phantom-like artist reporting only to the author Bobby Keyes. KEYES occasionally reveals his talents through works of visual art, most recently in these astonishing linoglyphs. KEYES is a genius of profound insight, intelligence, and surprising inventiveness. "I will reveal my work only through Bobby Keyes, who has my express permission to publish all my efforts."

This new volume *Linoglyphic Art: the finger works* as well as the original volume *Linoglyphic Art* are available in electronic or print versions at Amazon.com.

The finger works

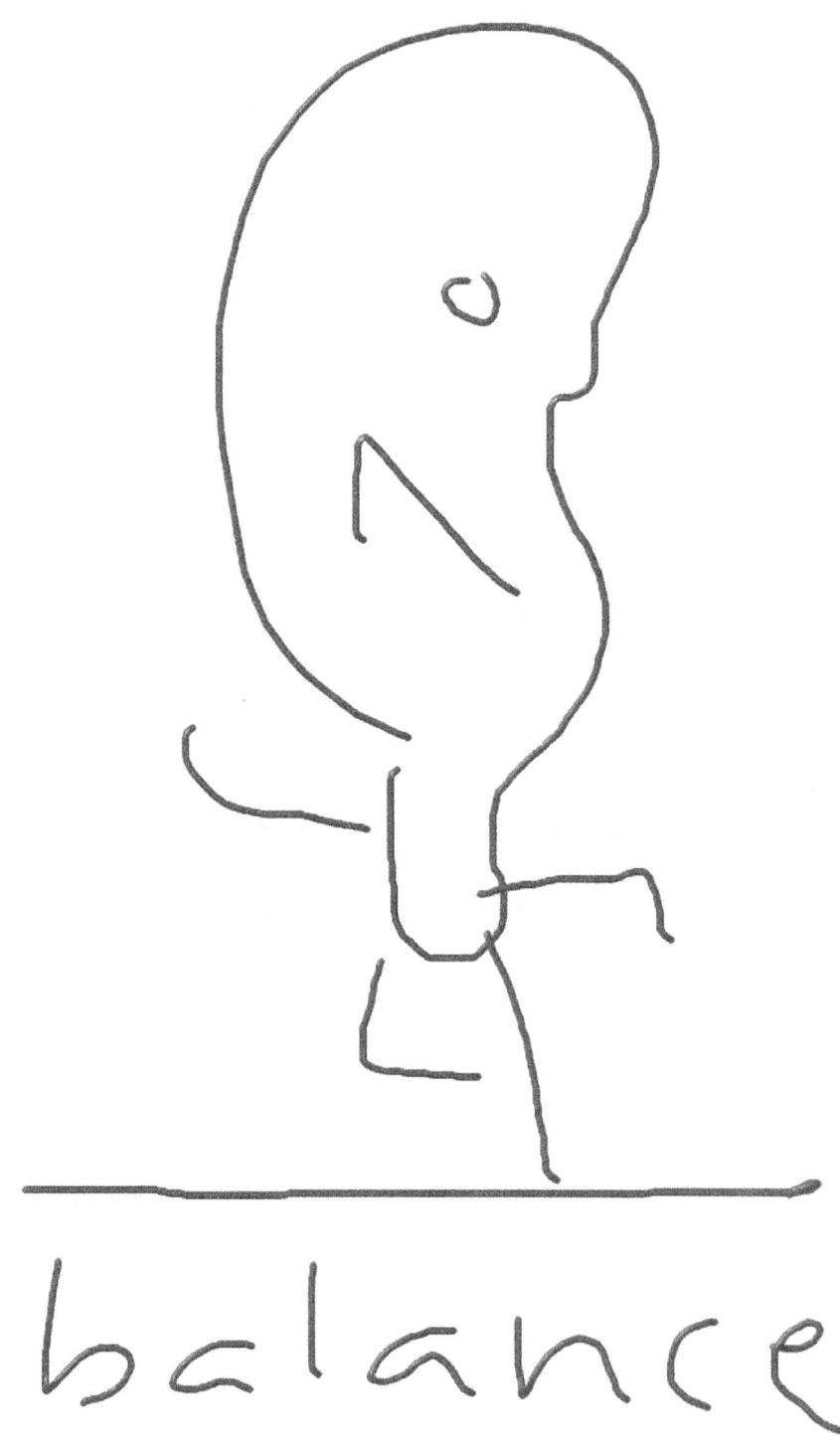
balance

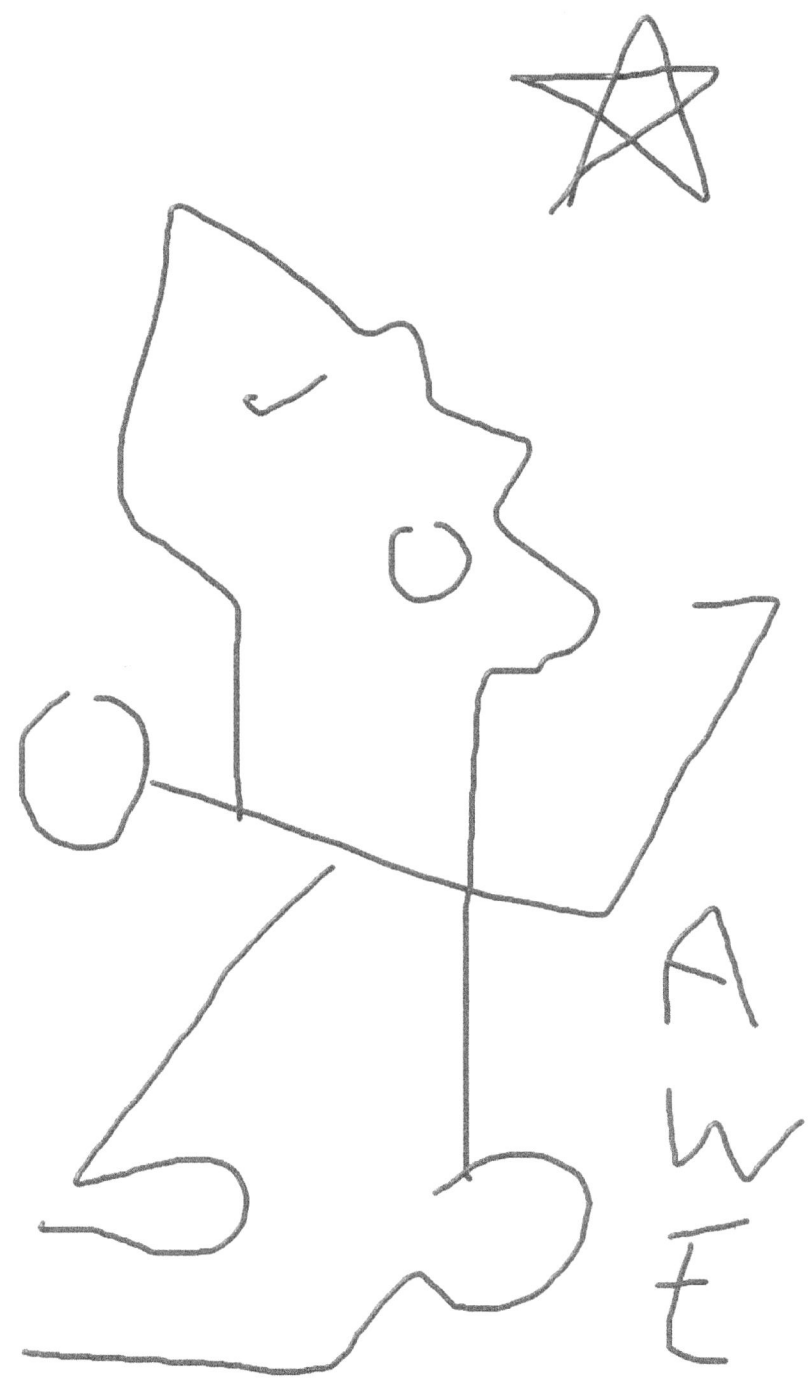

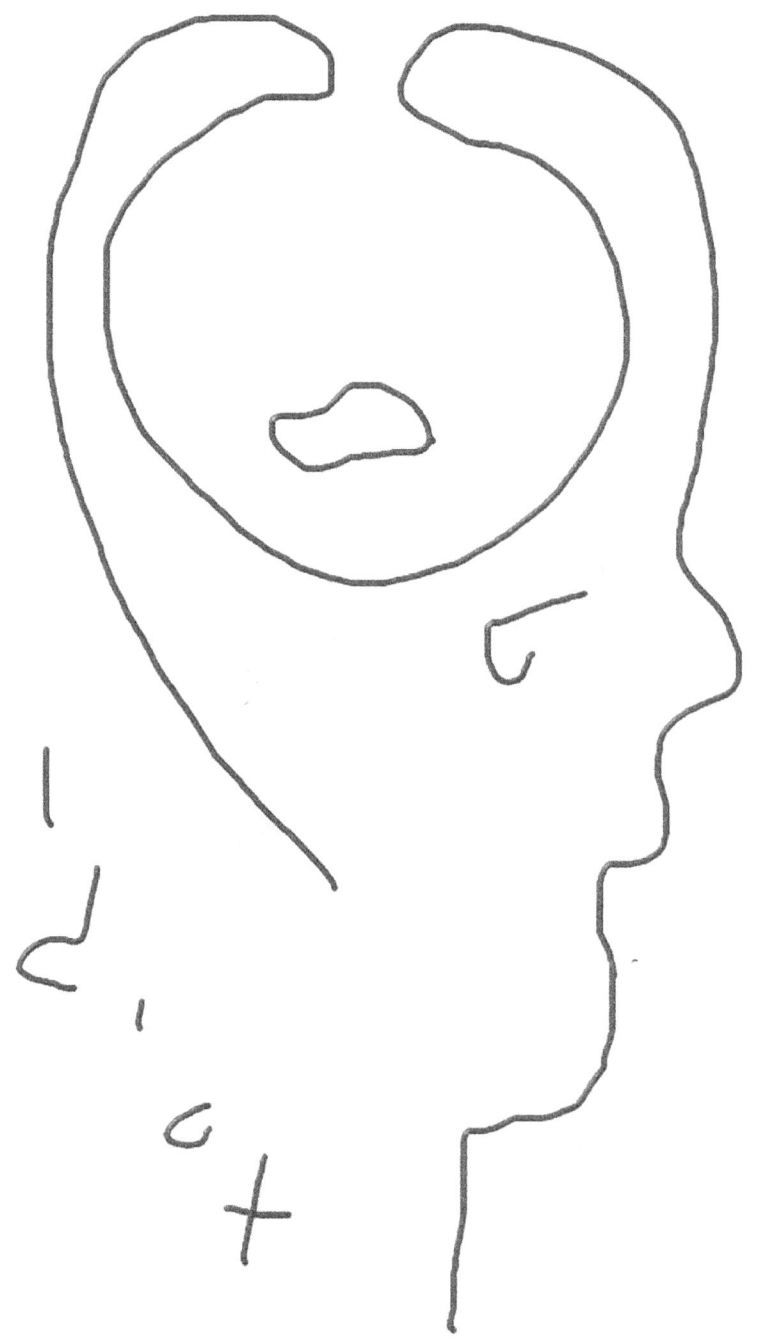

pianist

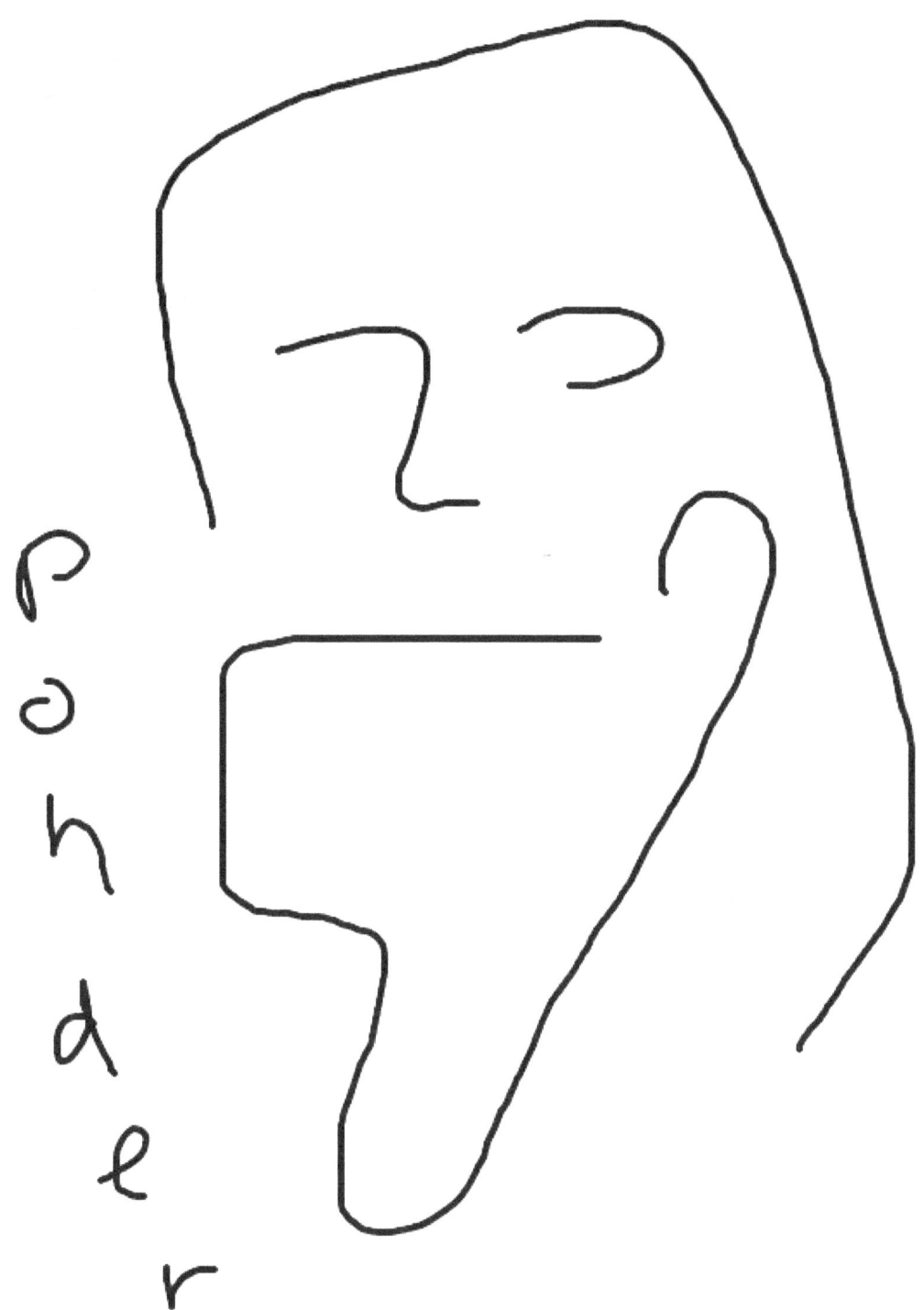

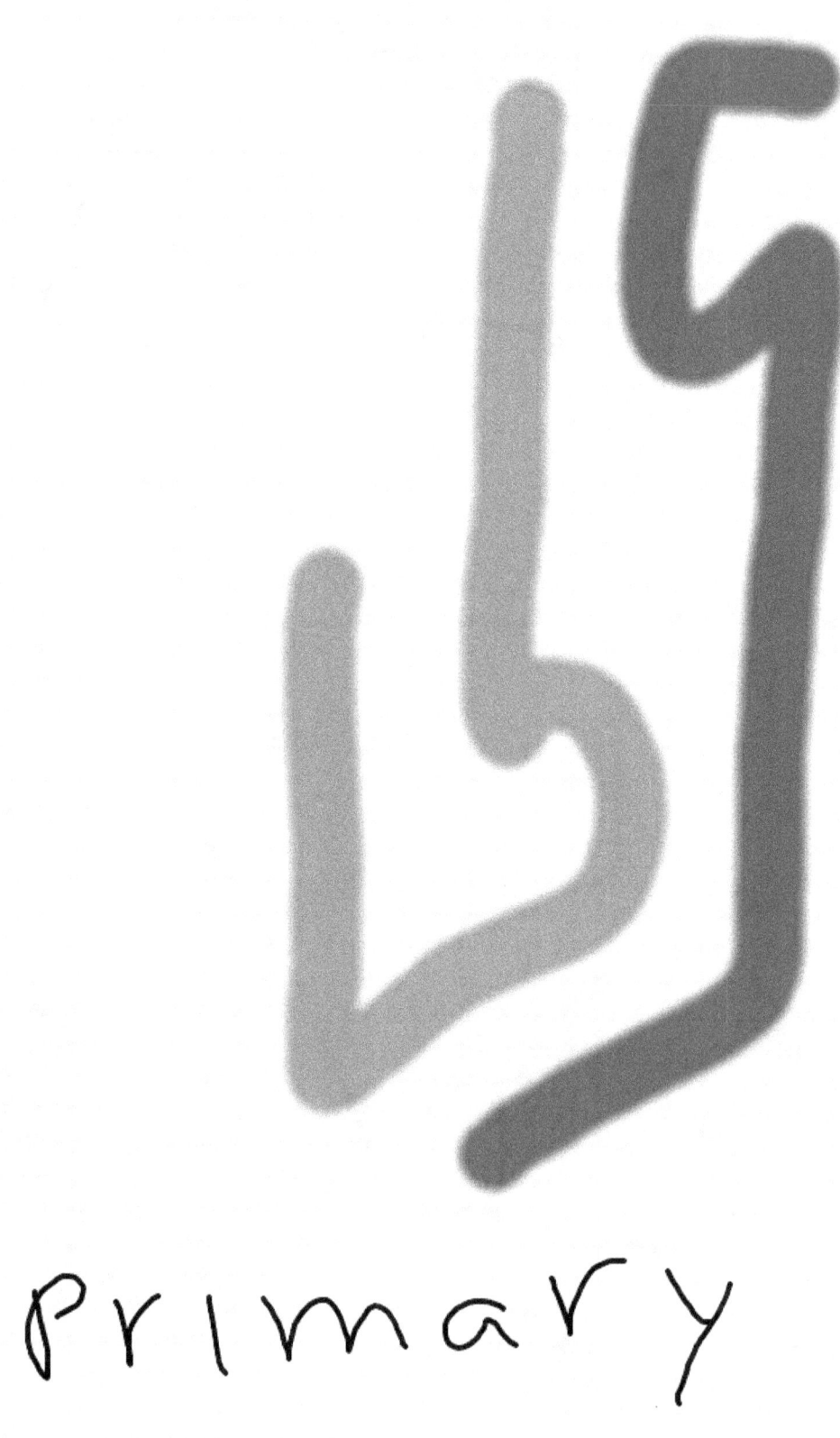

Primary

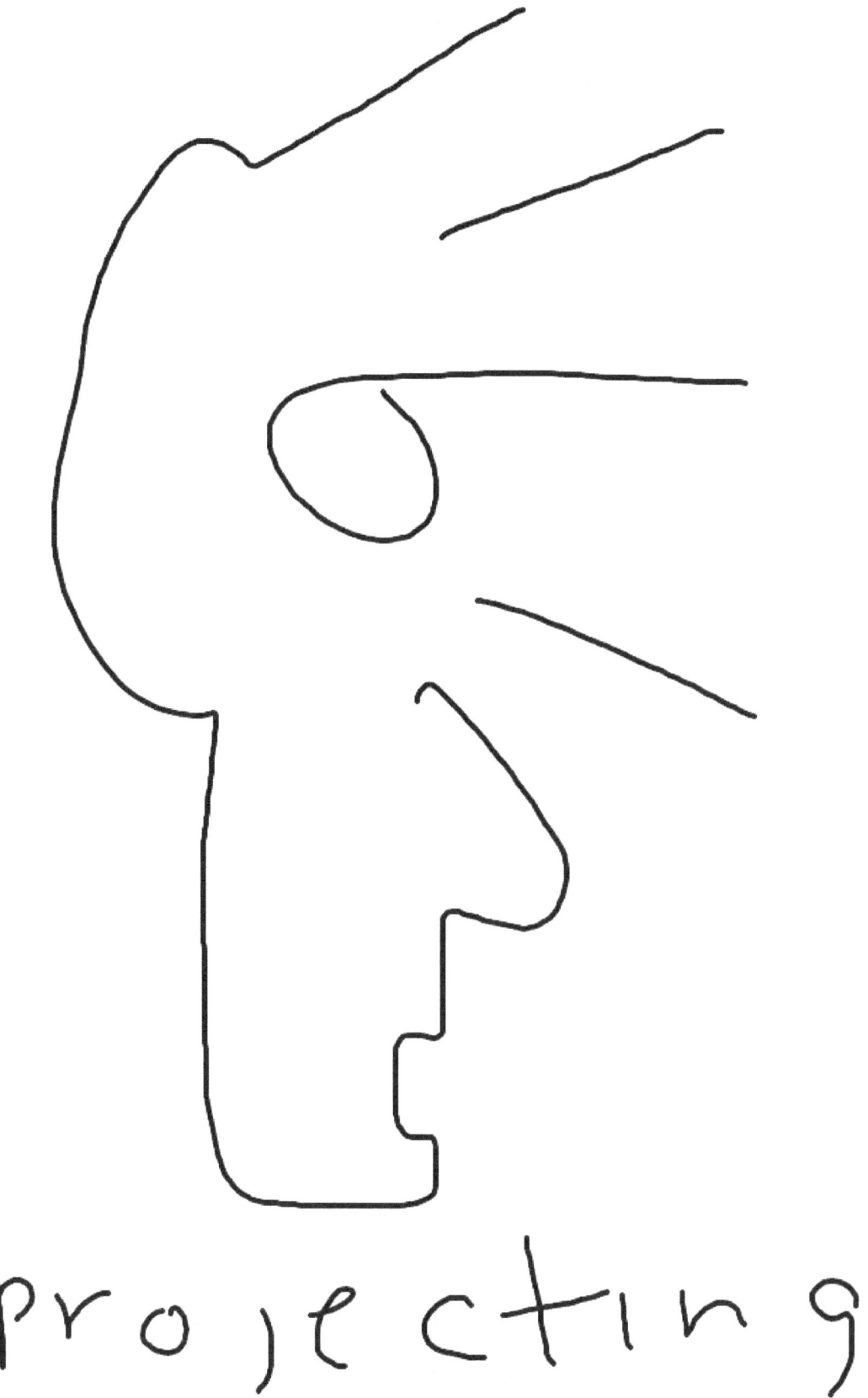
projecting

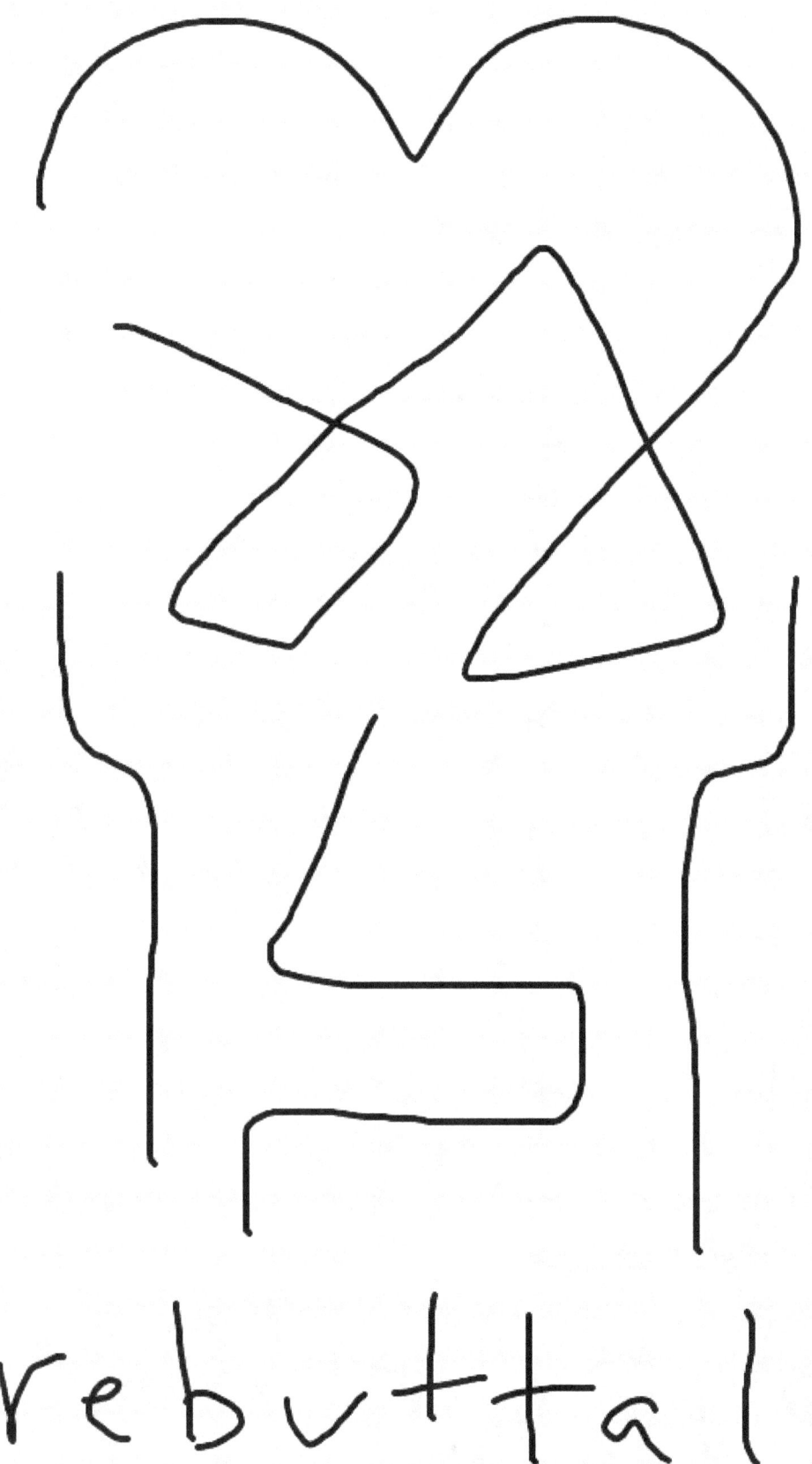

rebuttal

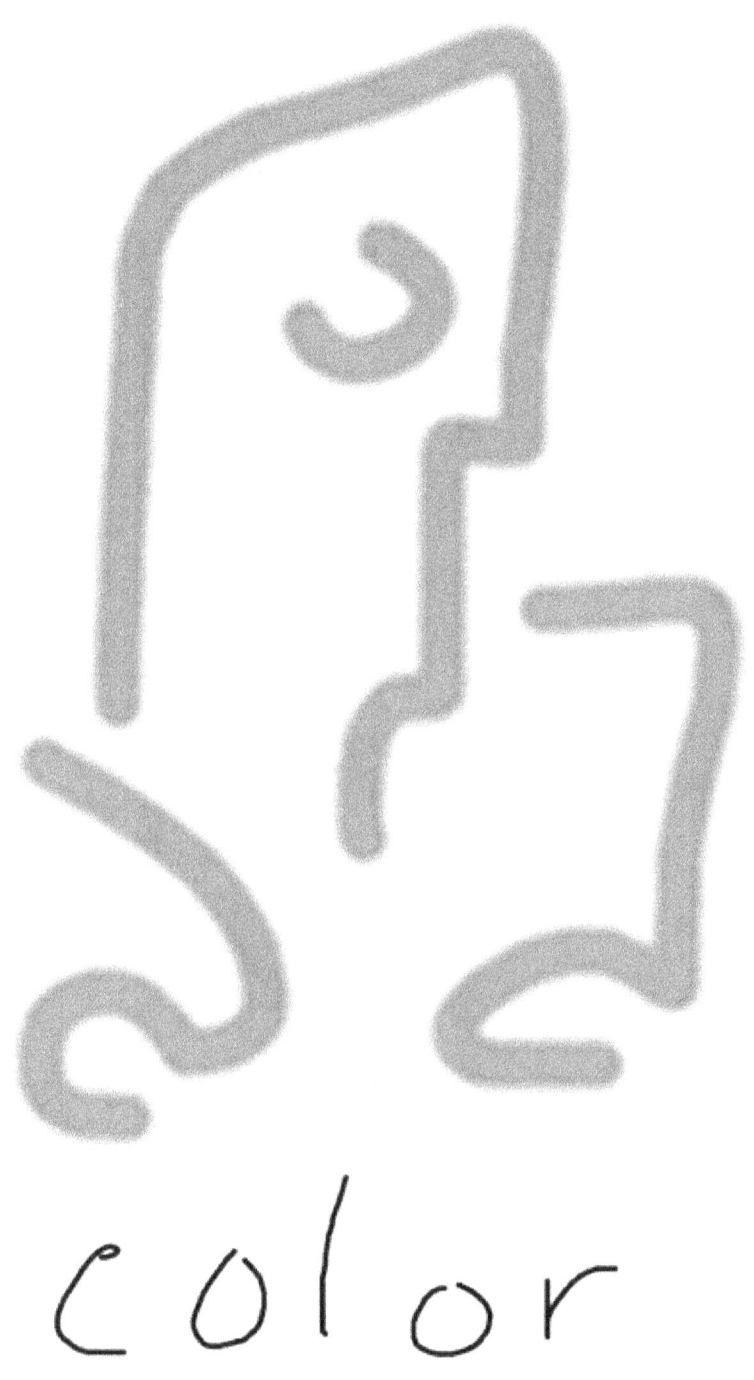

color

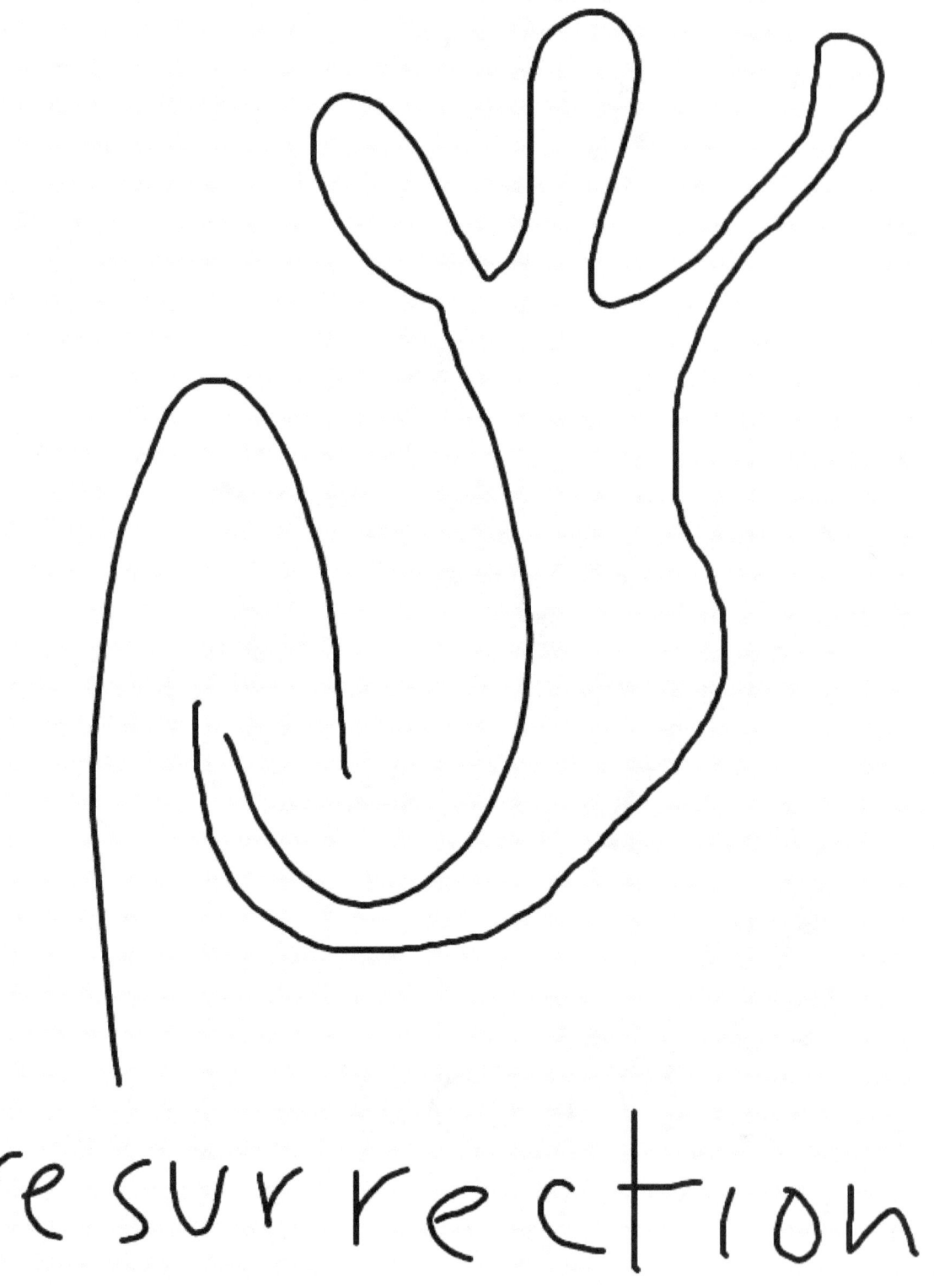

resurrection

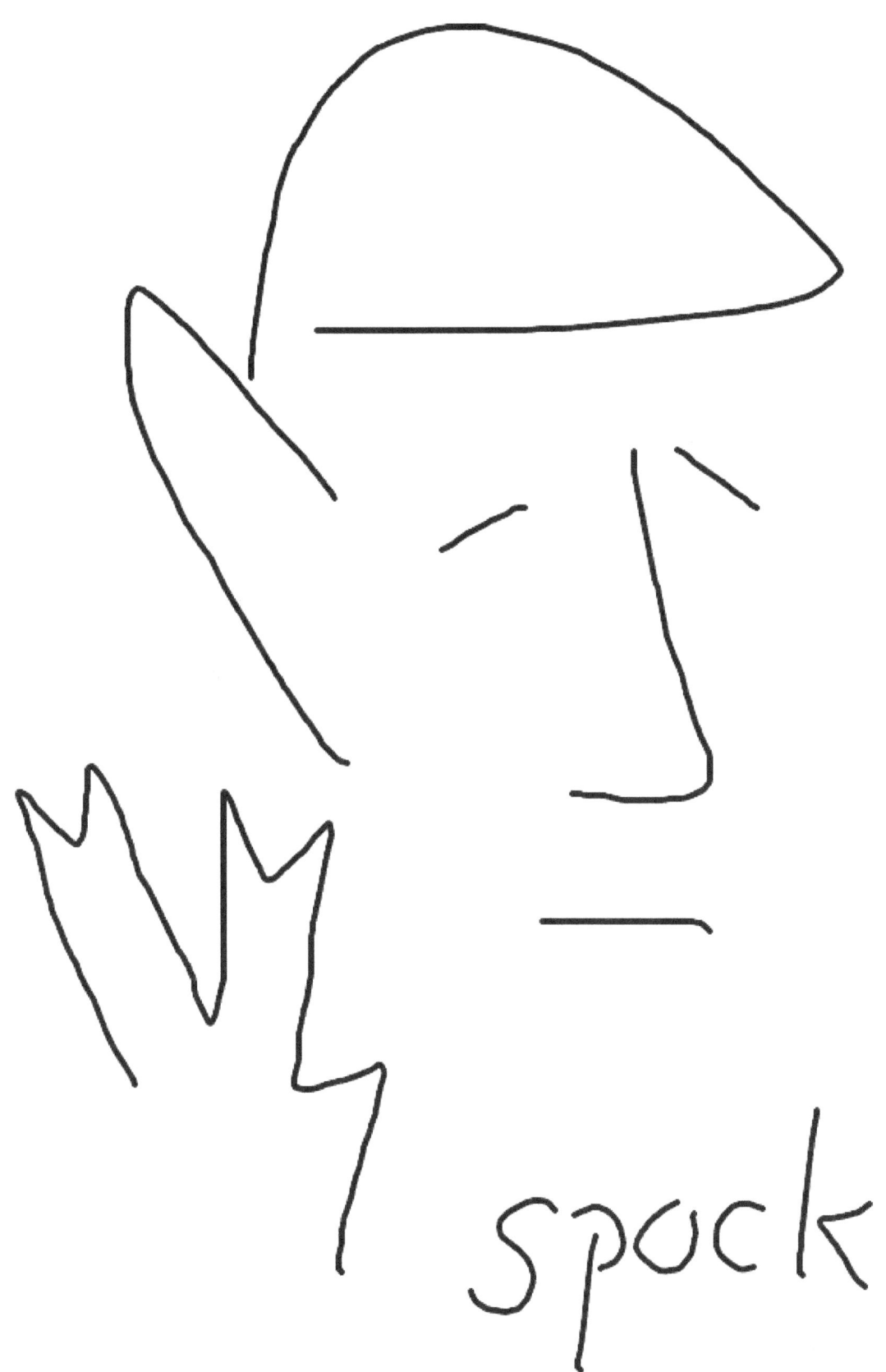

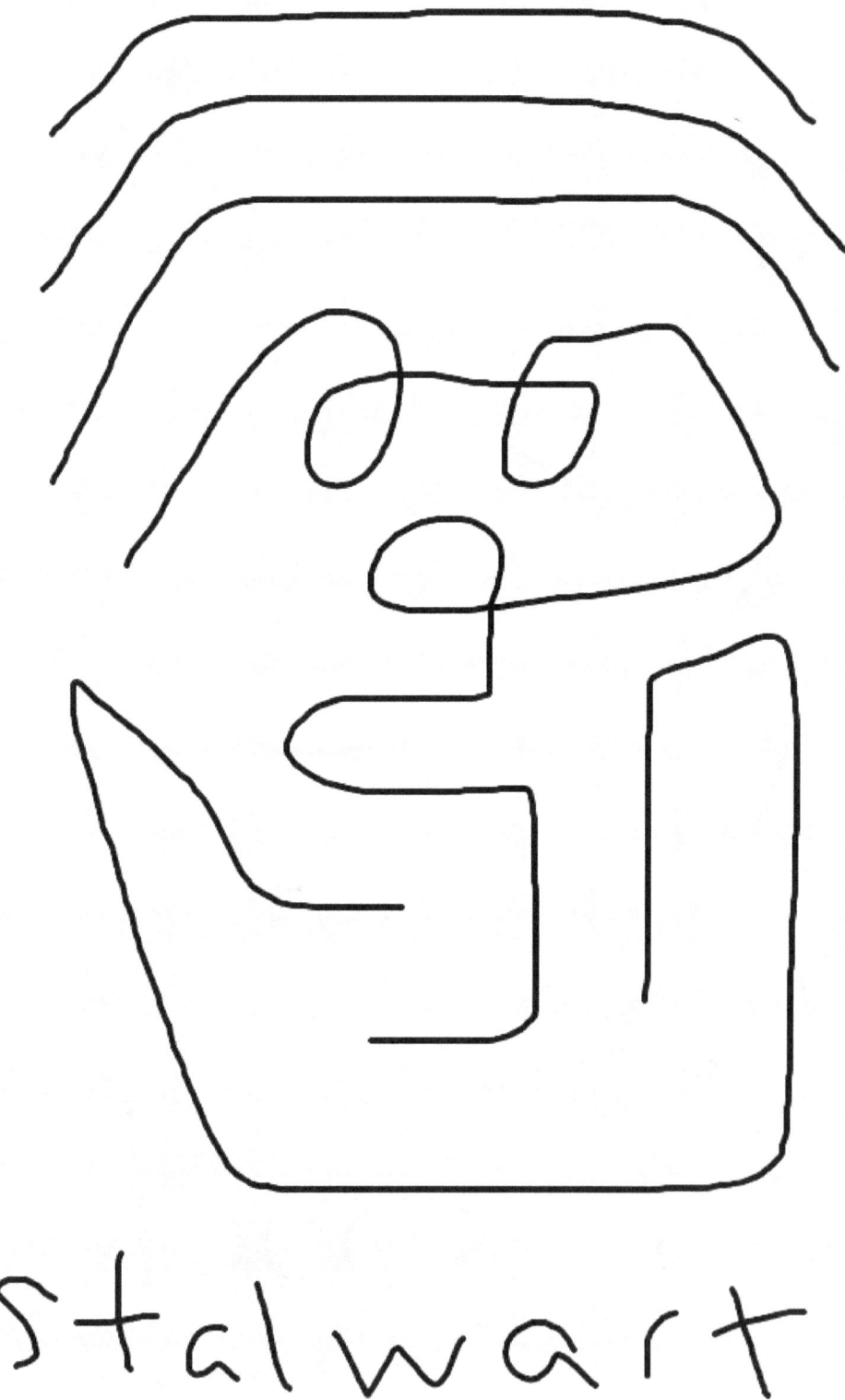

stalwart

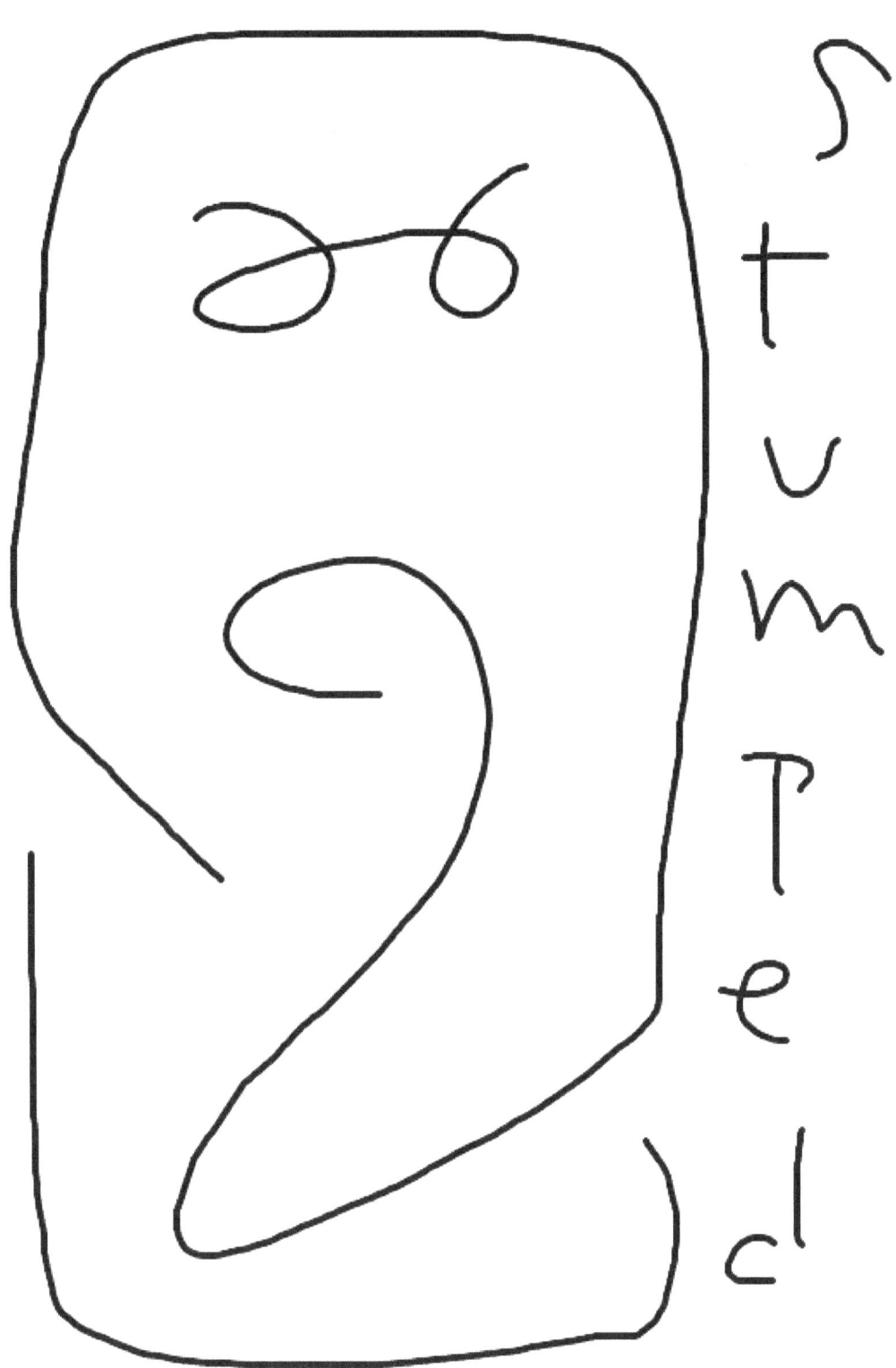

stumped

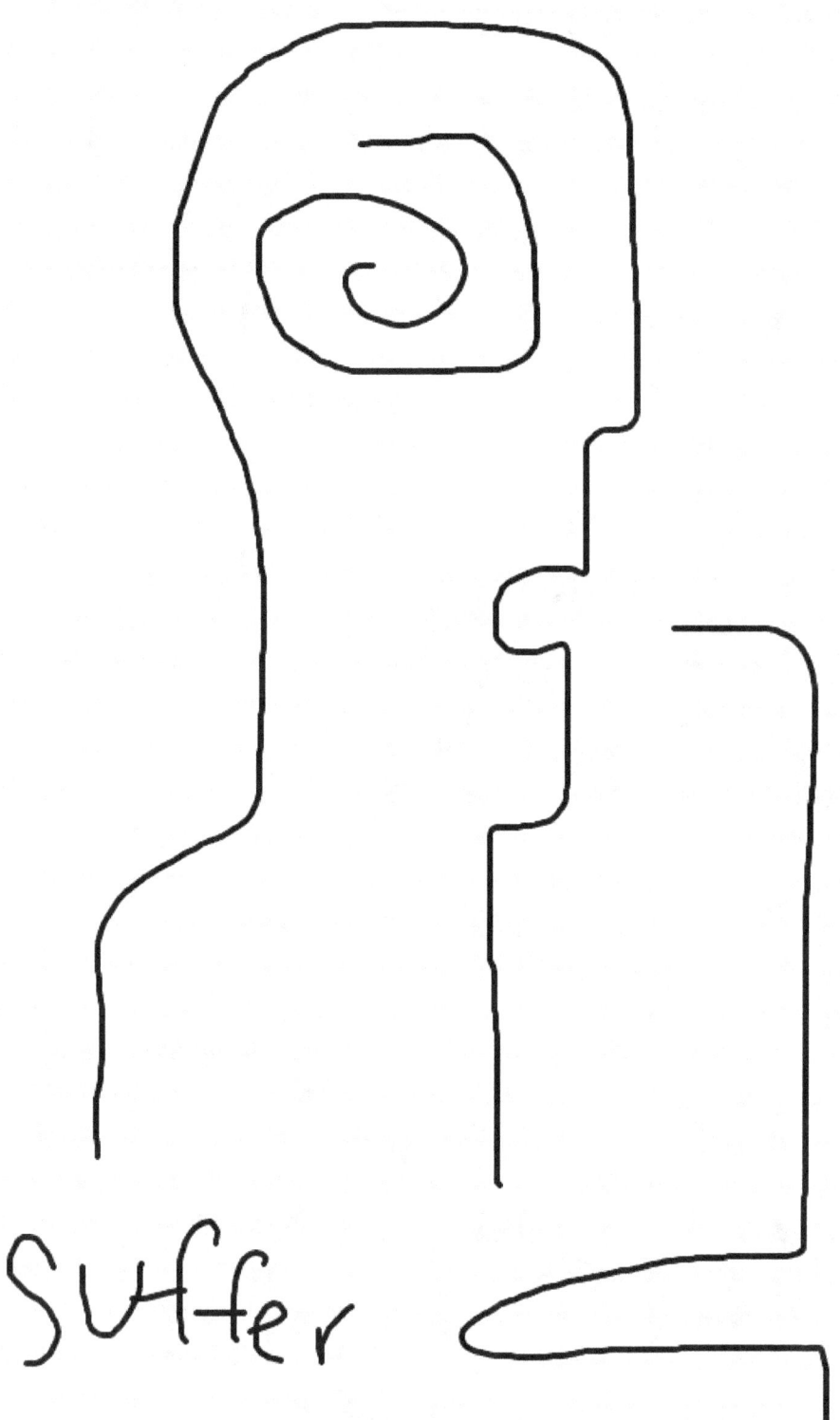

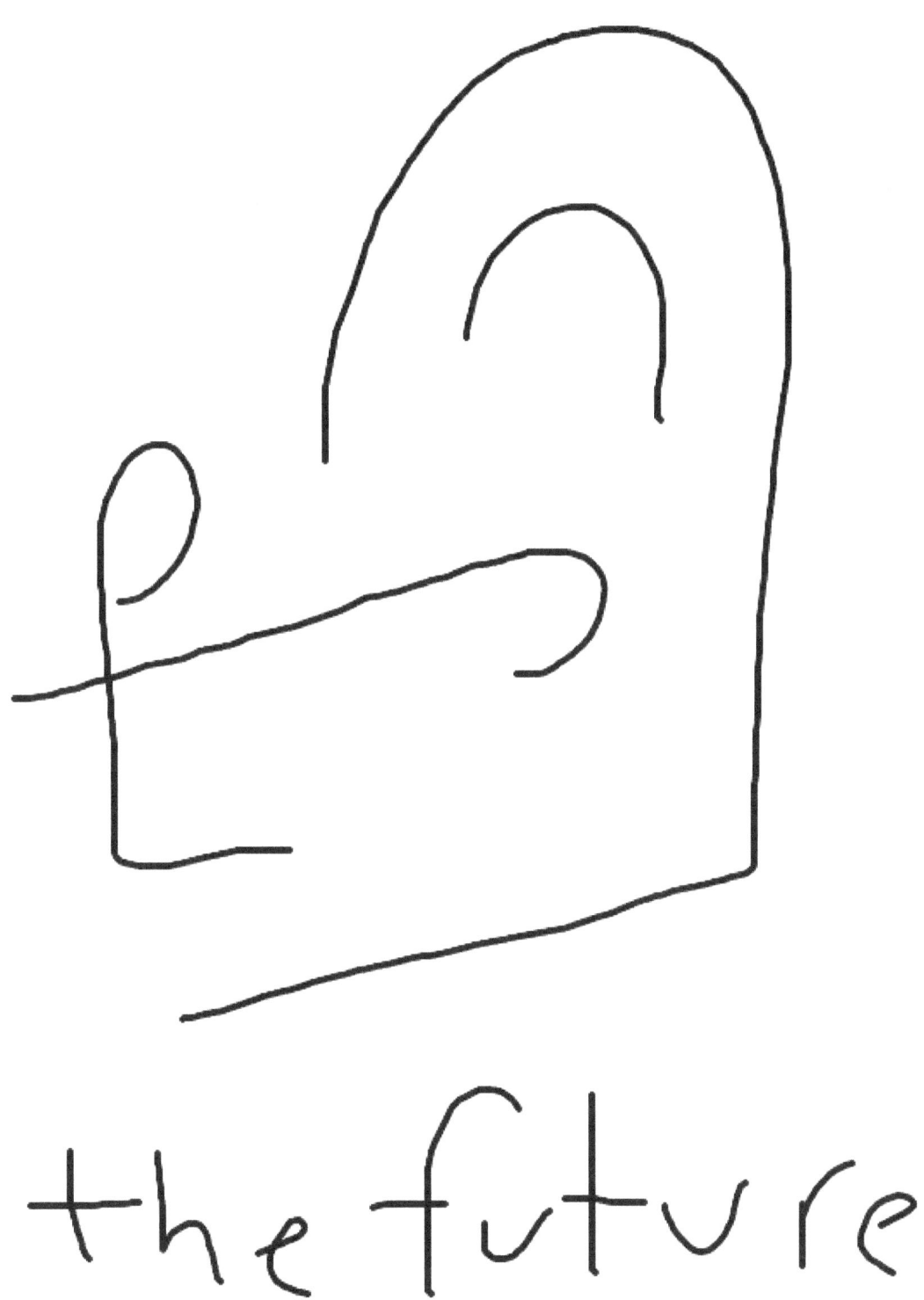

the future

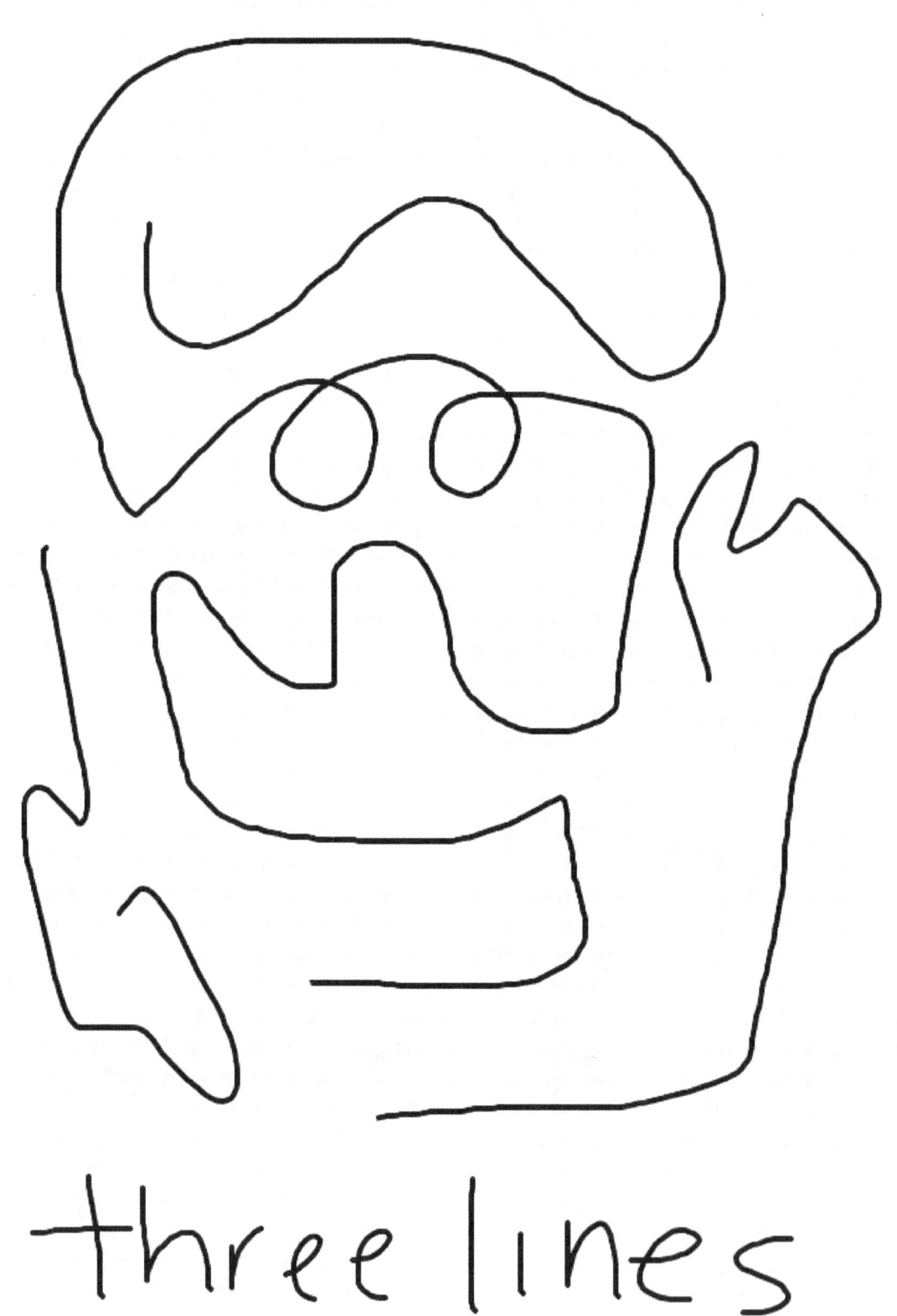

three lines

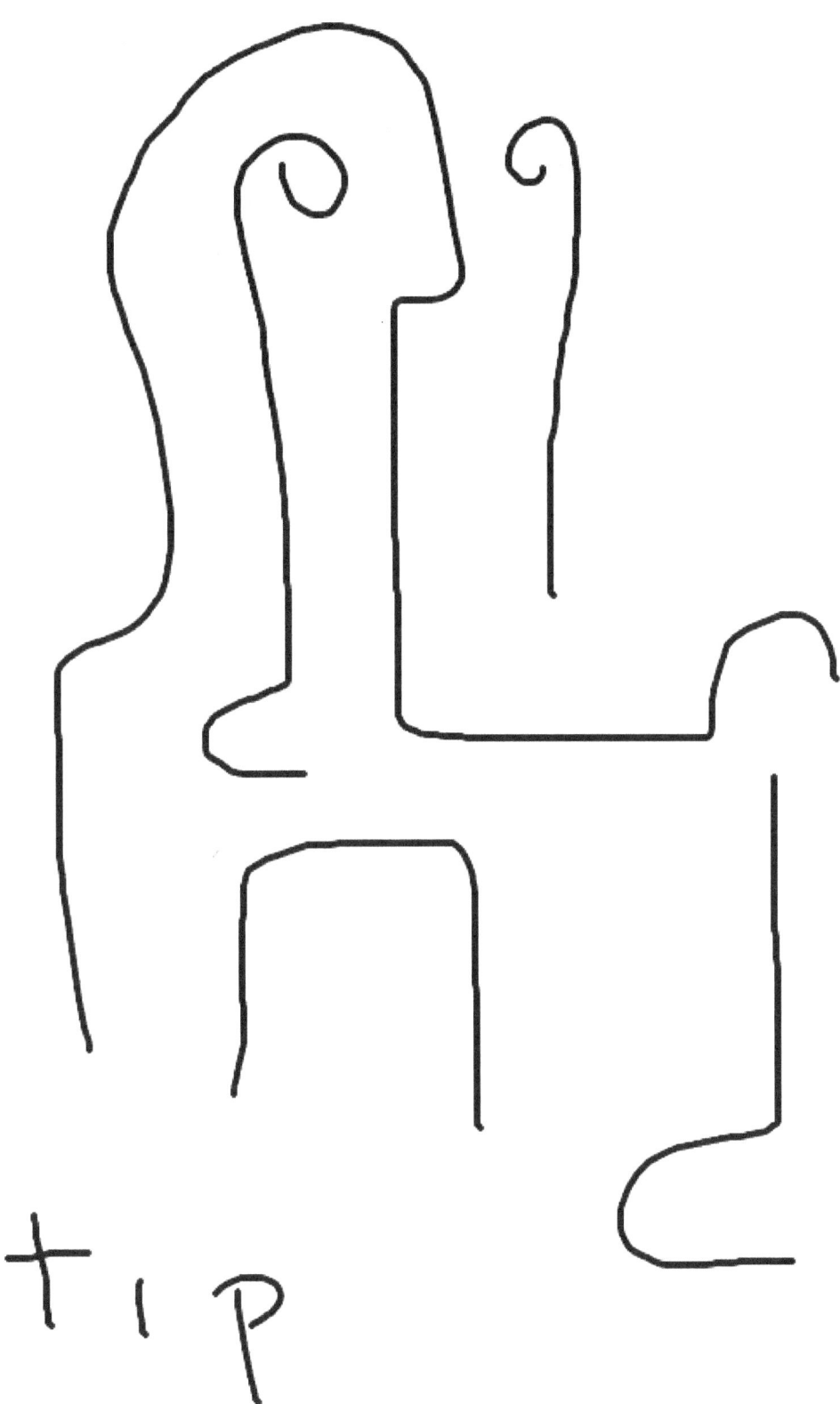

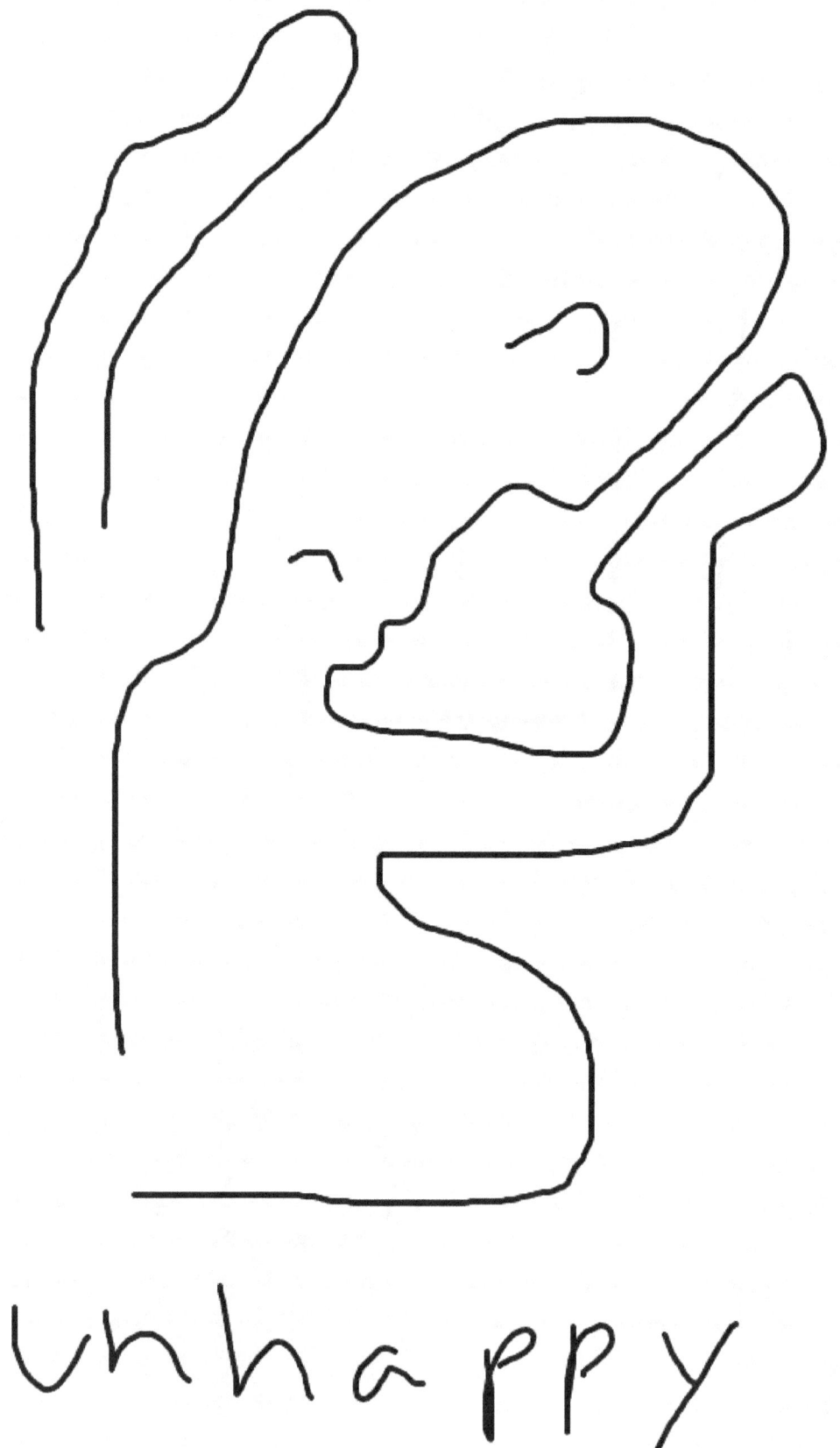

unhappy

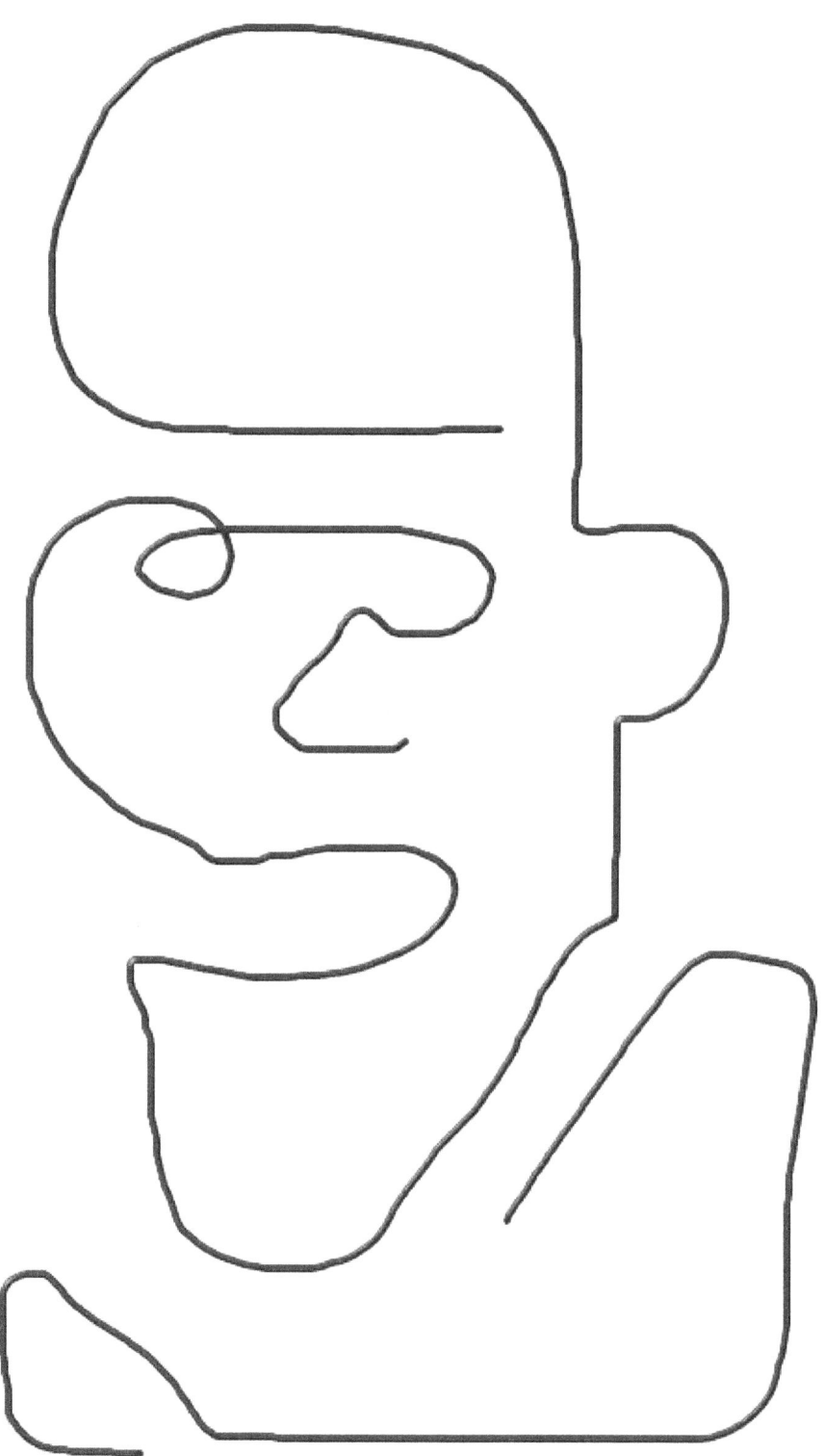

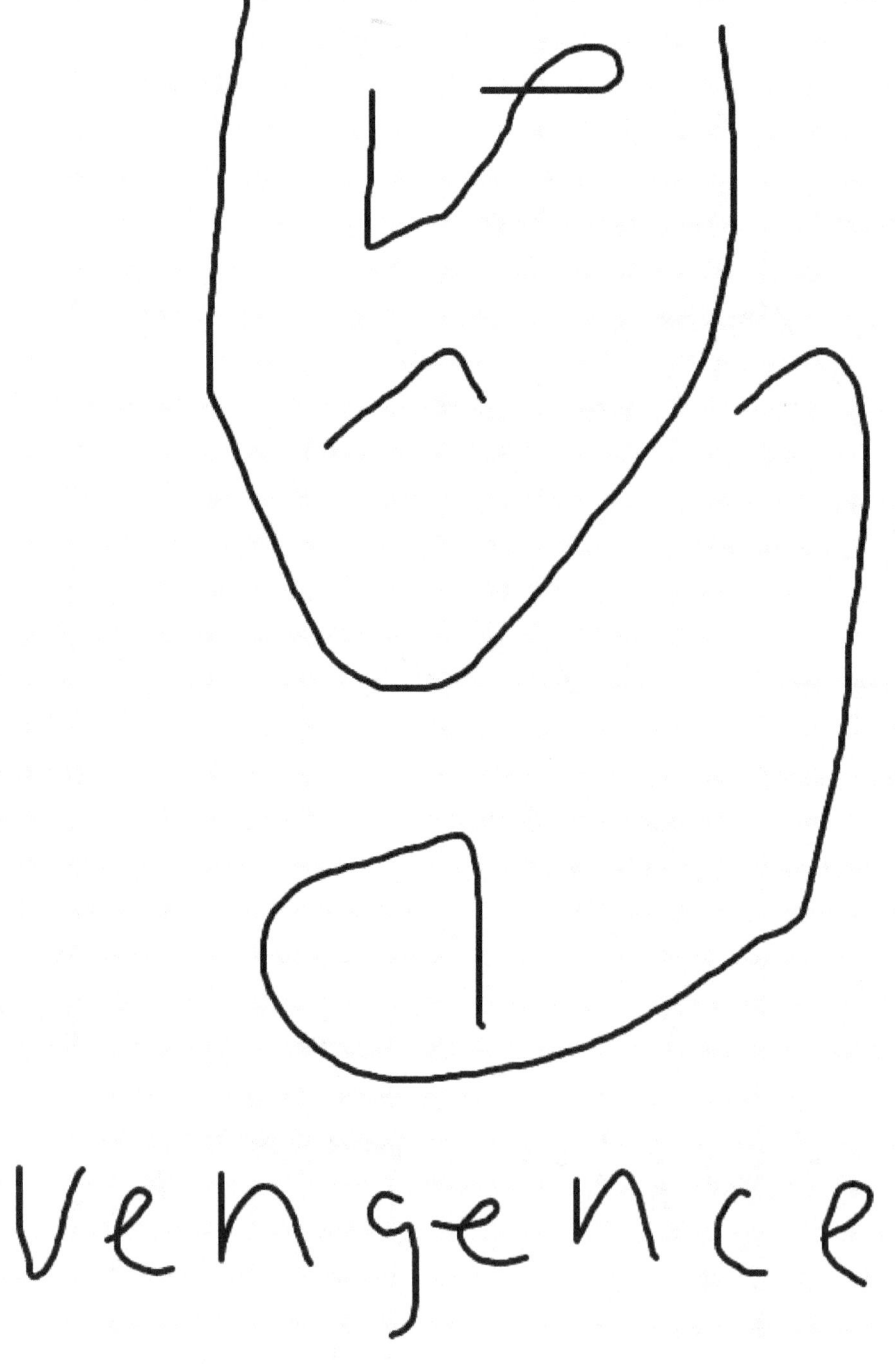

vengence

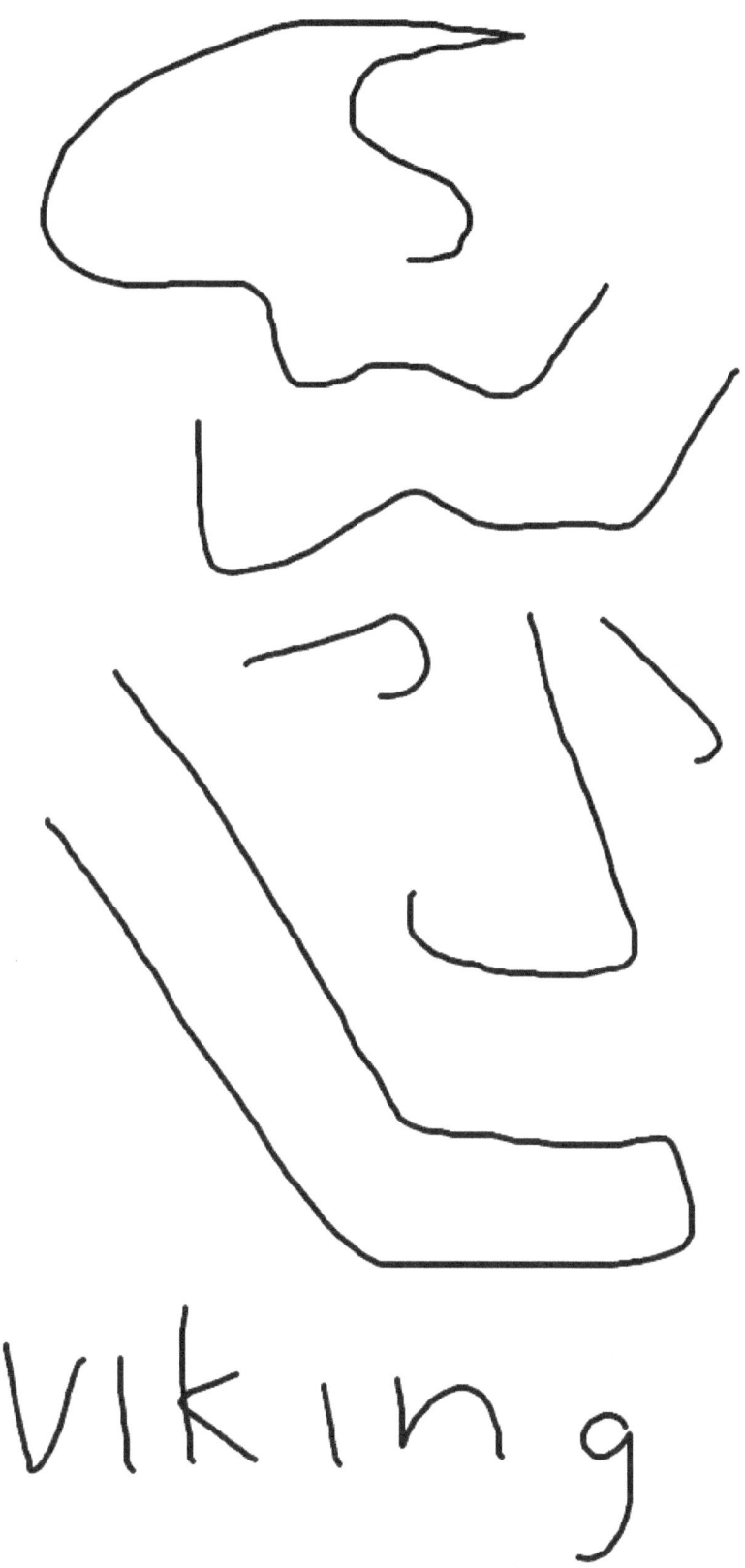

viking

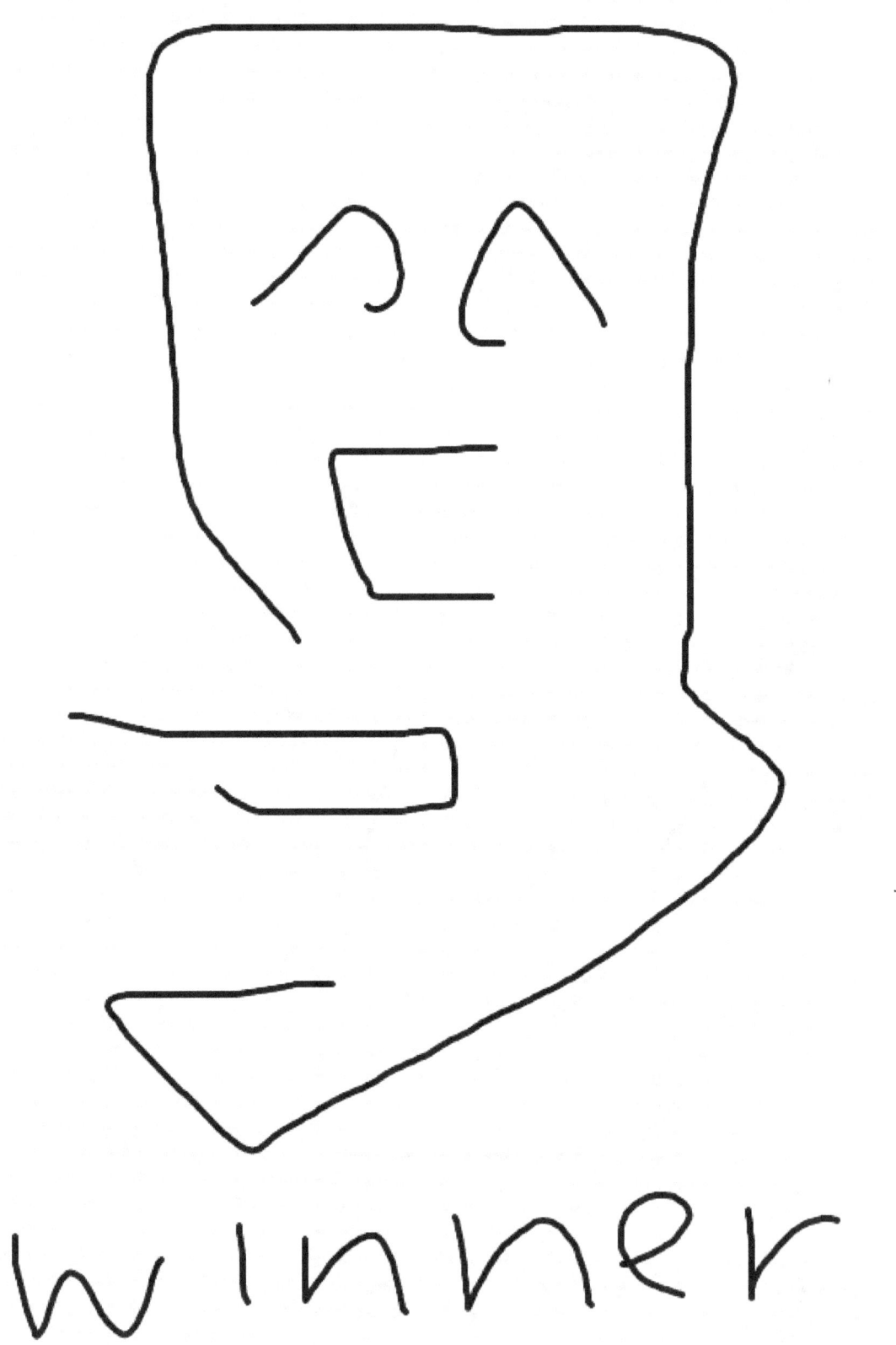
winner

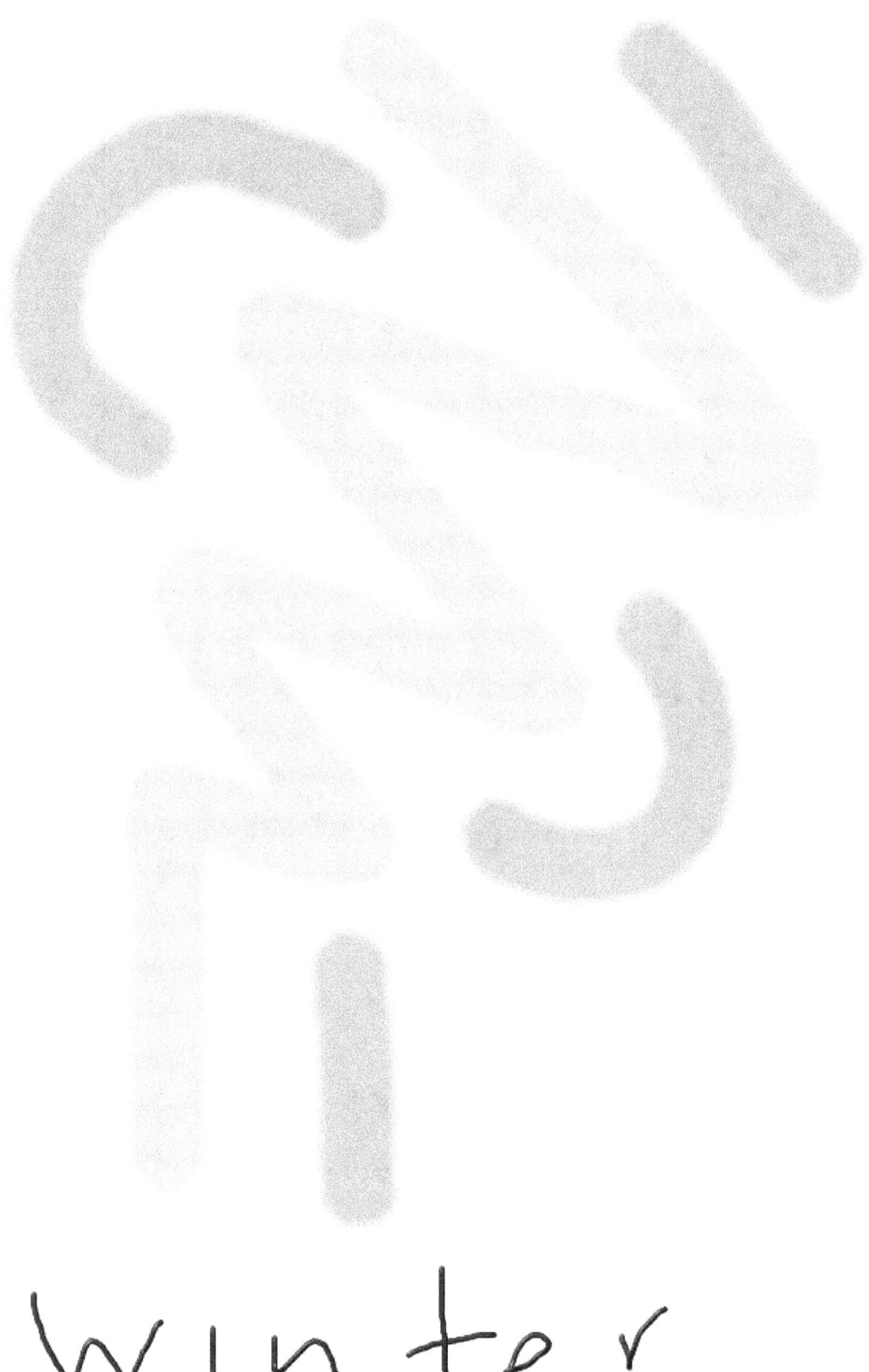

winter

2014
new year

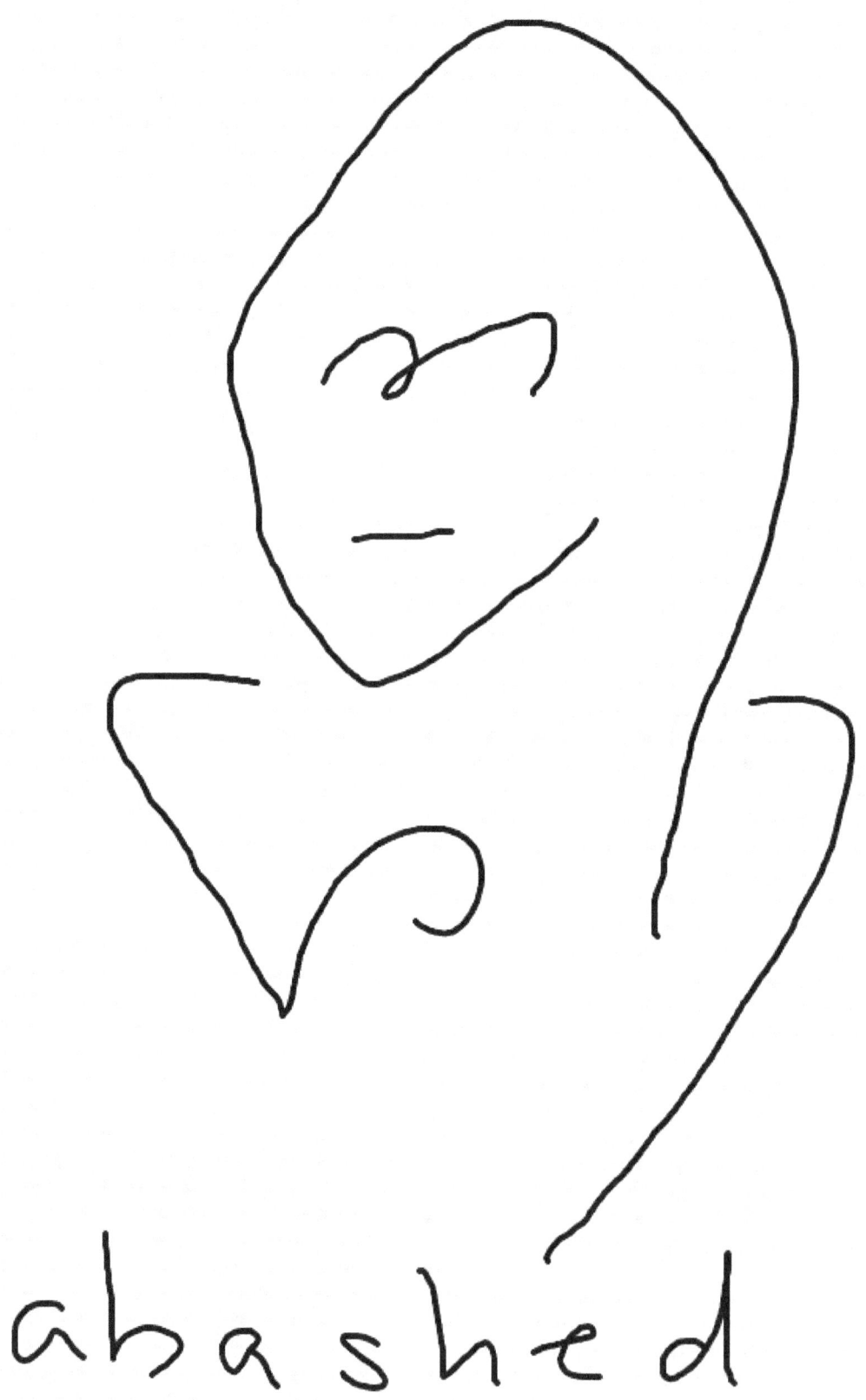

abashed

a sleep

Carlsbad

comedian

conformist

defensive

deprivation

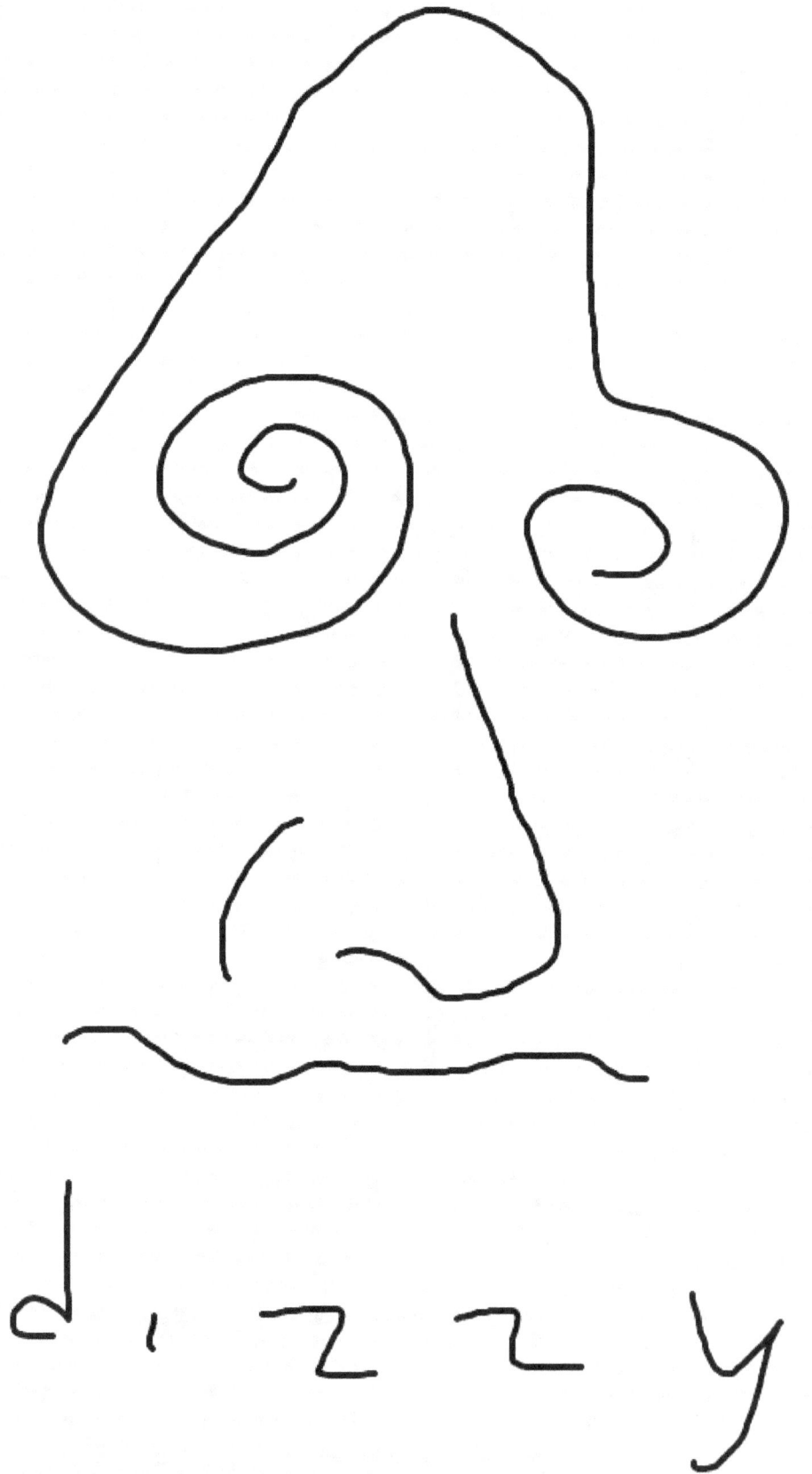

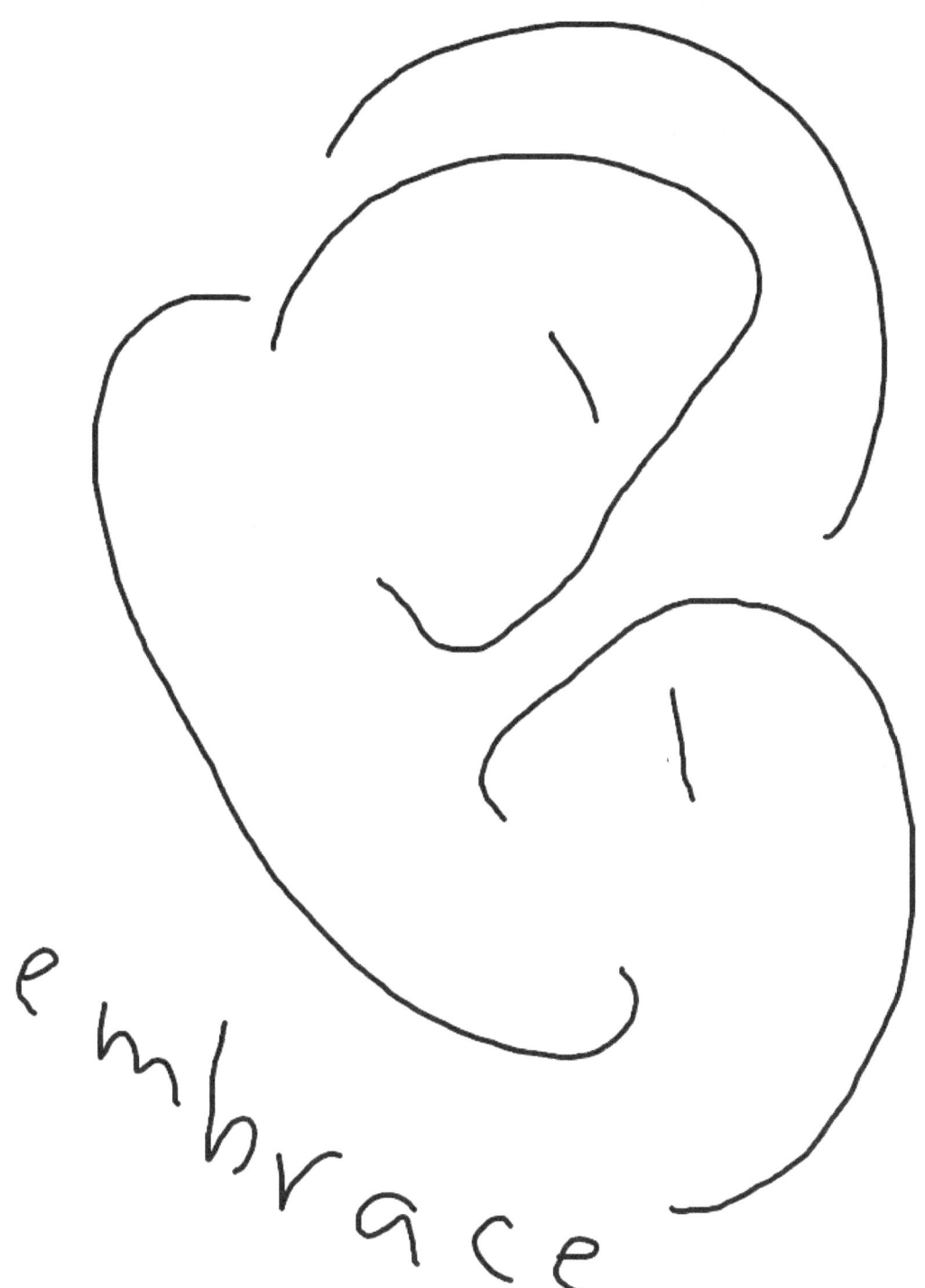

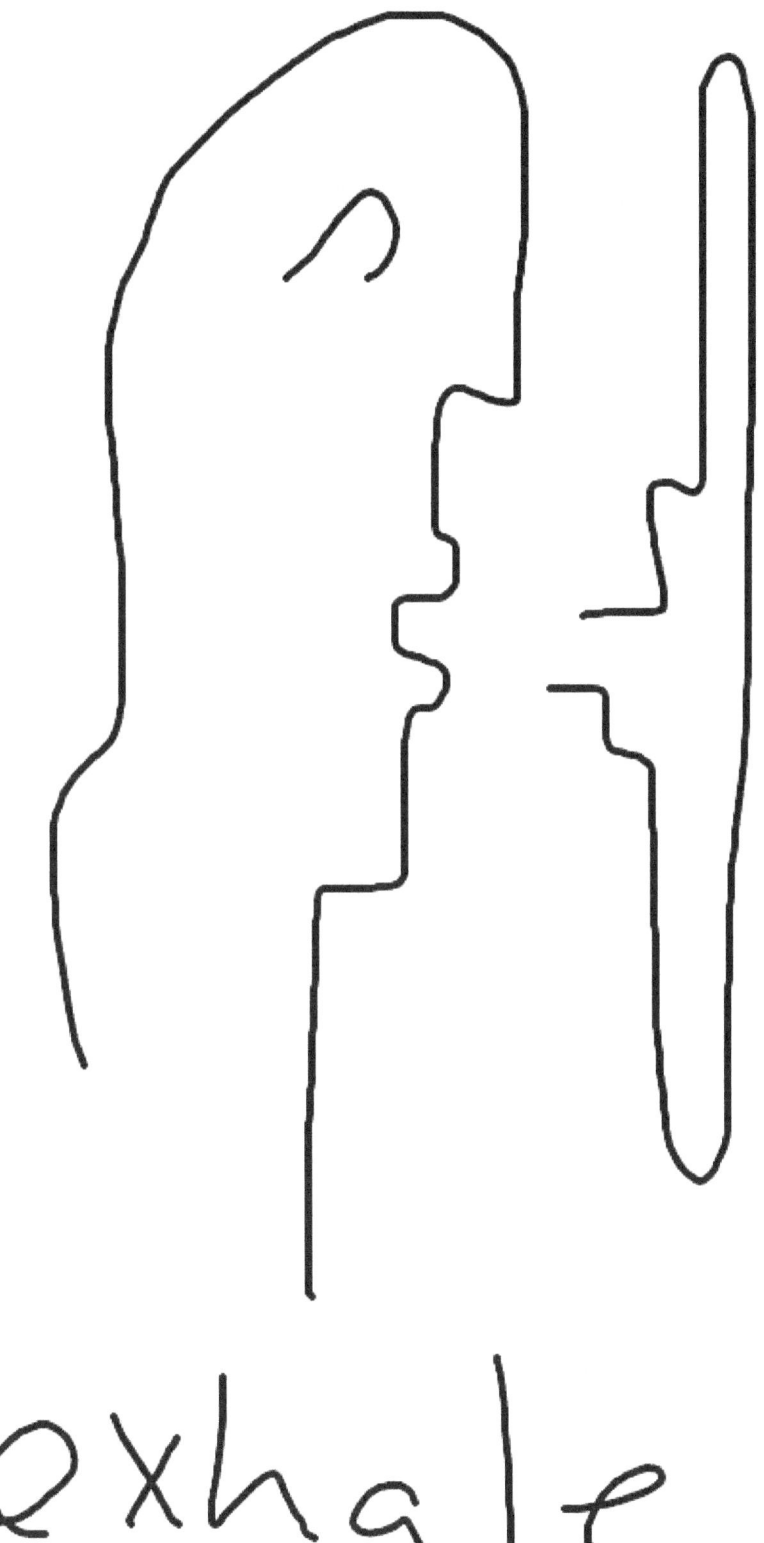

exhale

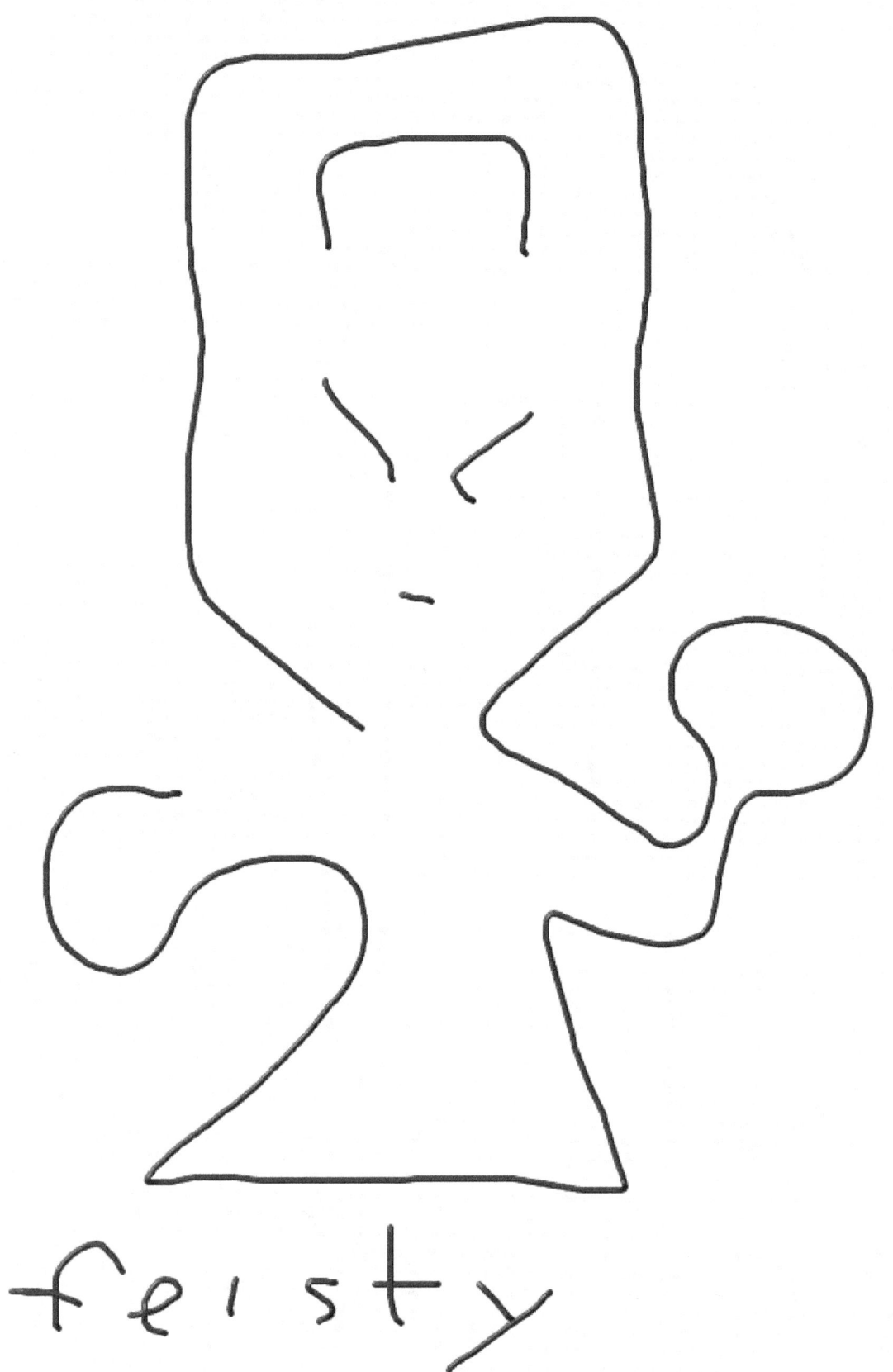

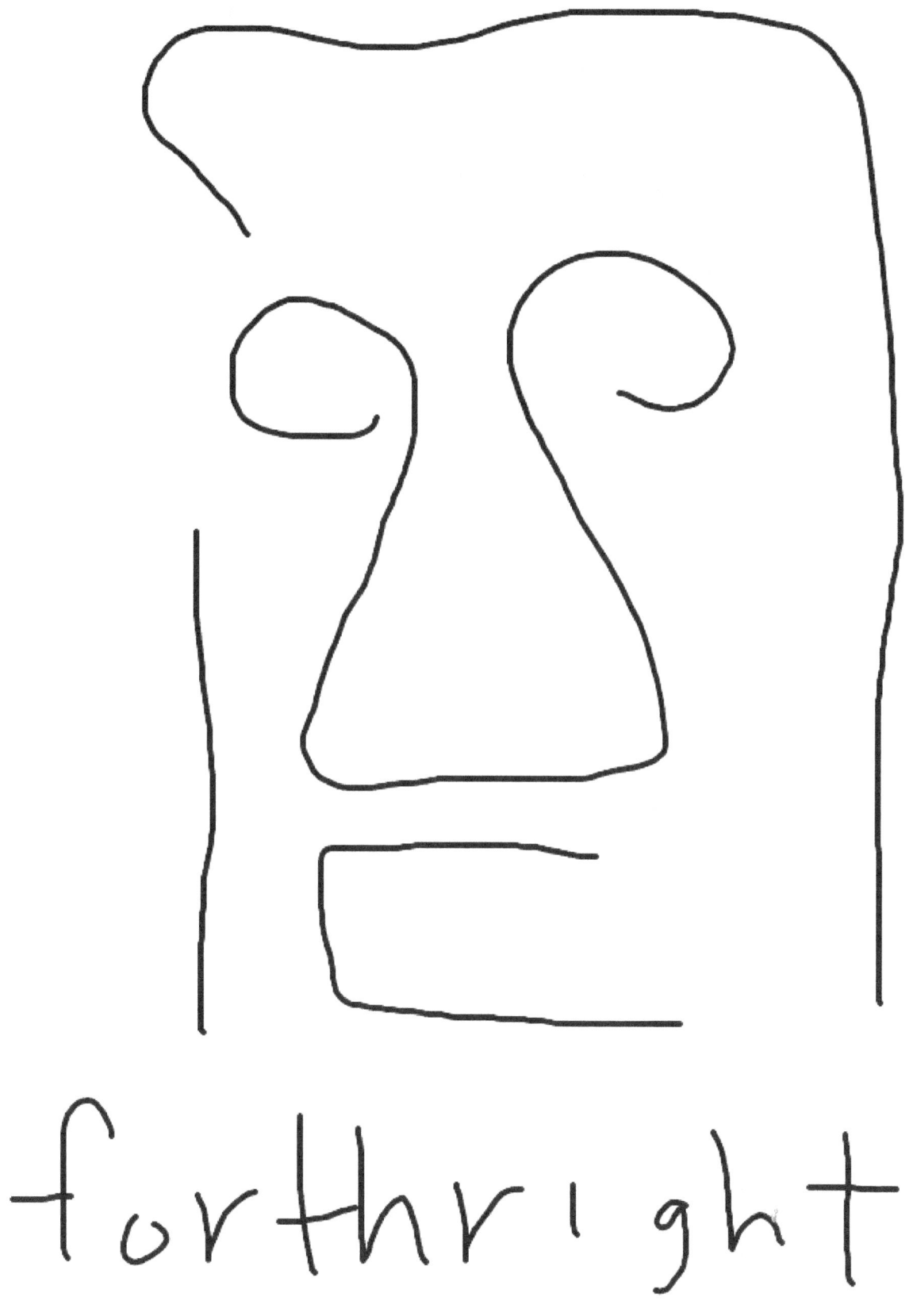

forthright

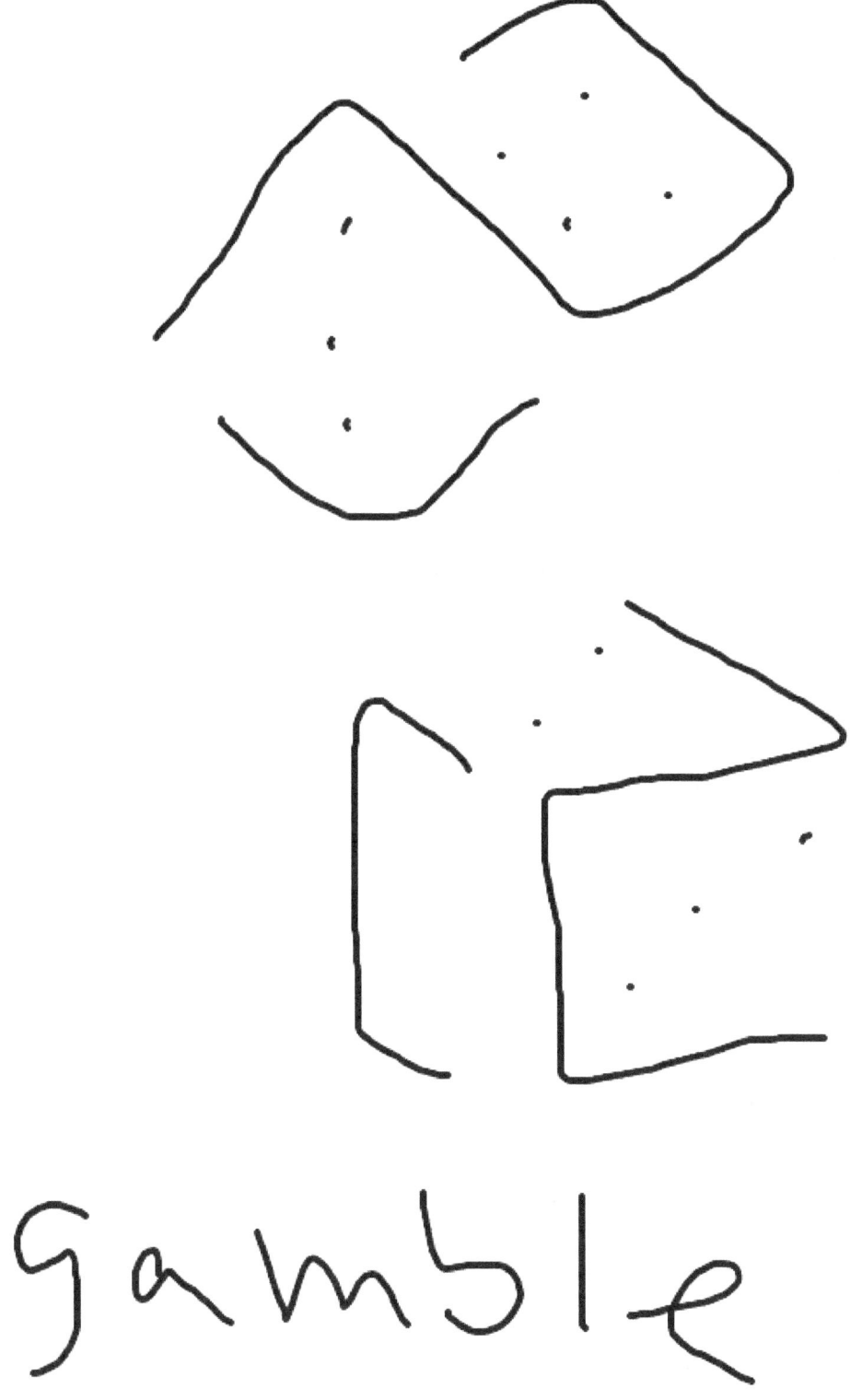

gamble

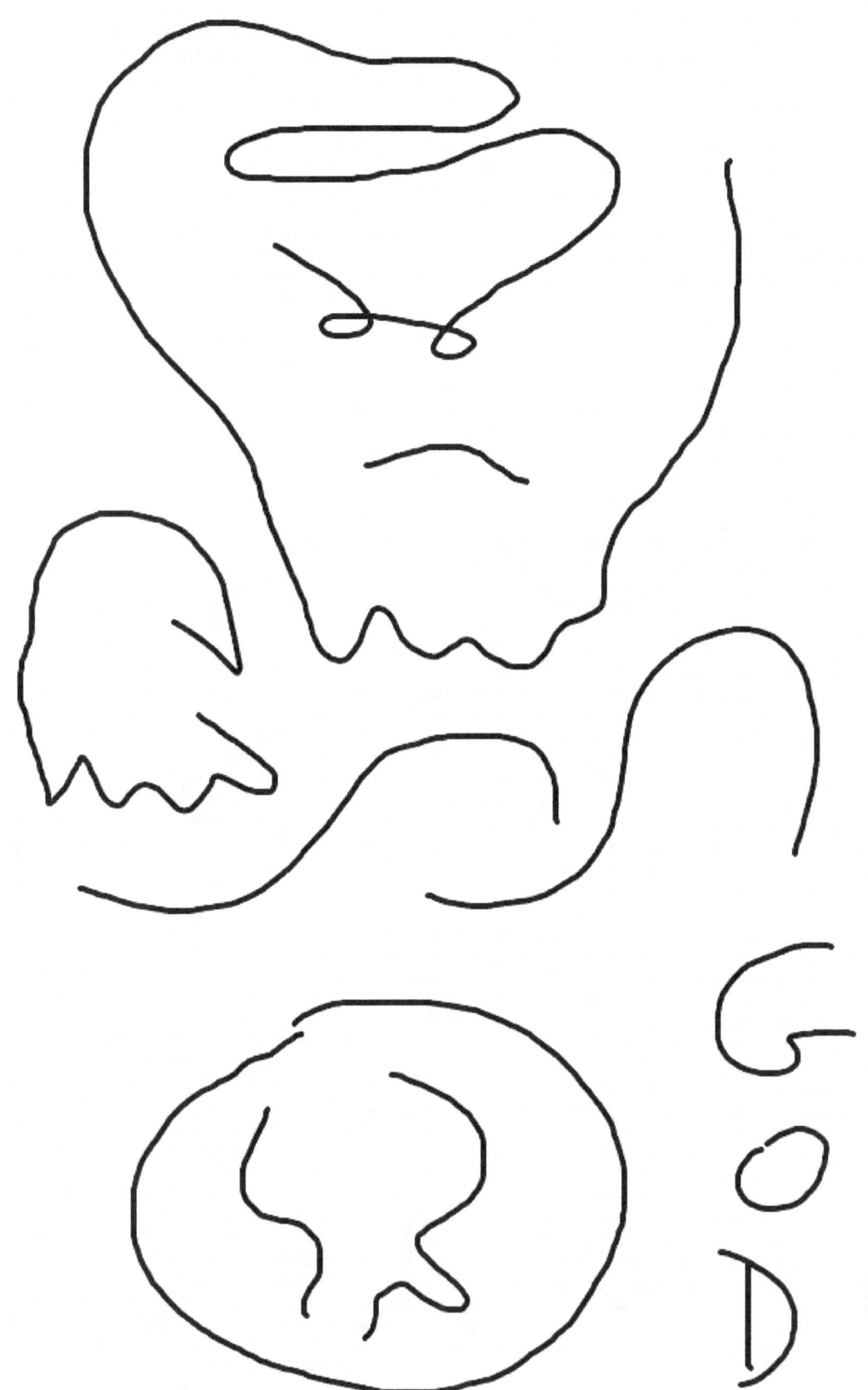

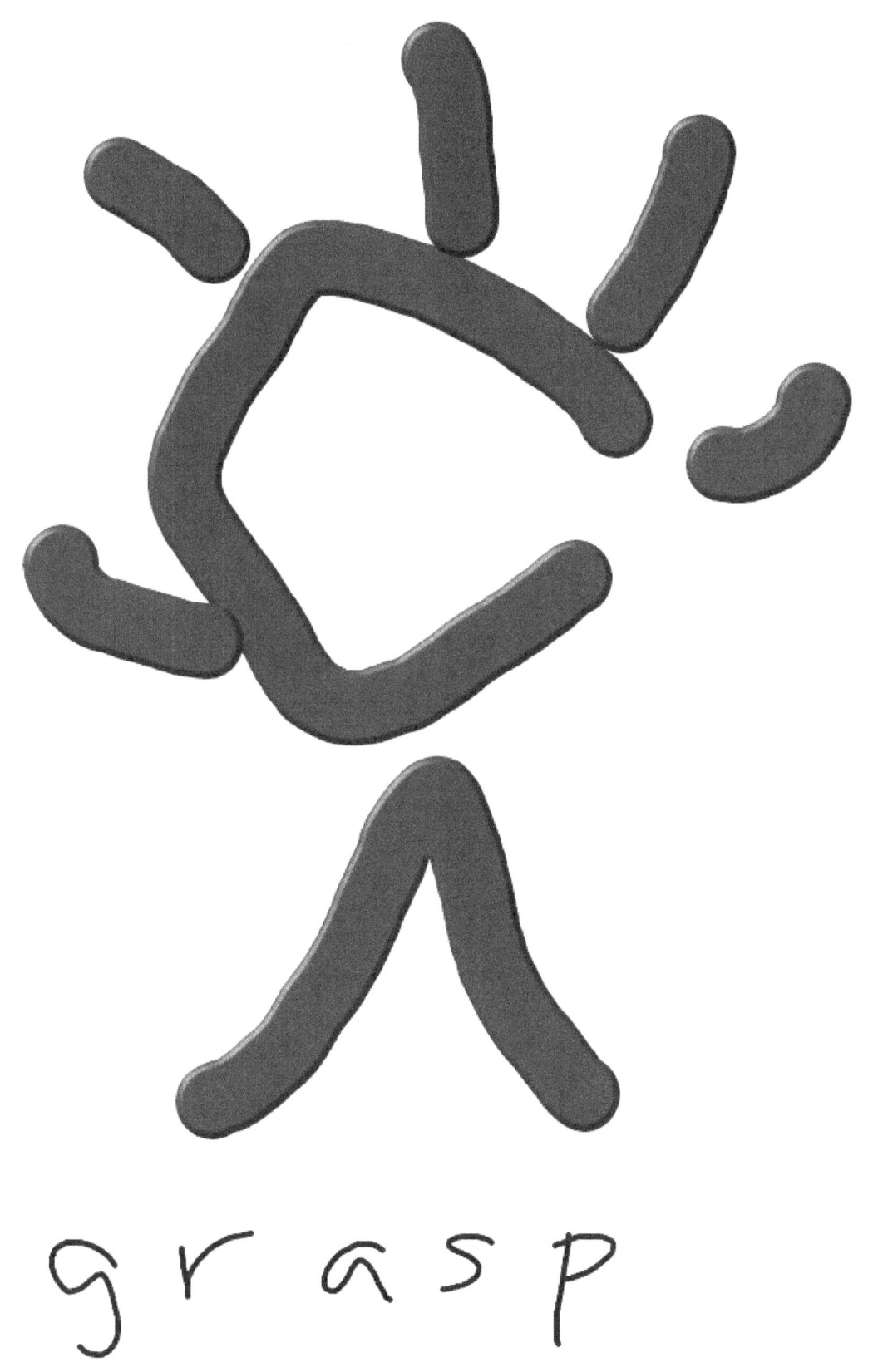

grasp

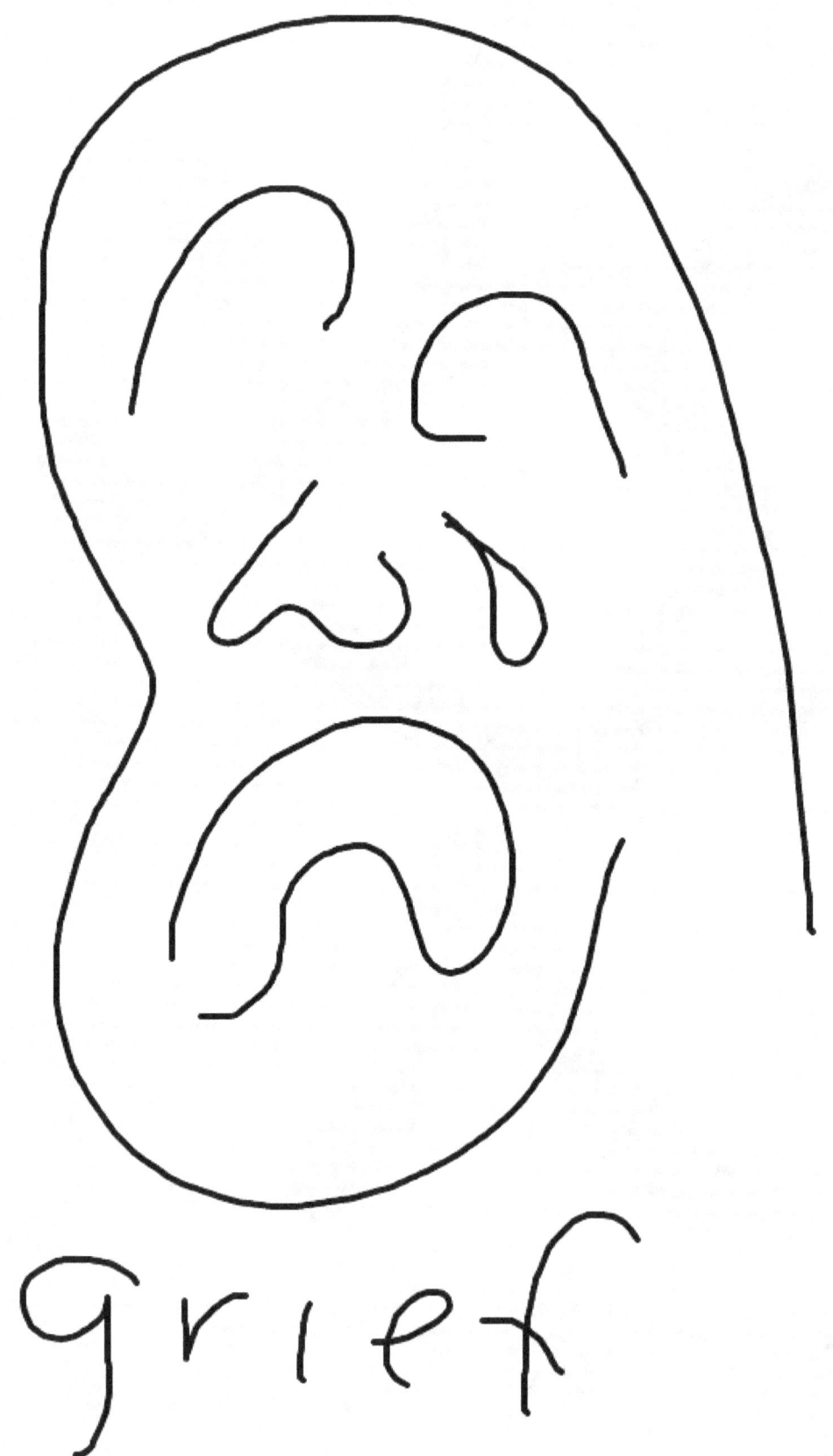

grief

L

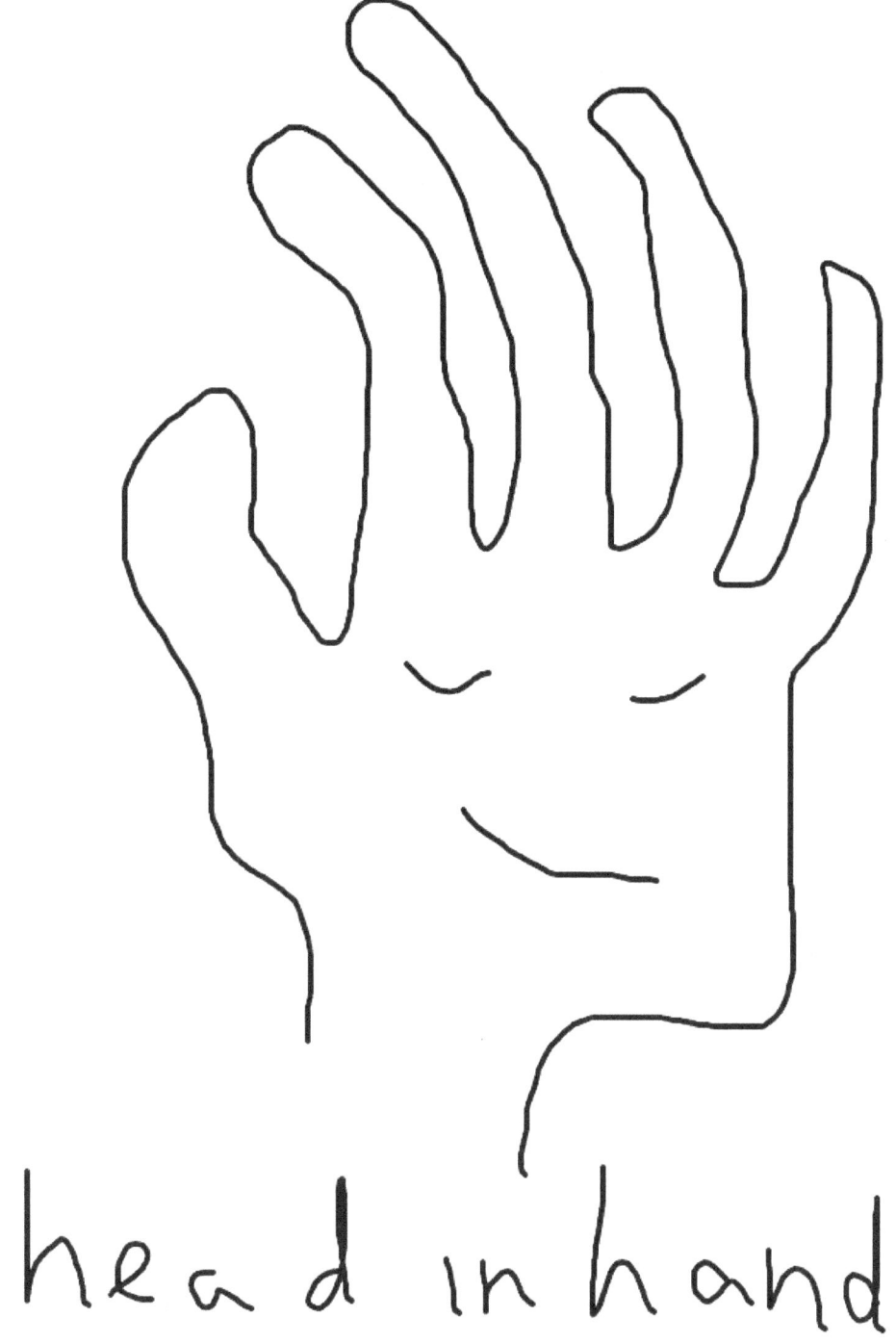

head in hand

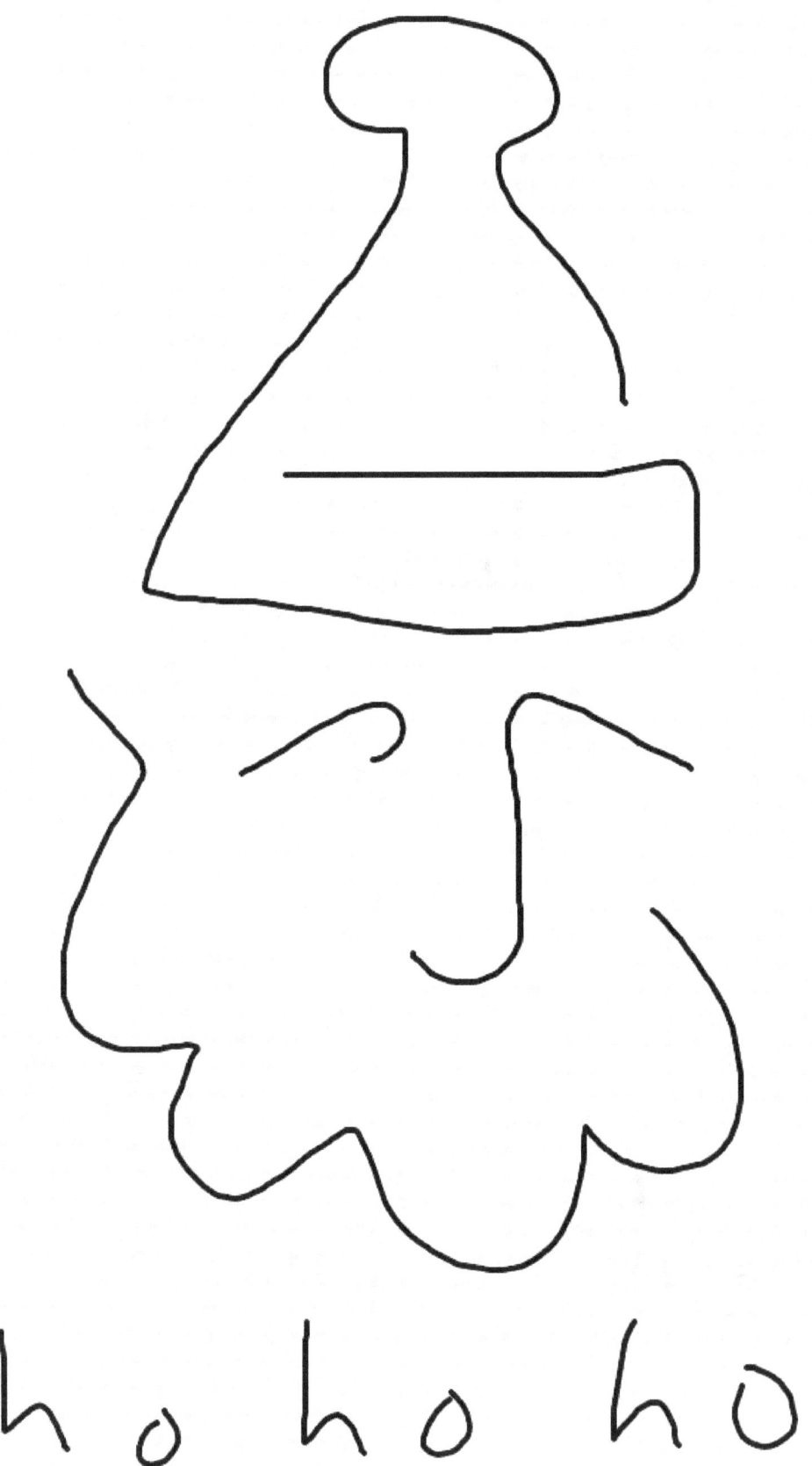

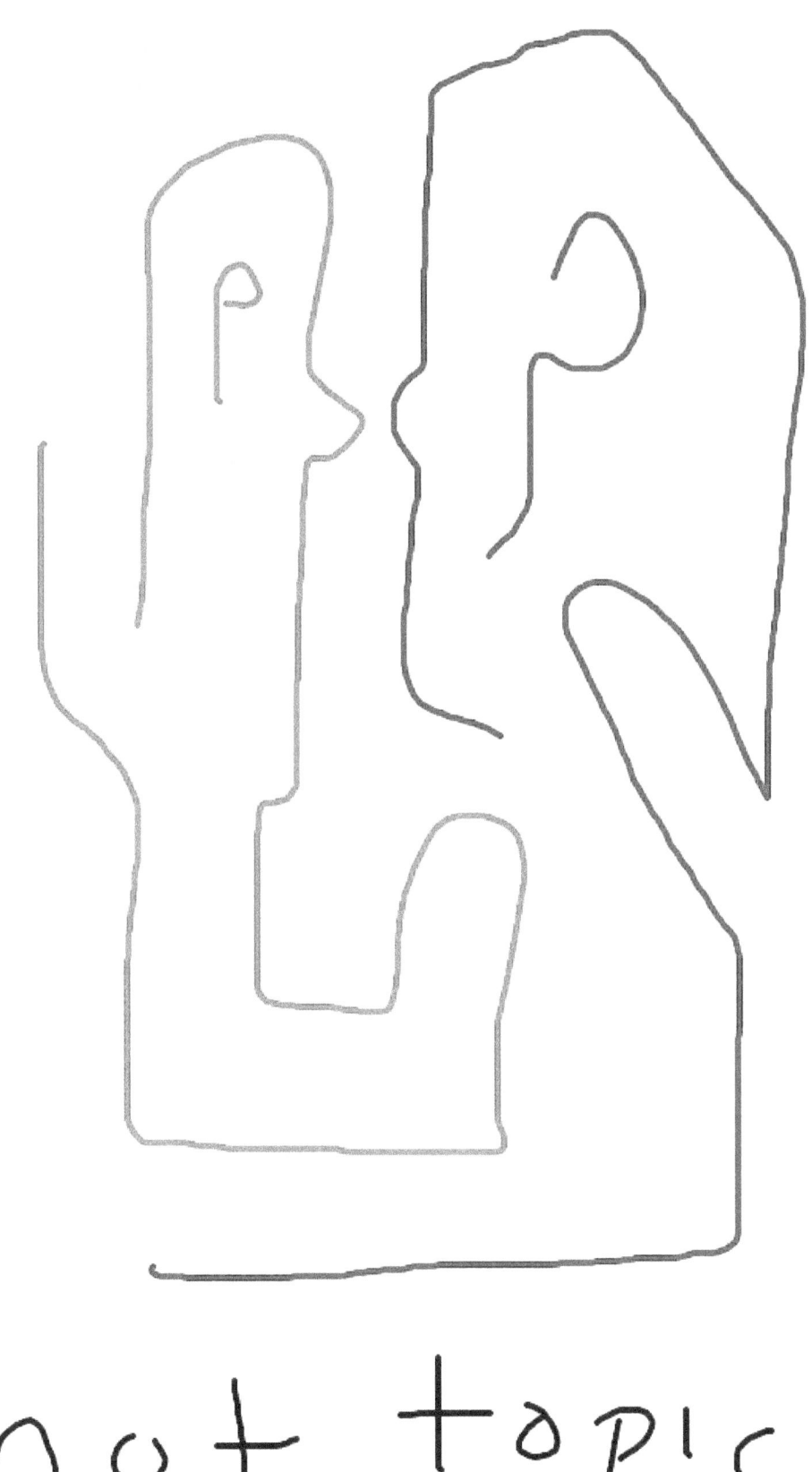

hot topic

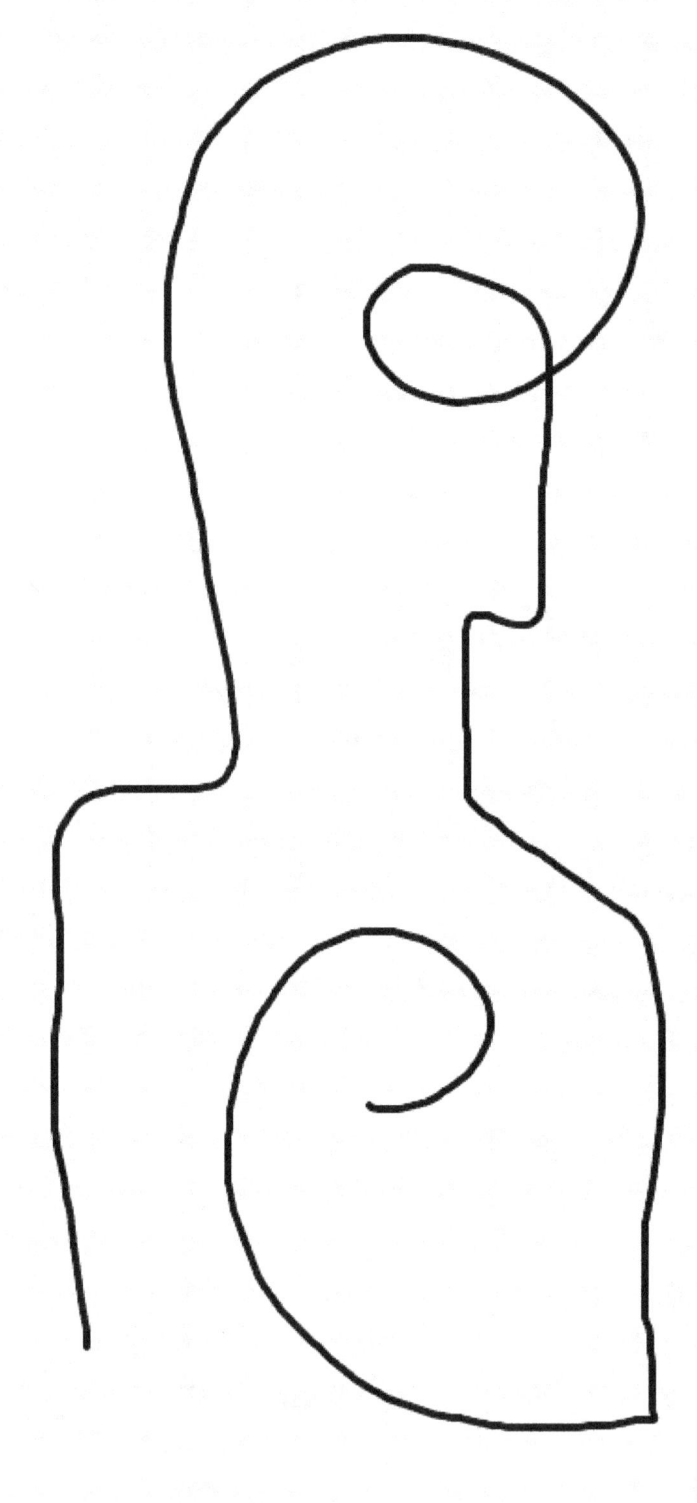

insecure

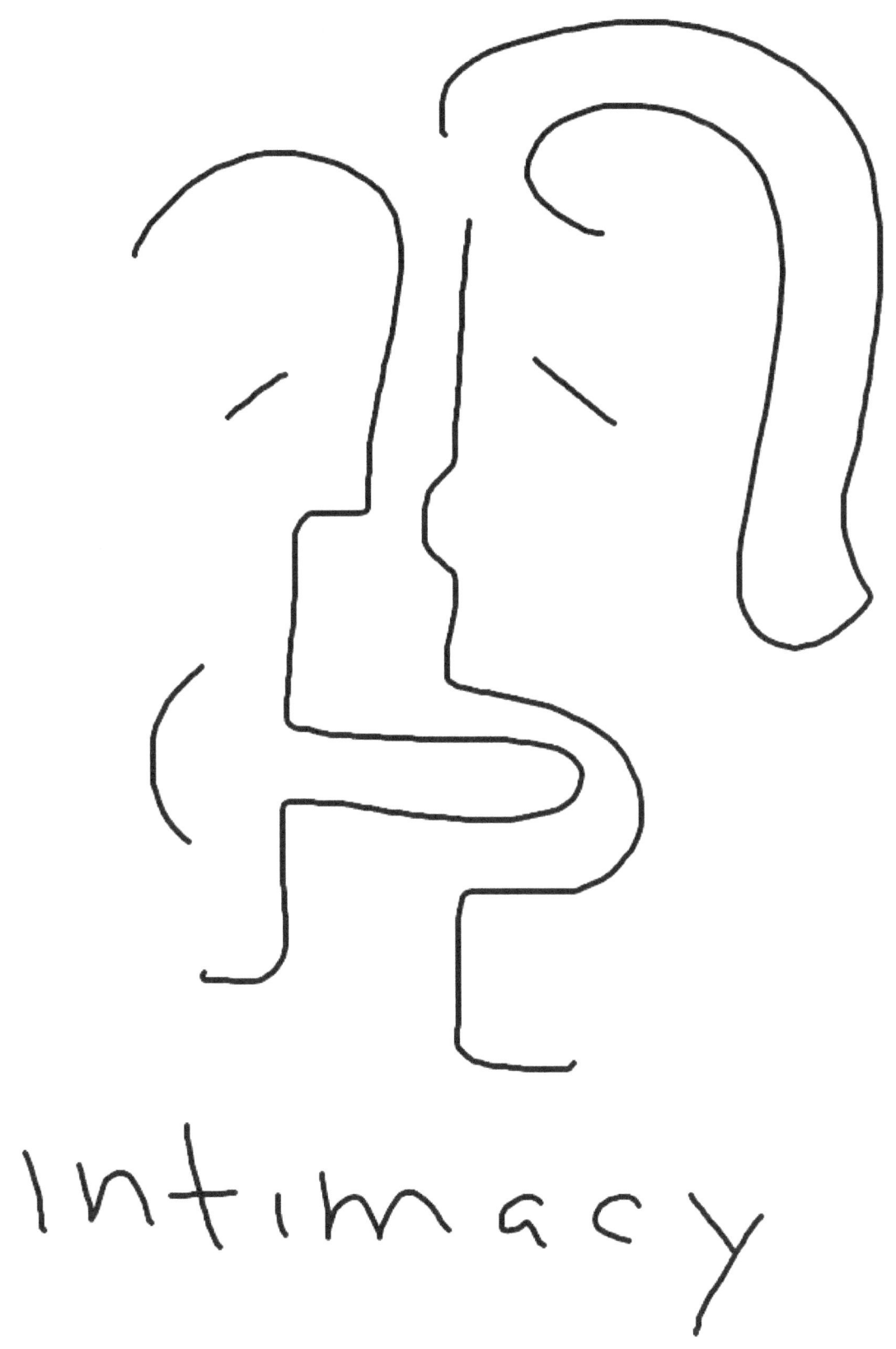

intimacy

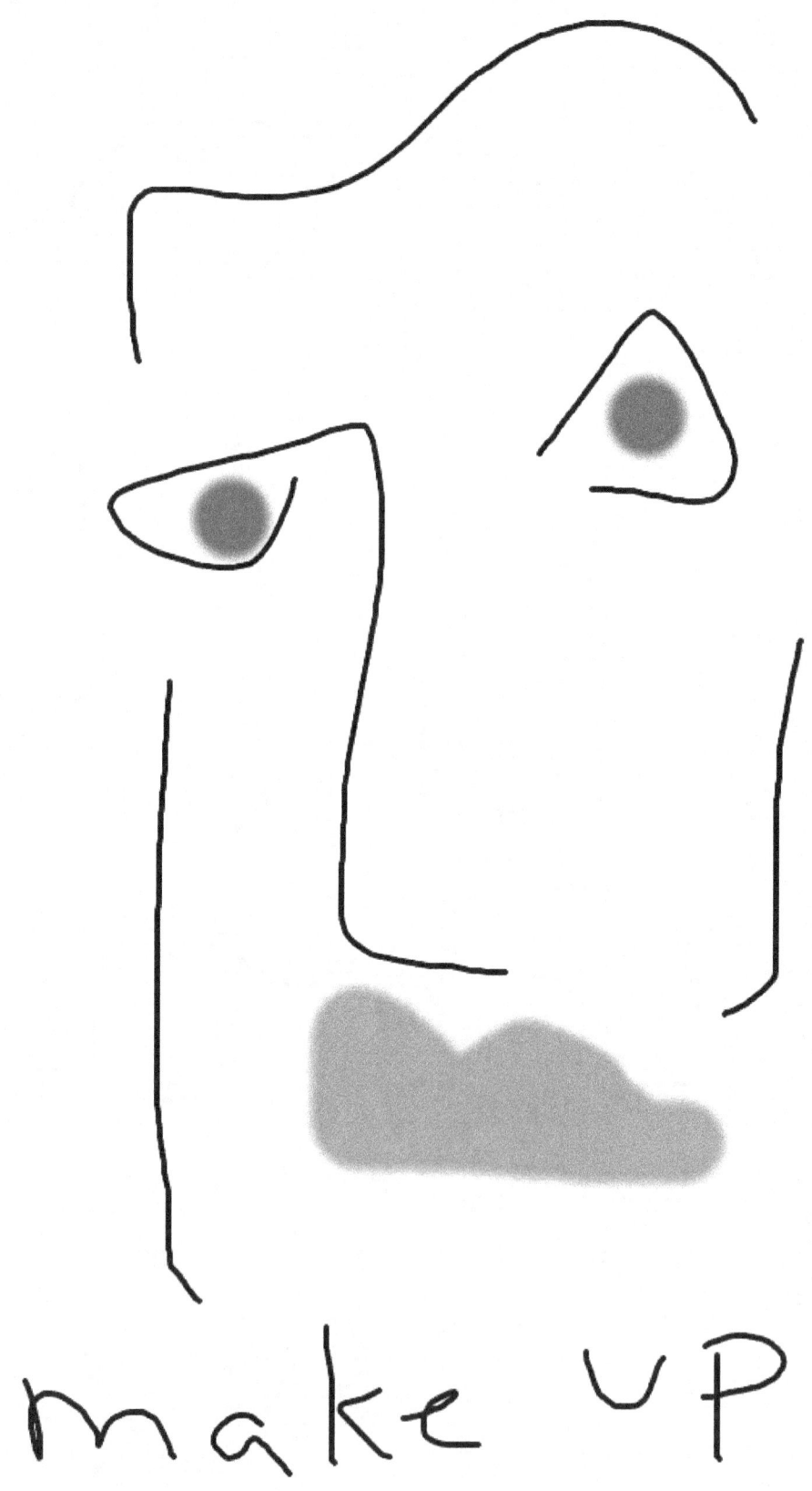

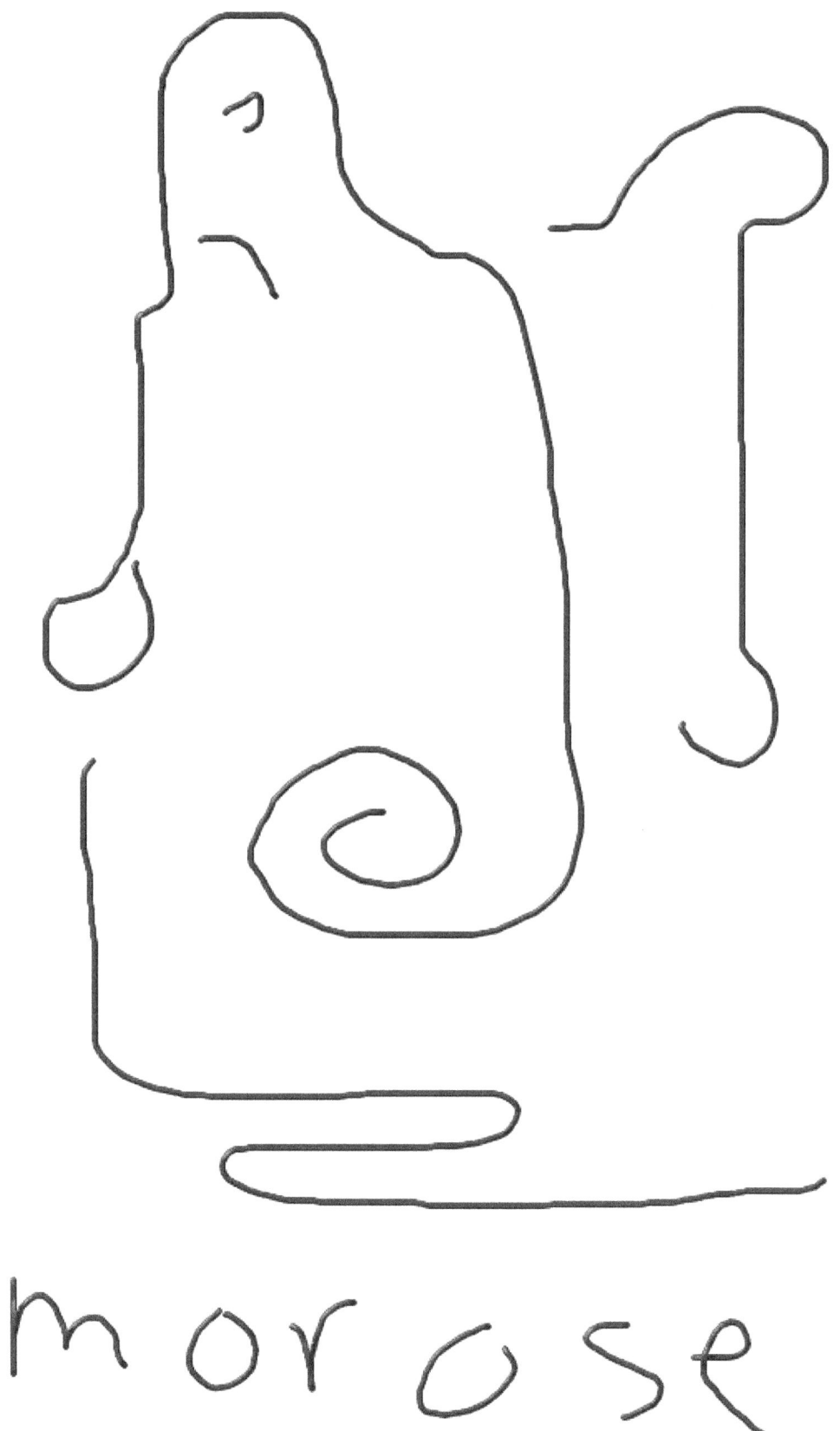

morose

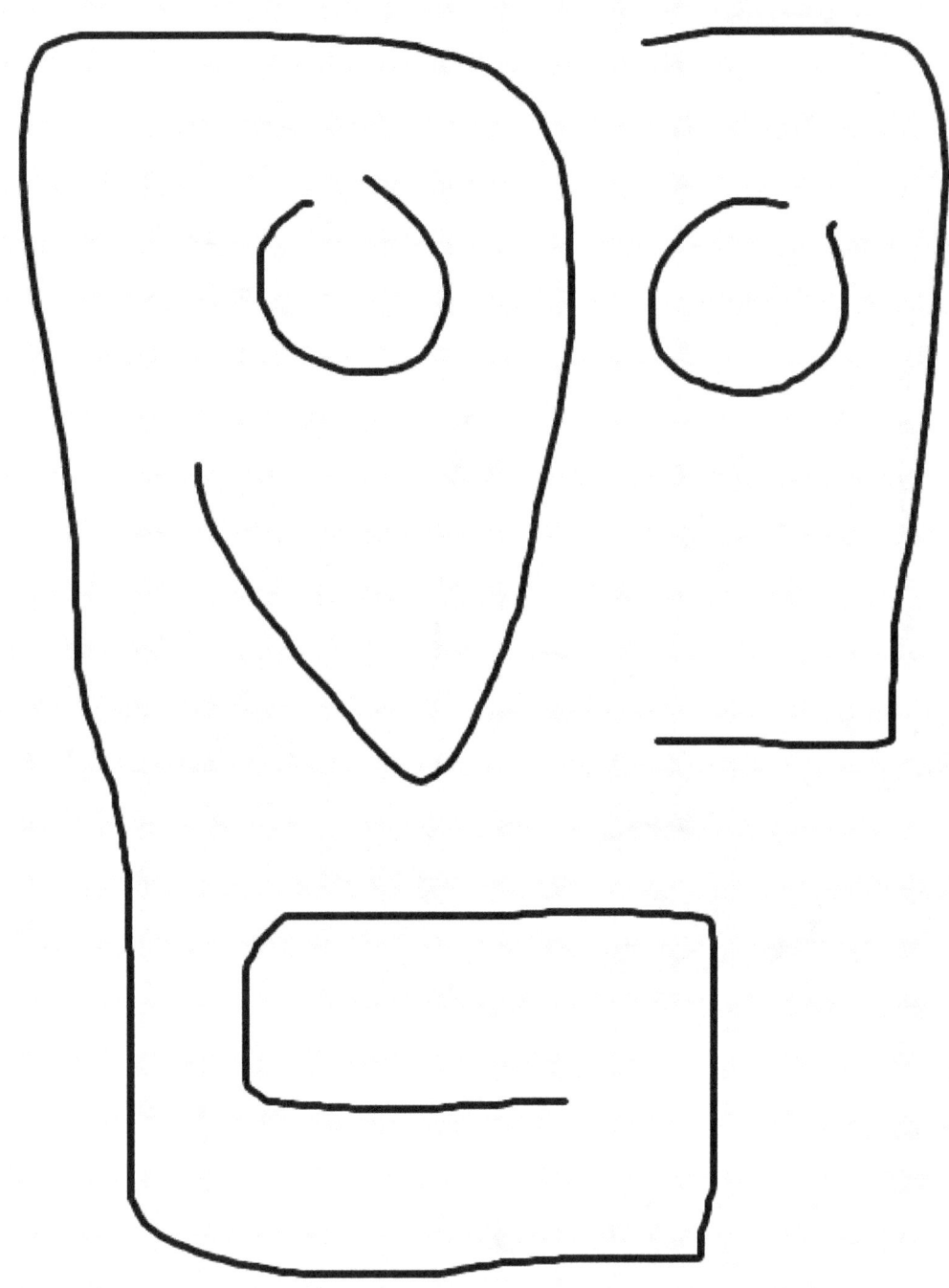

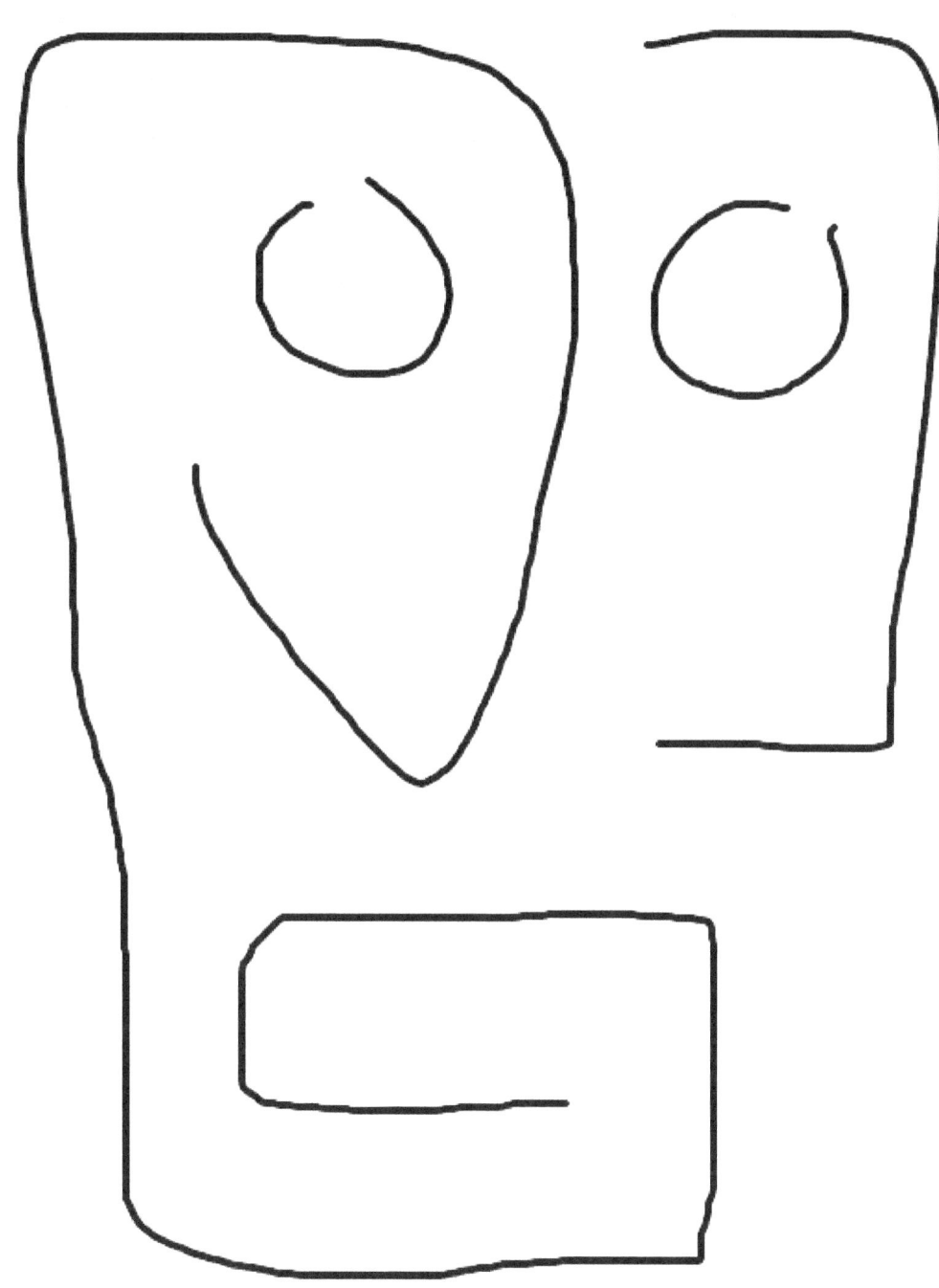

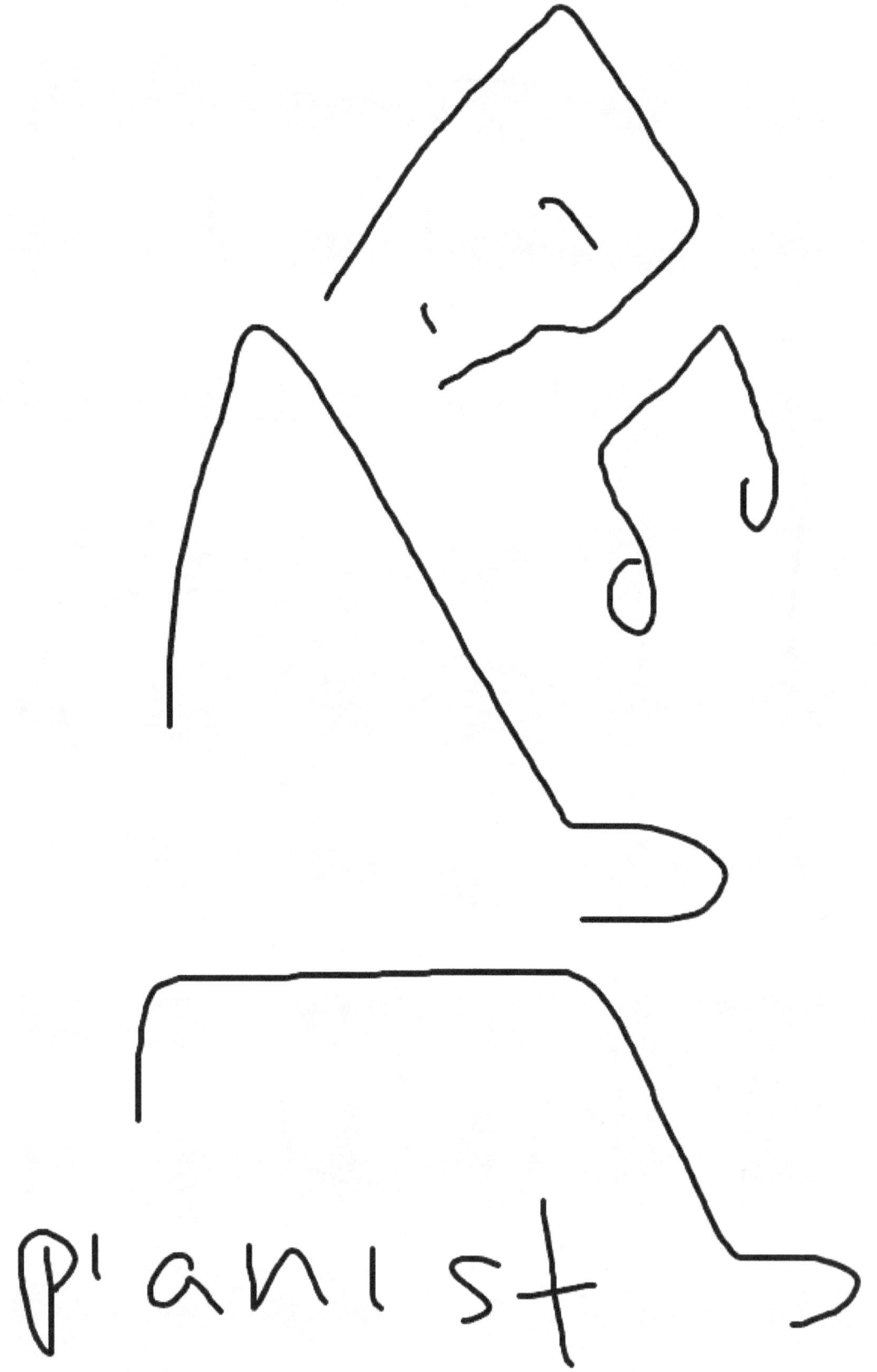

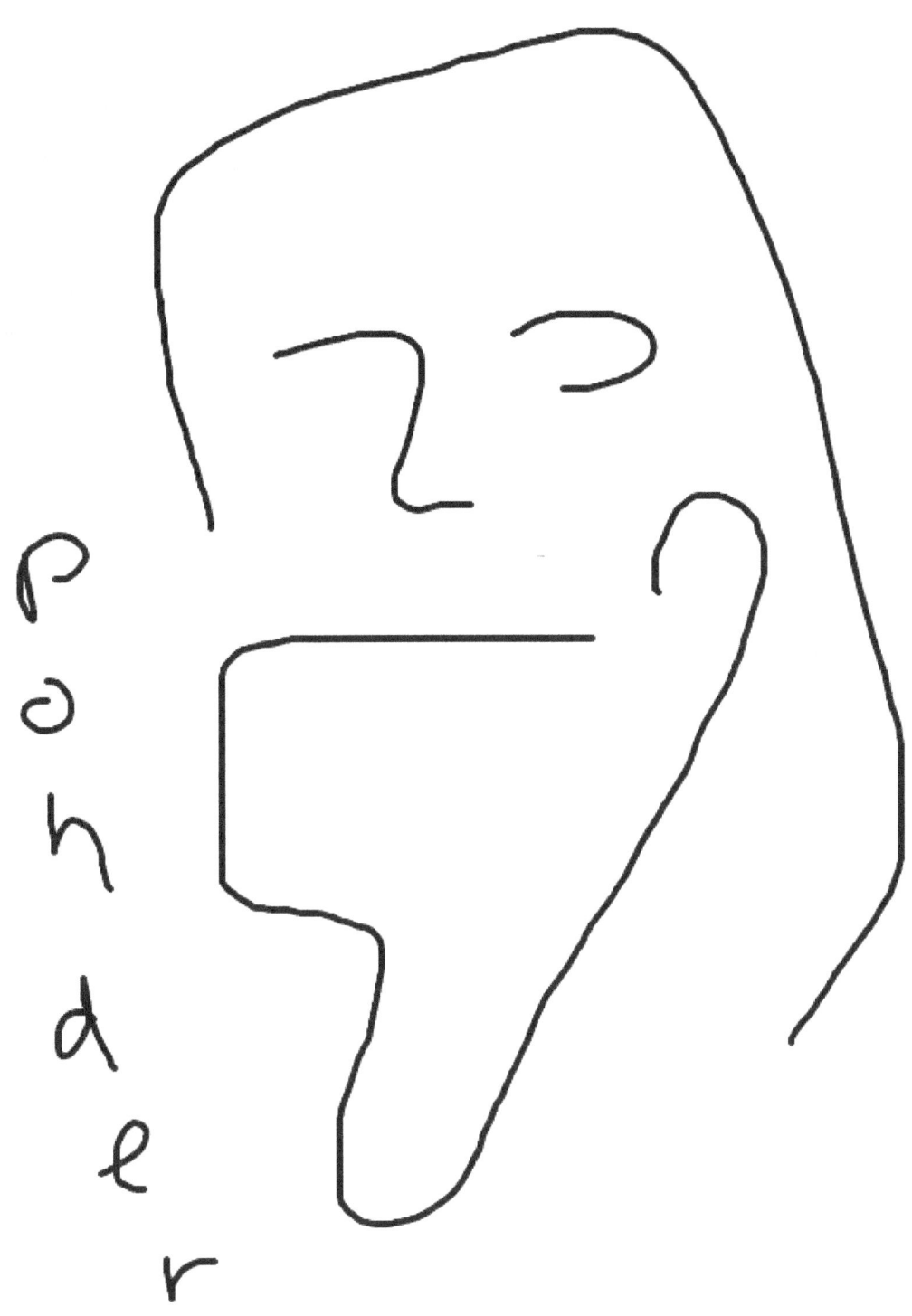

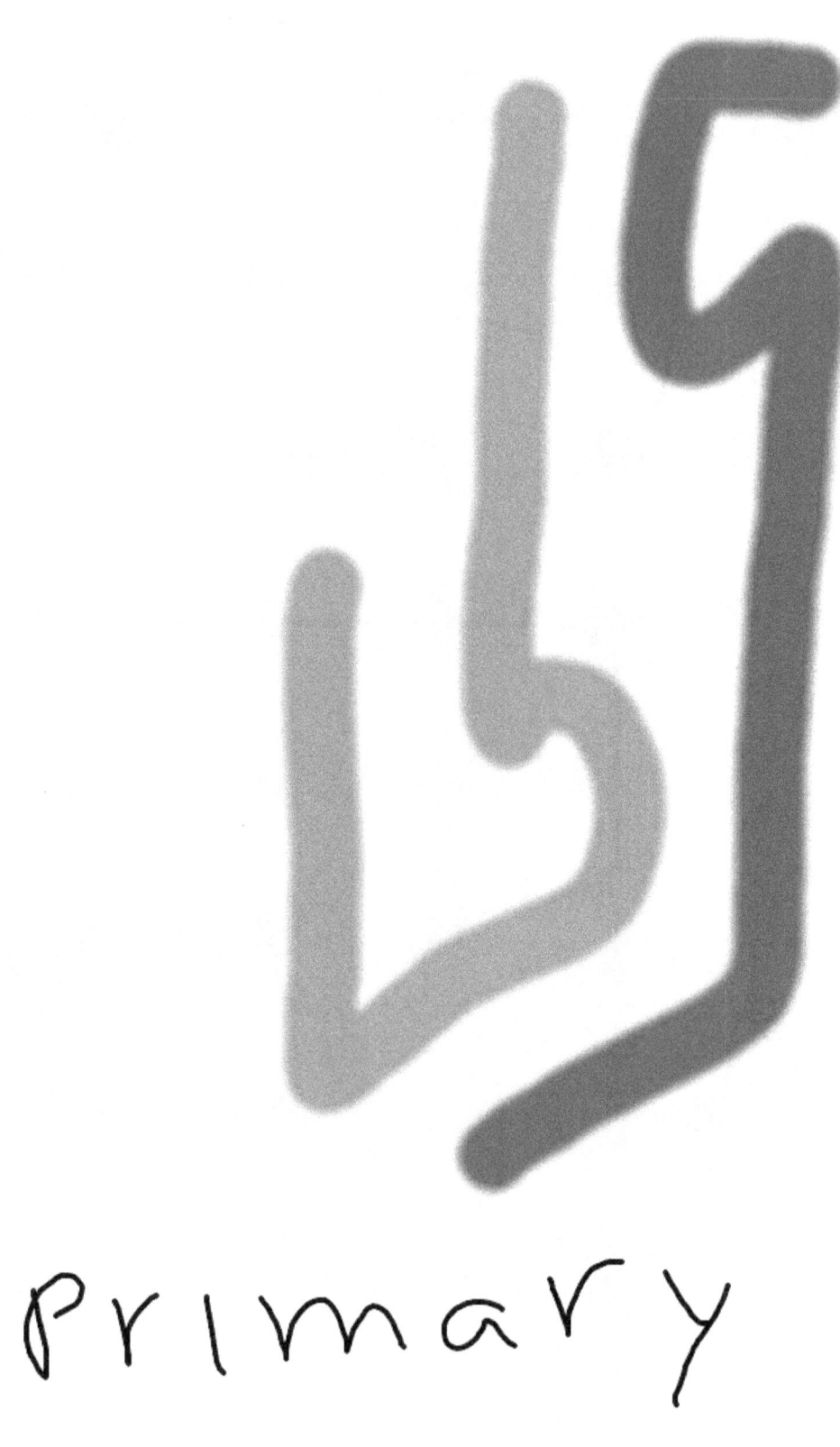

Primary

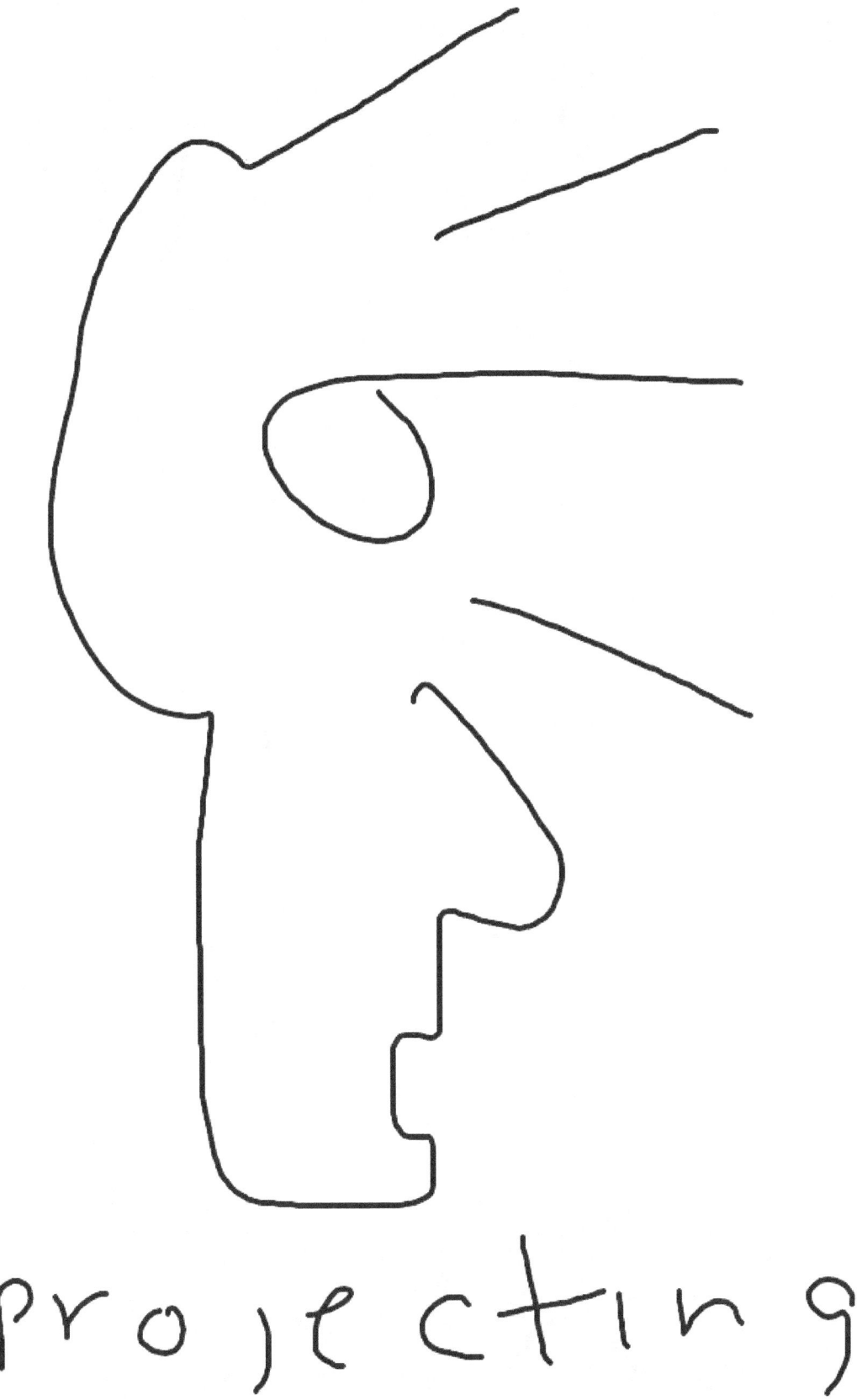

projecting

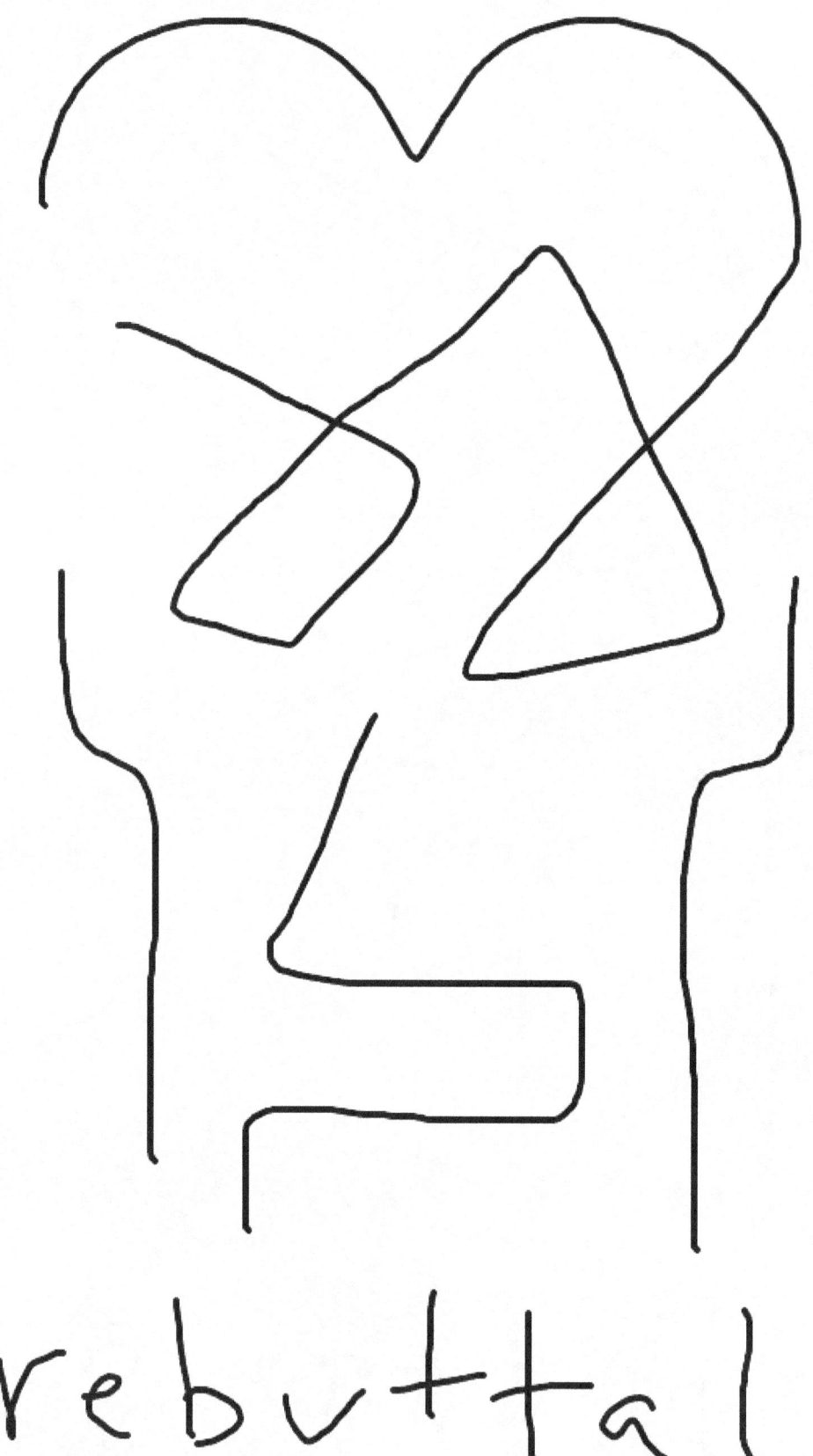

rebuttal

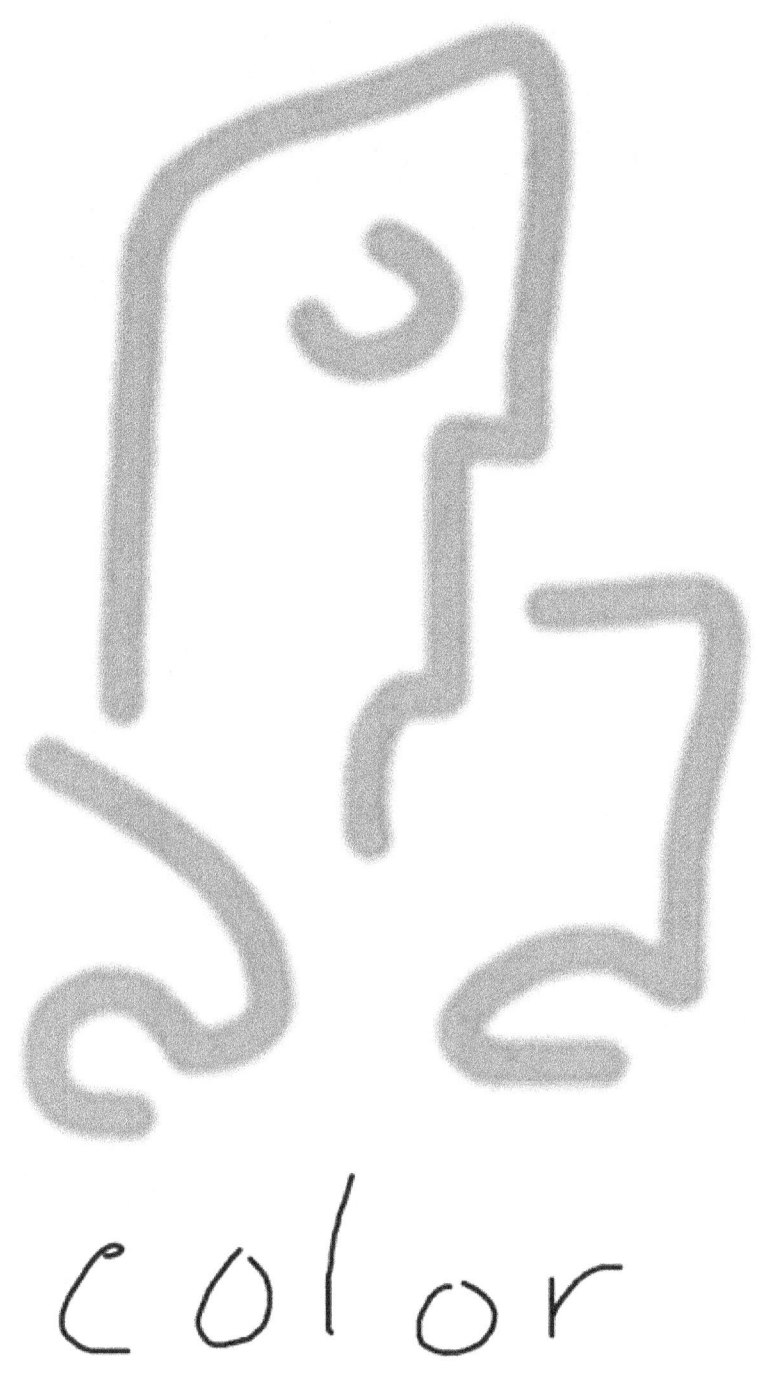

color

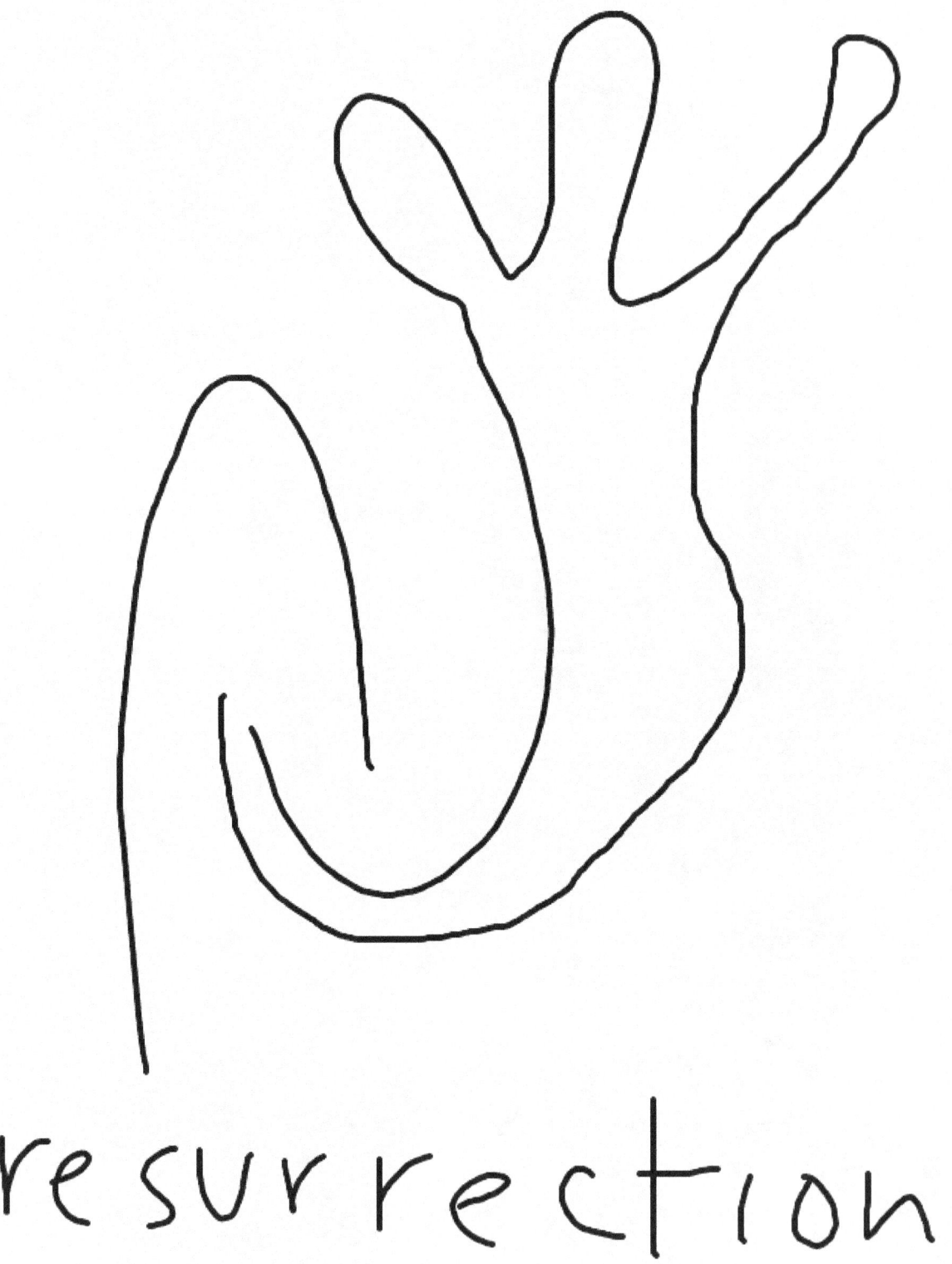

resurrection

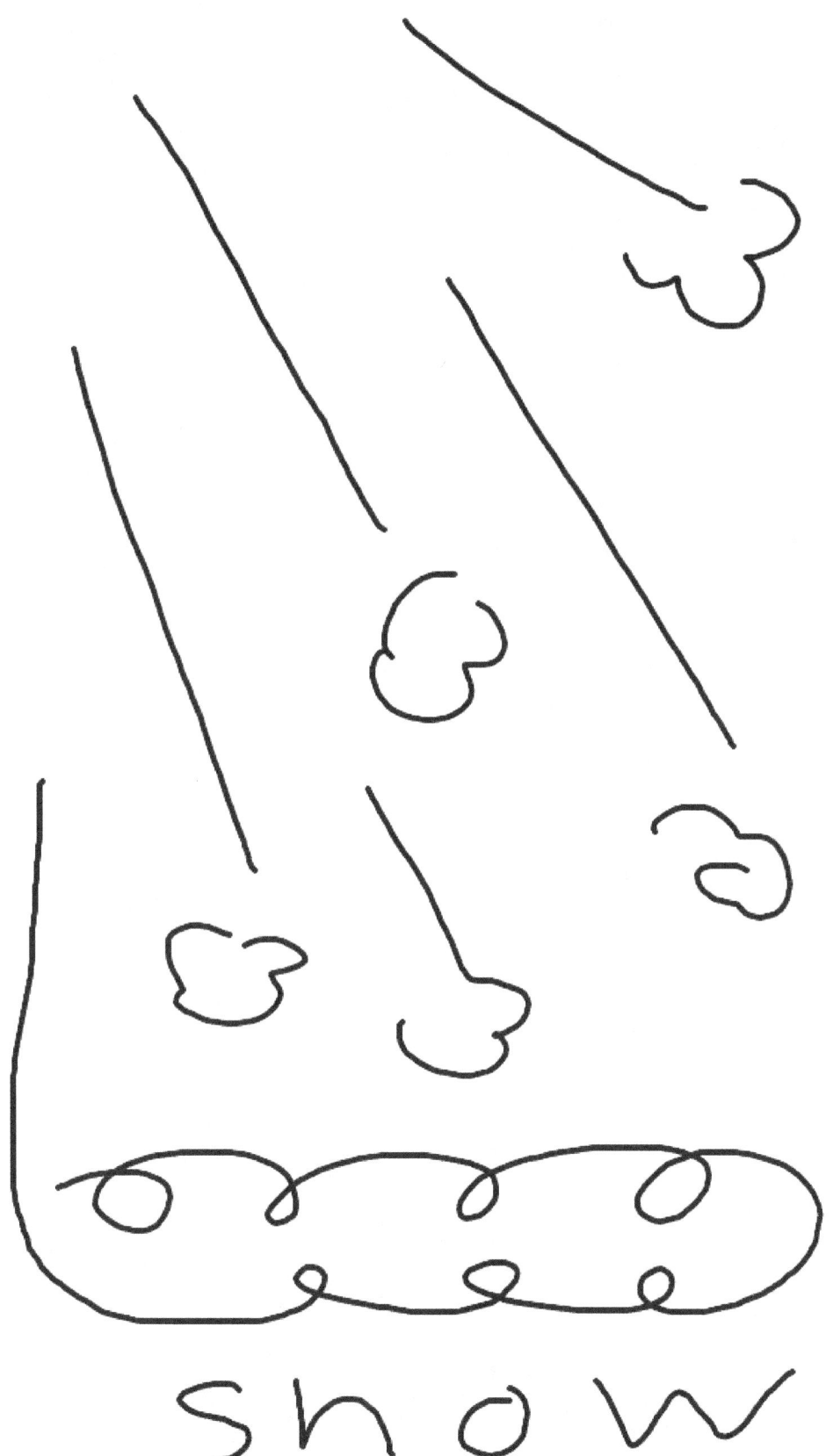

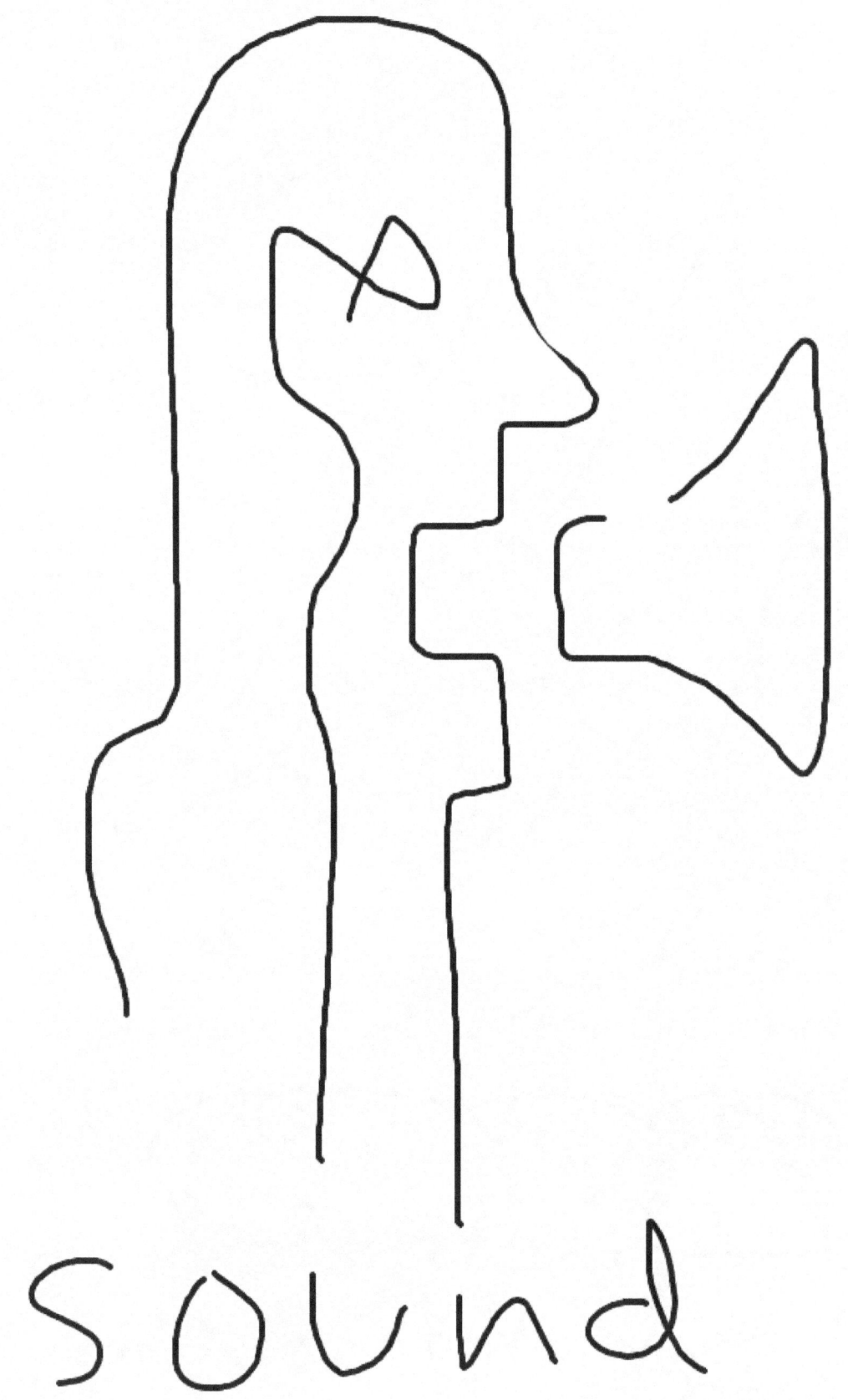

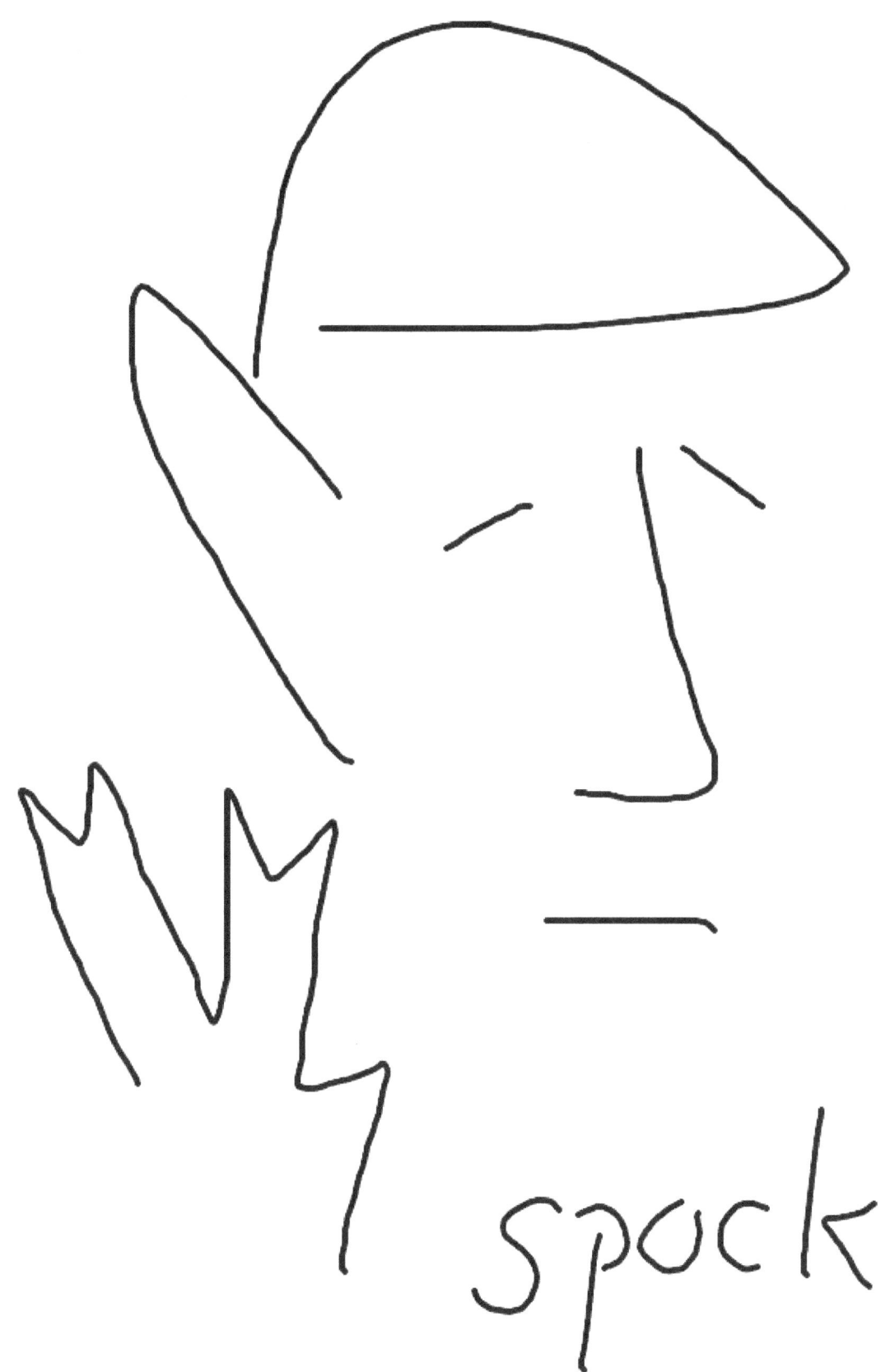

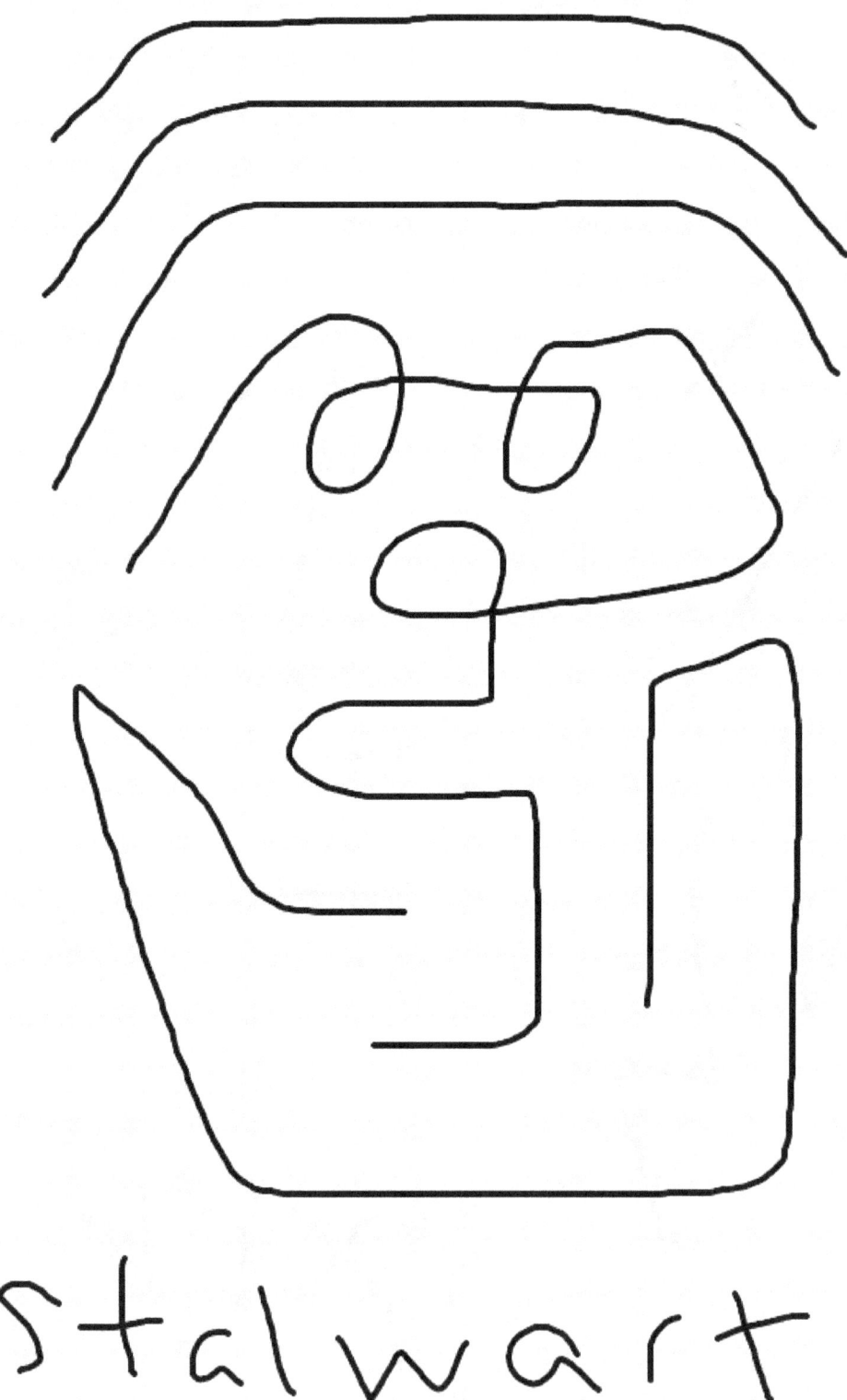

stalwart

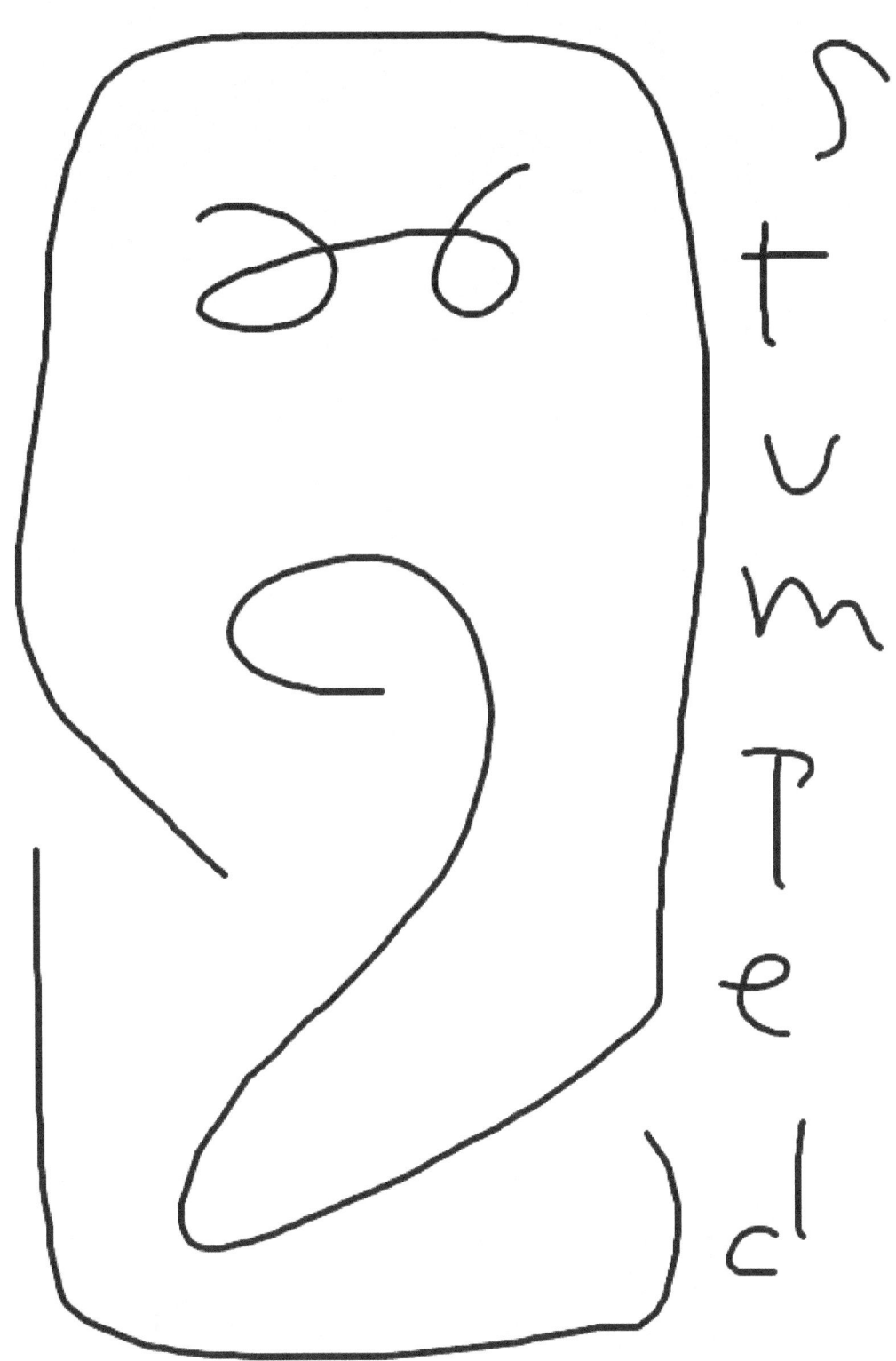

stumpted

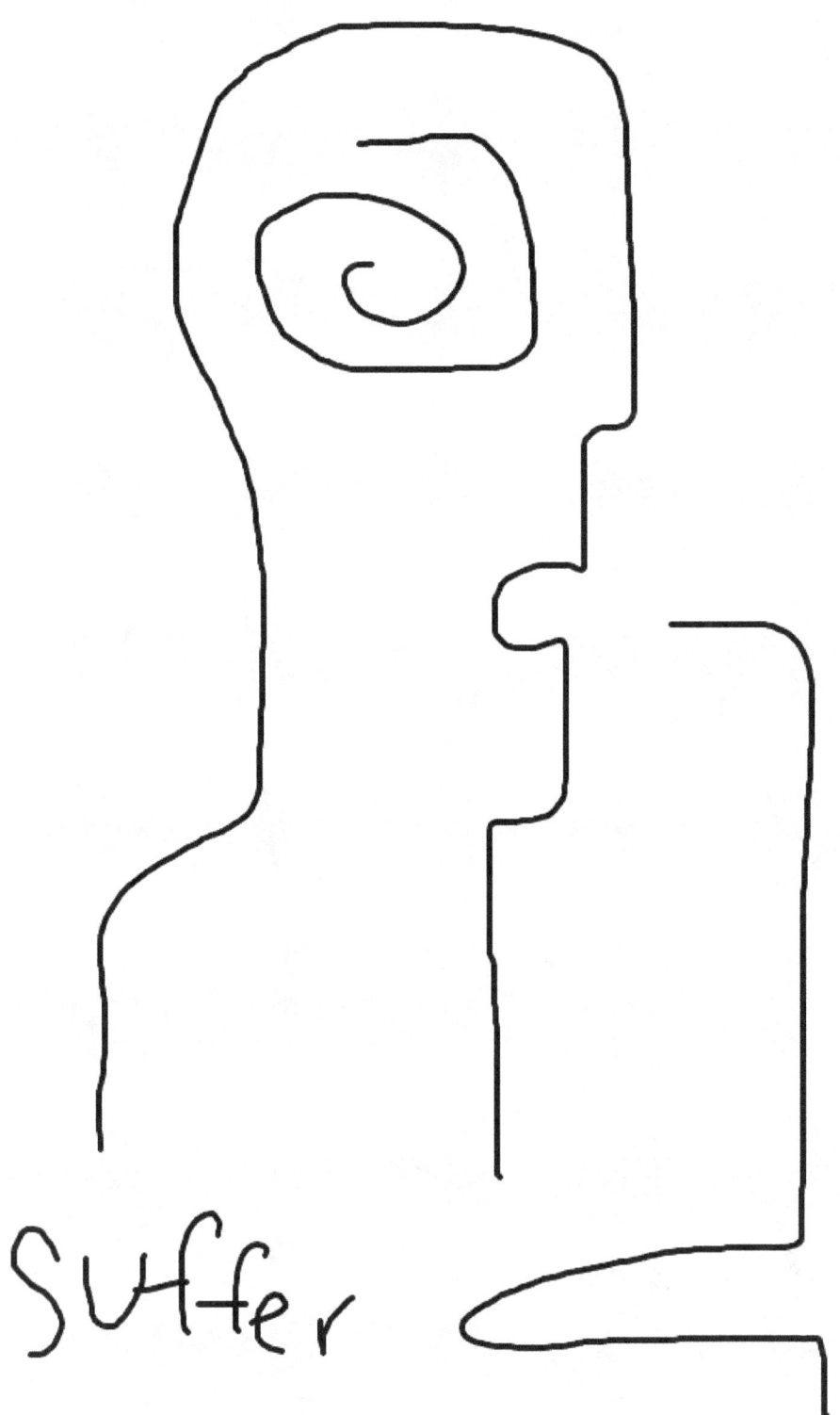

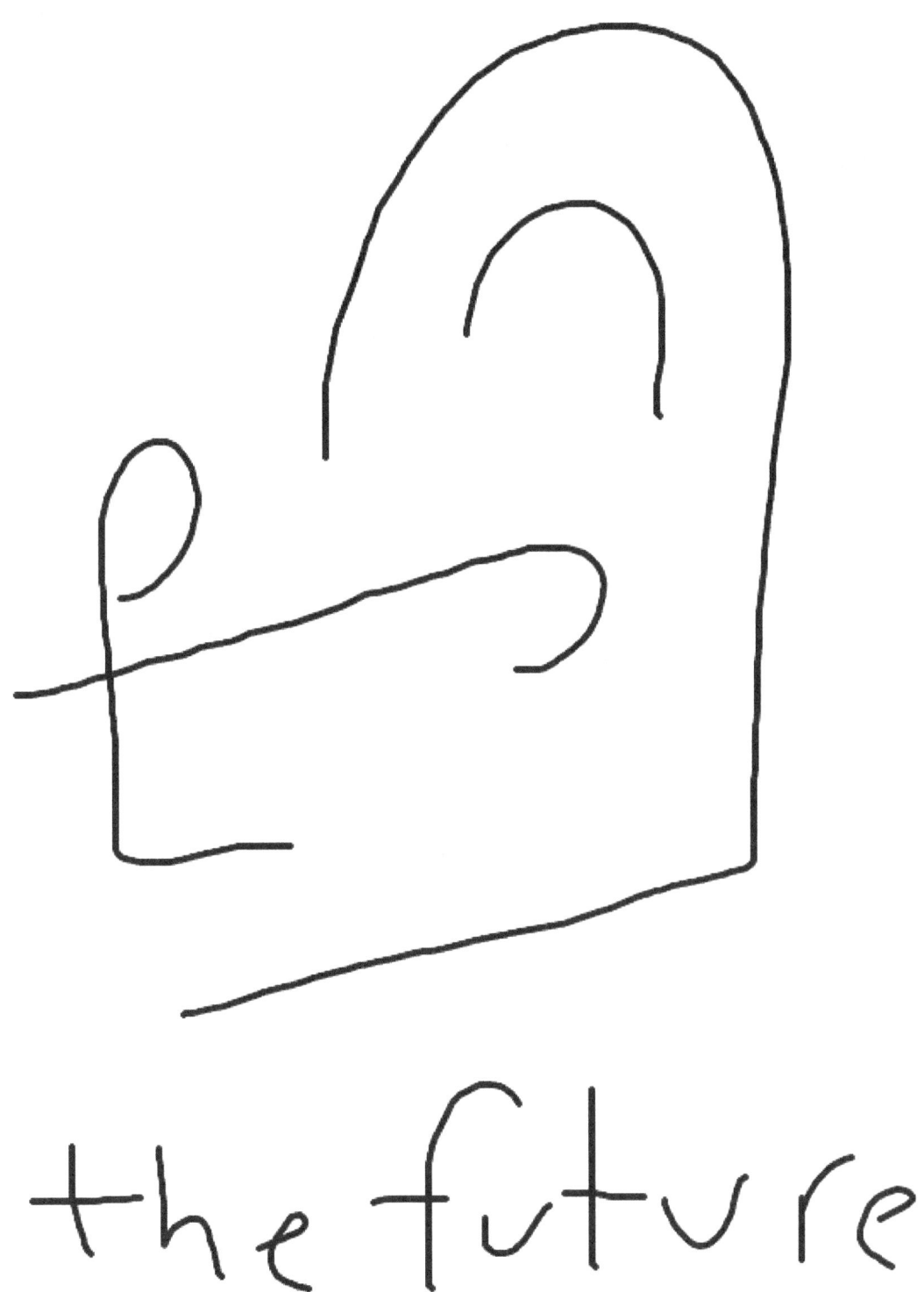

the future

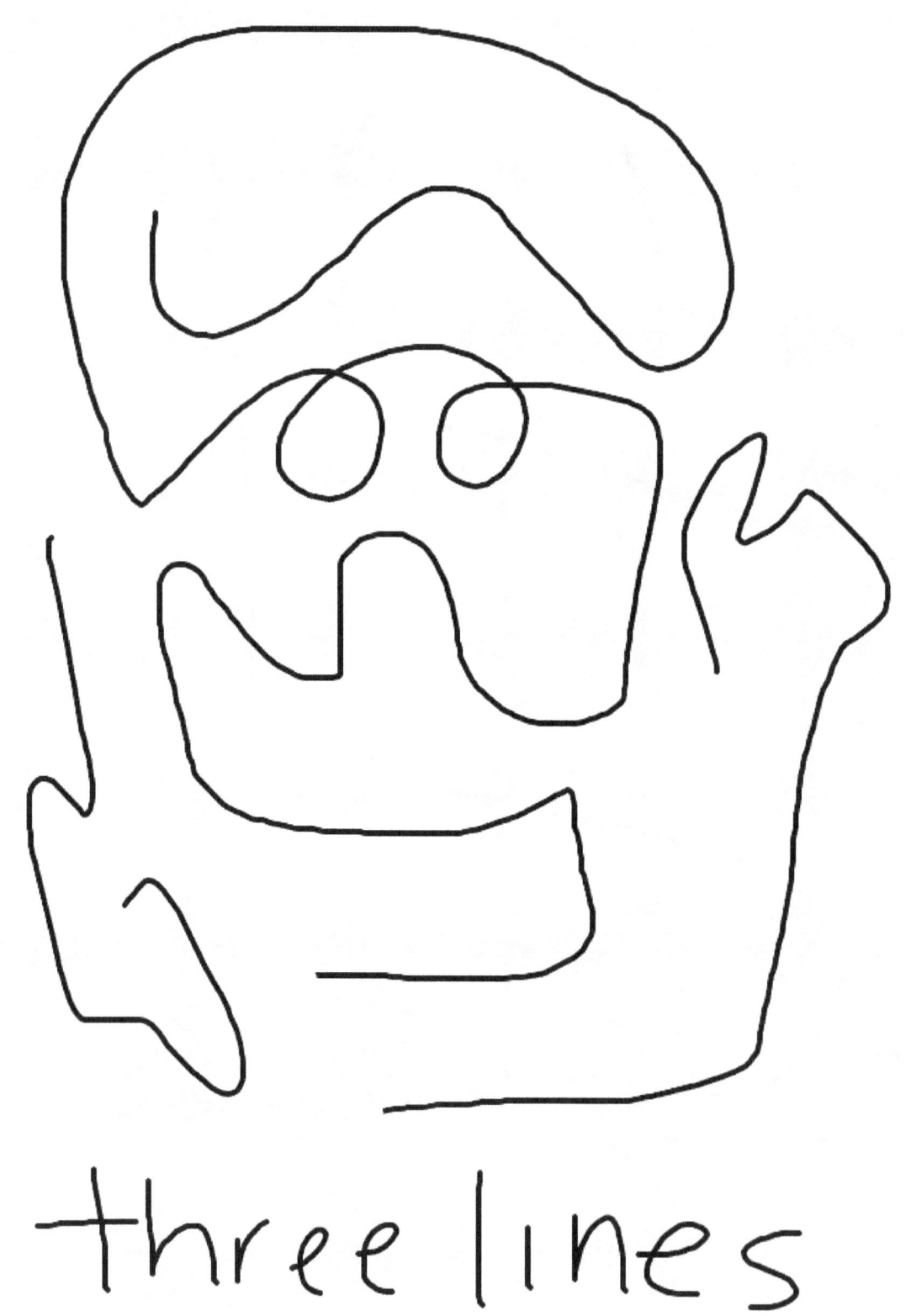

three lines

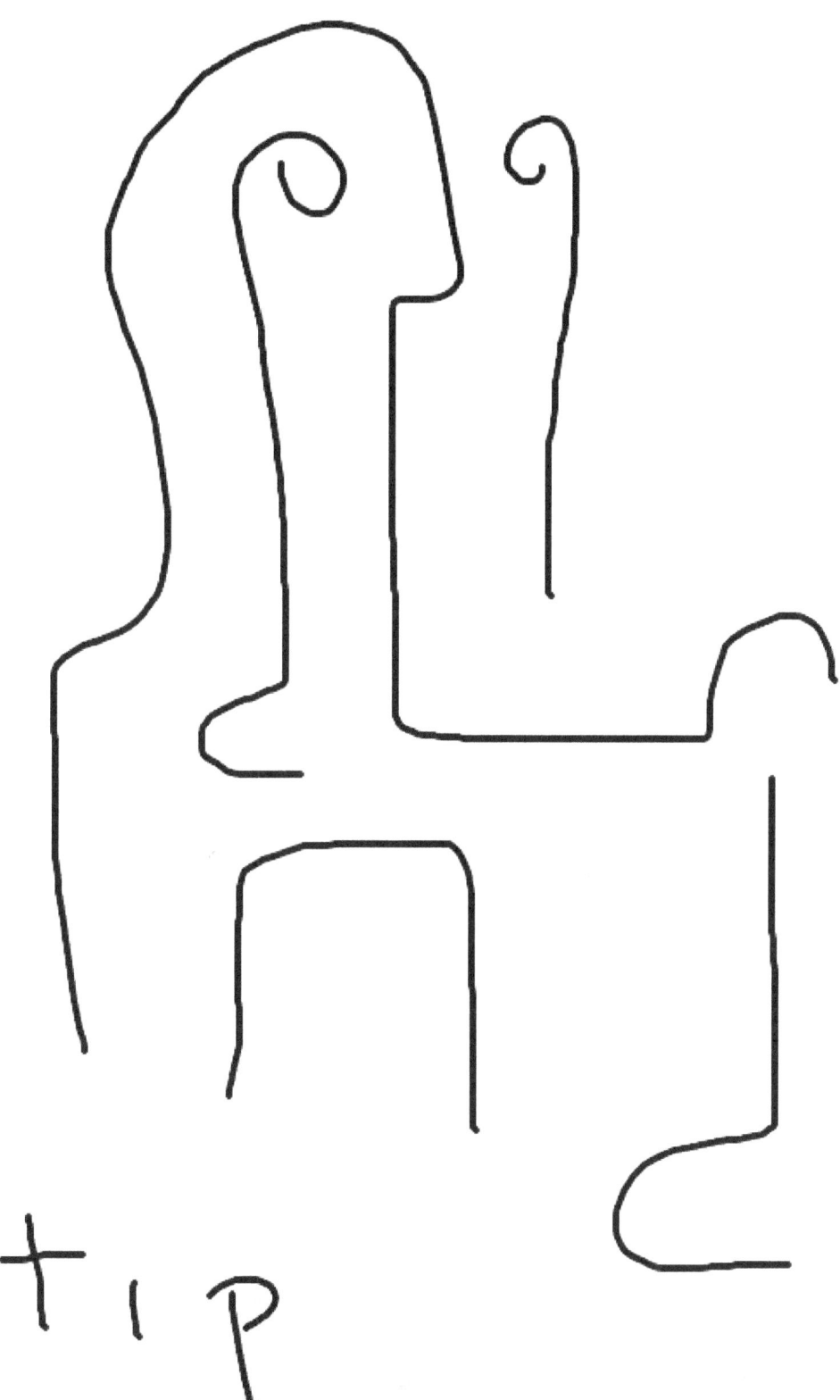

unhappy

vengence

viking

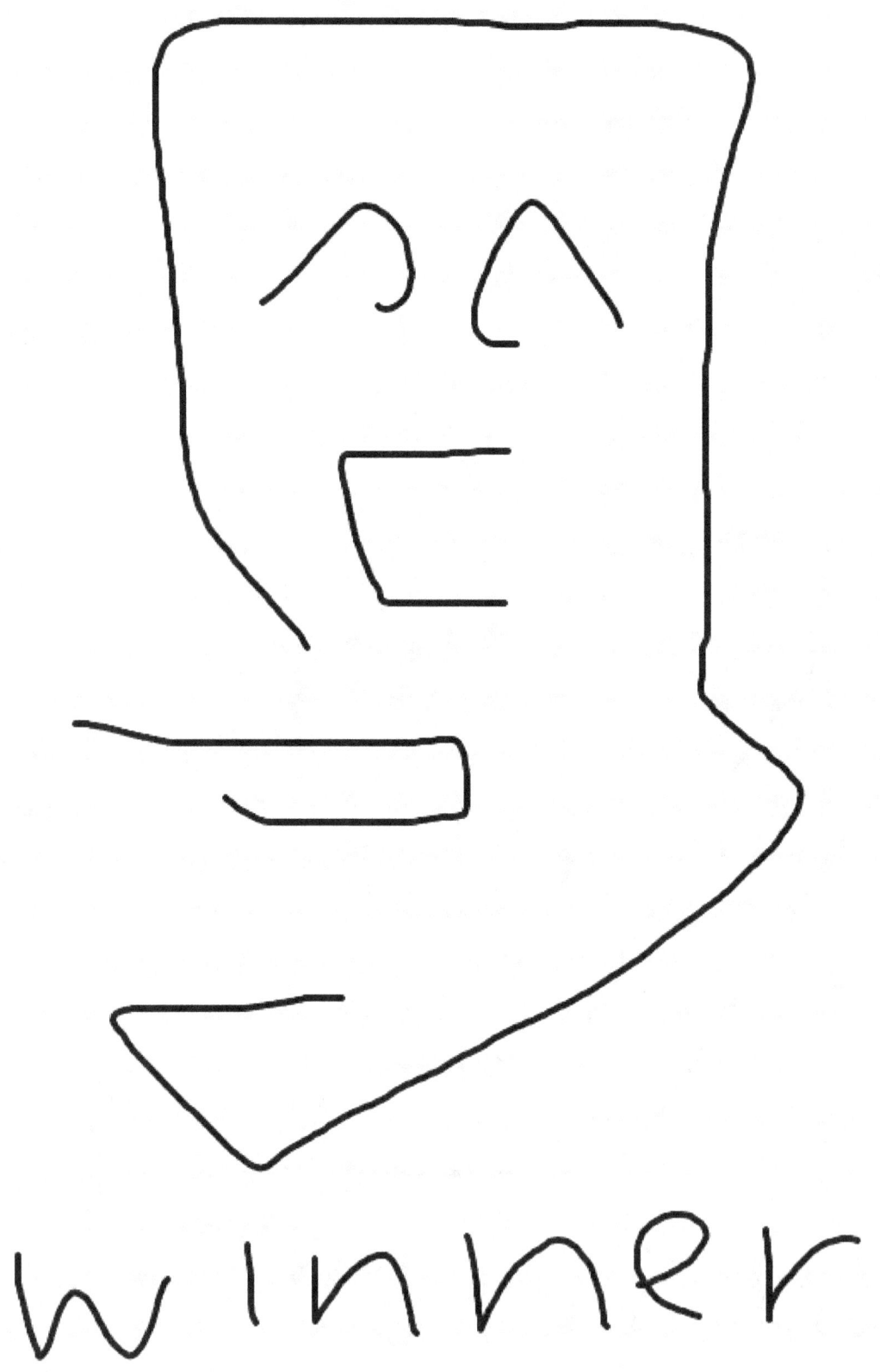
winner

winter

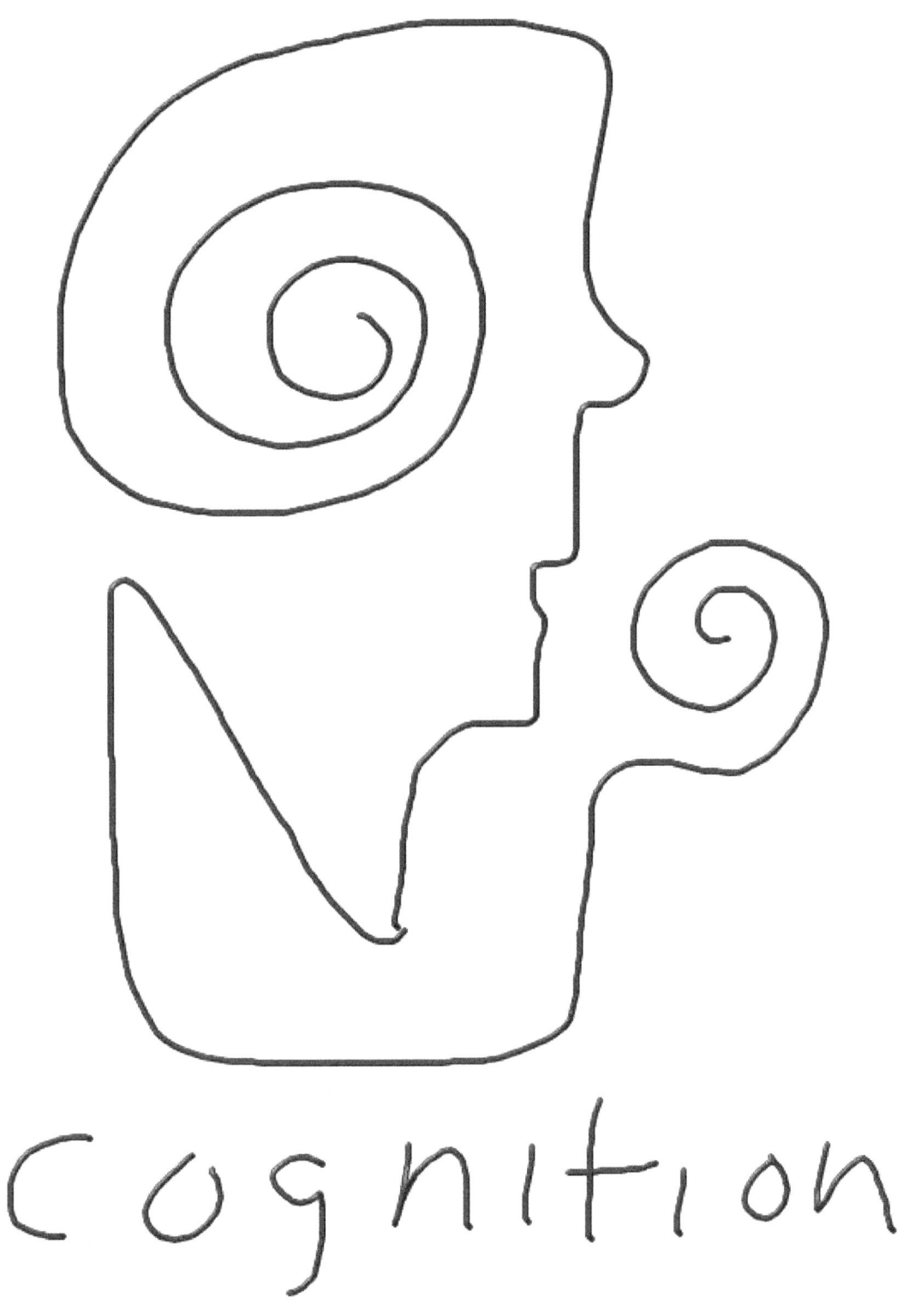
cognition

familiar

fastidious

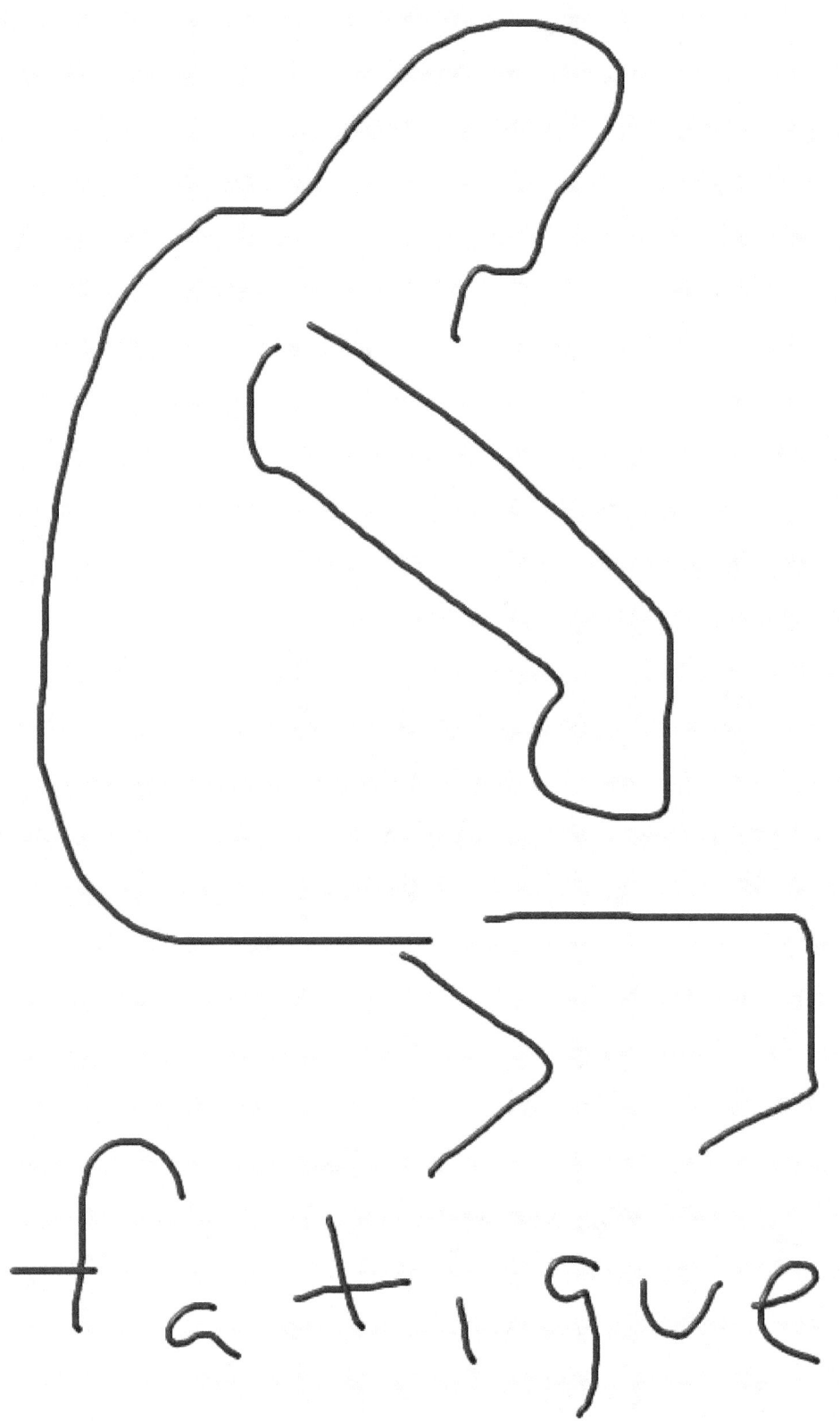

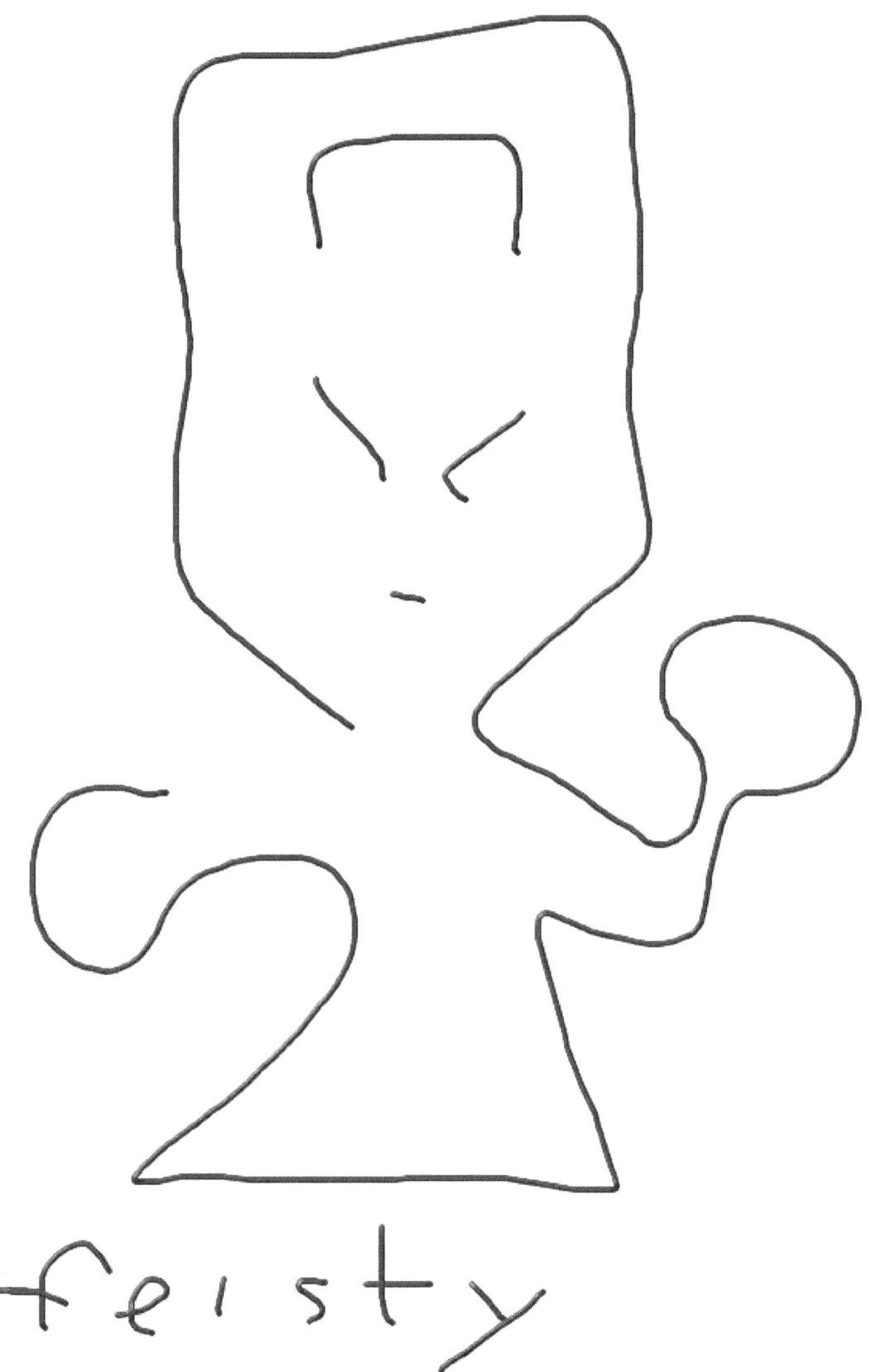

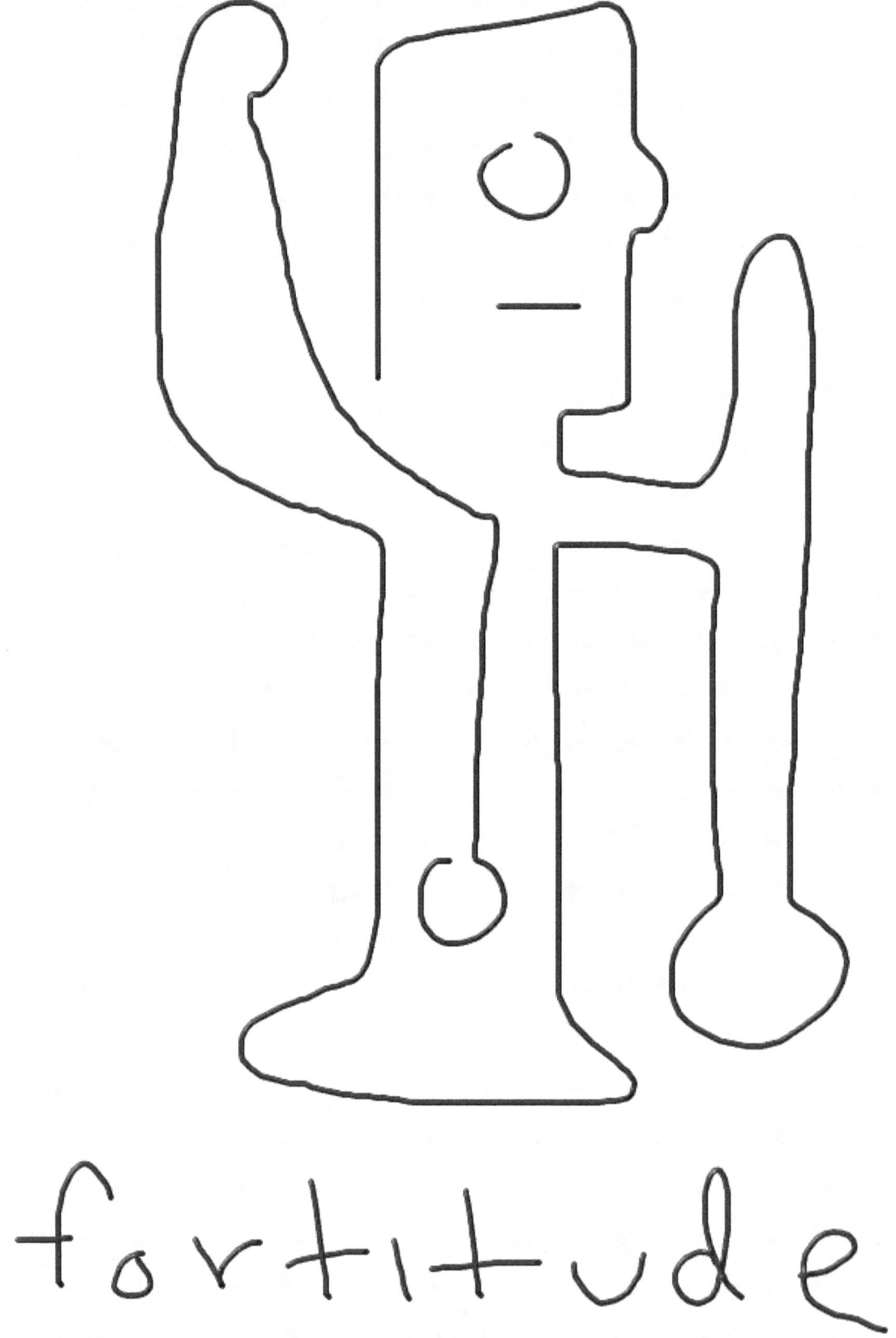
fortitude

hesitant

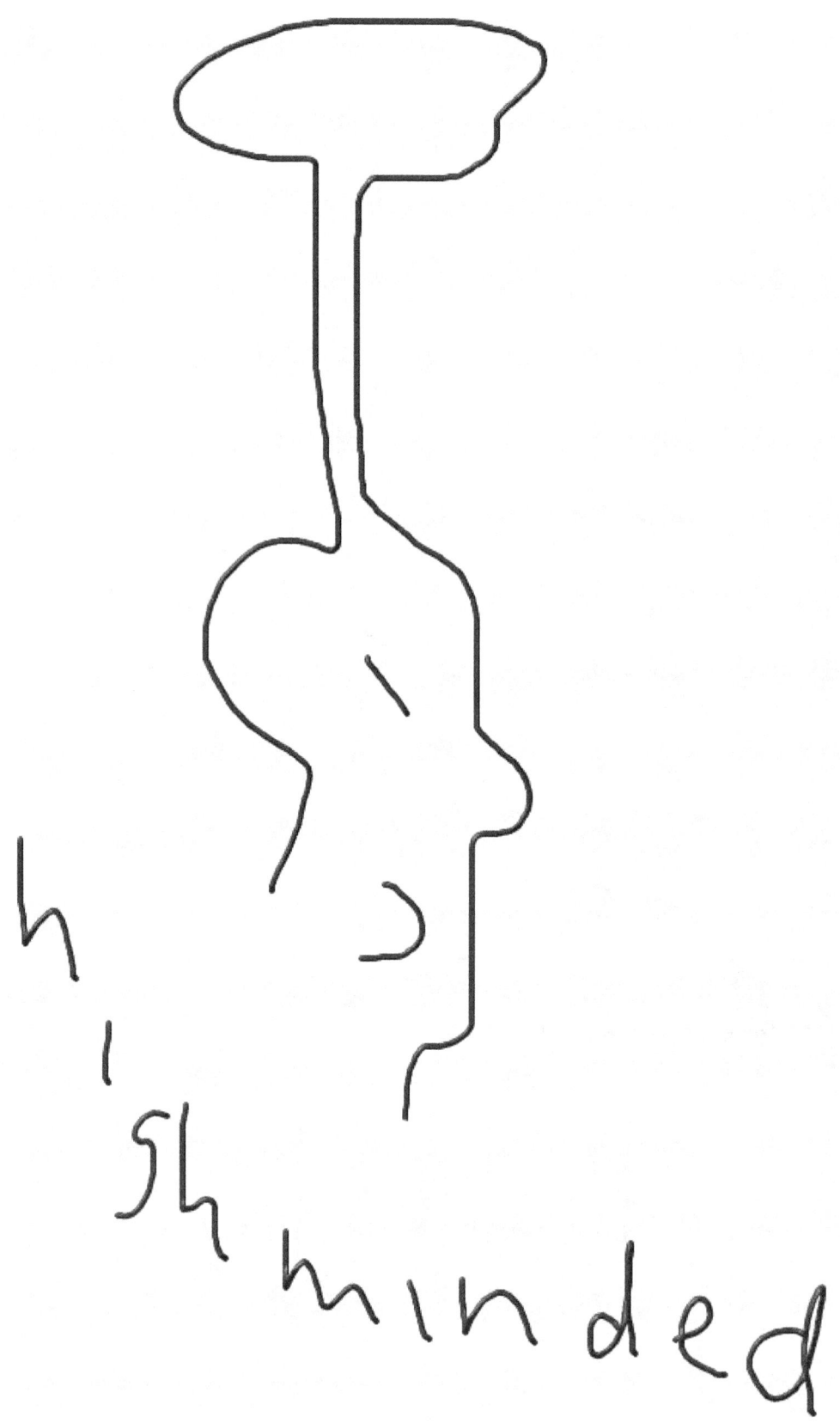

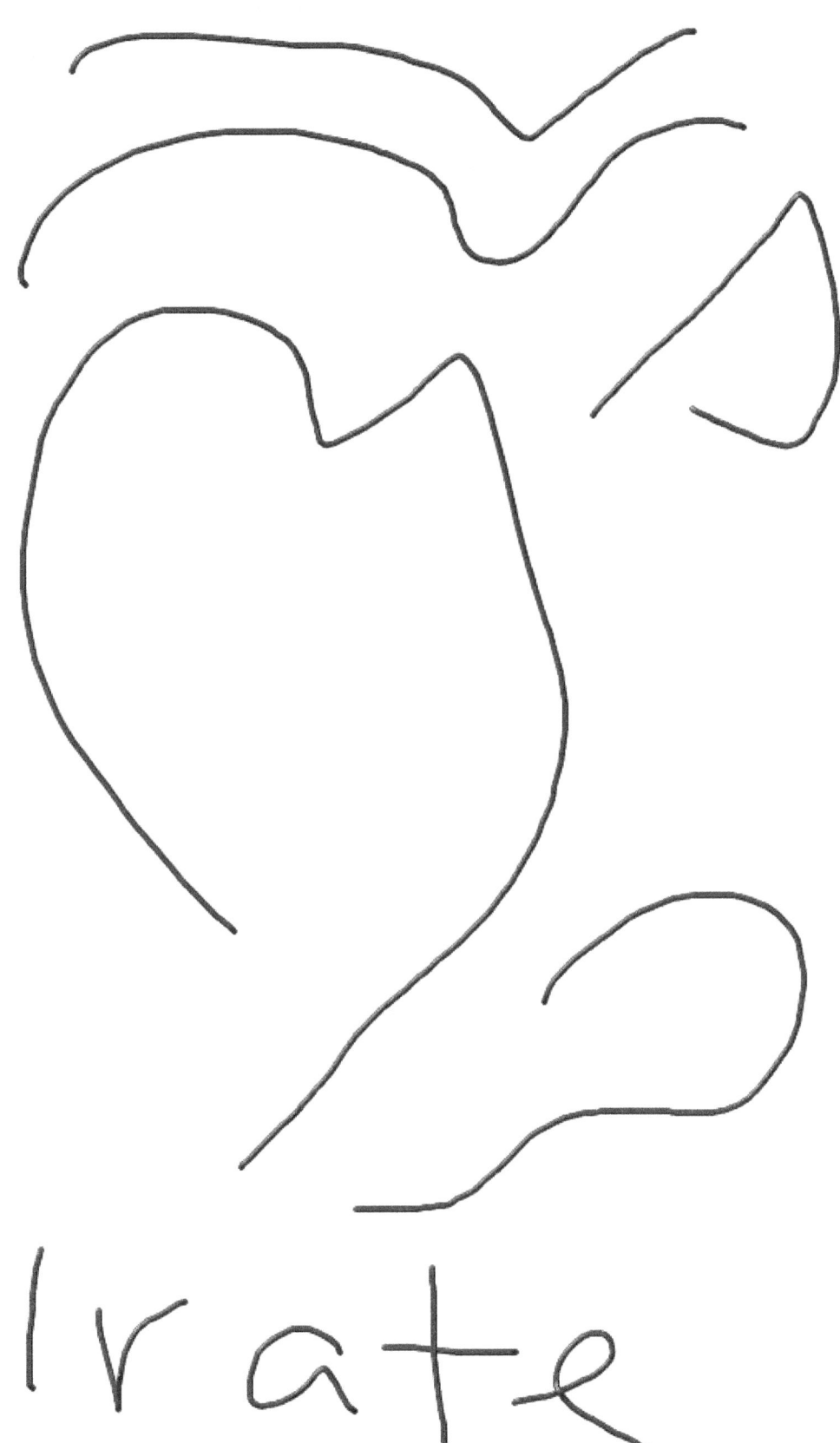
Irate

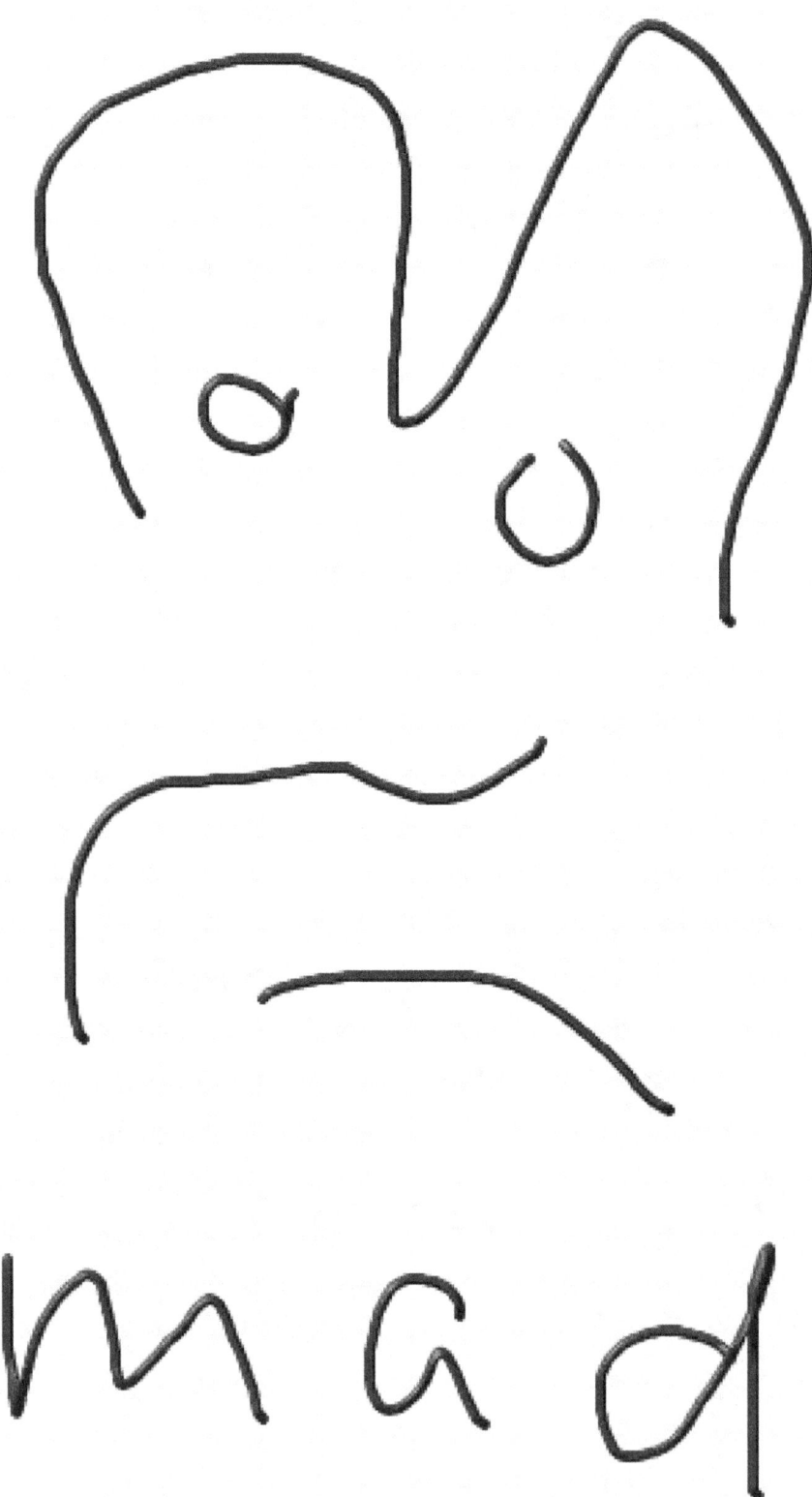

mad

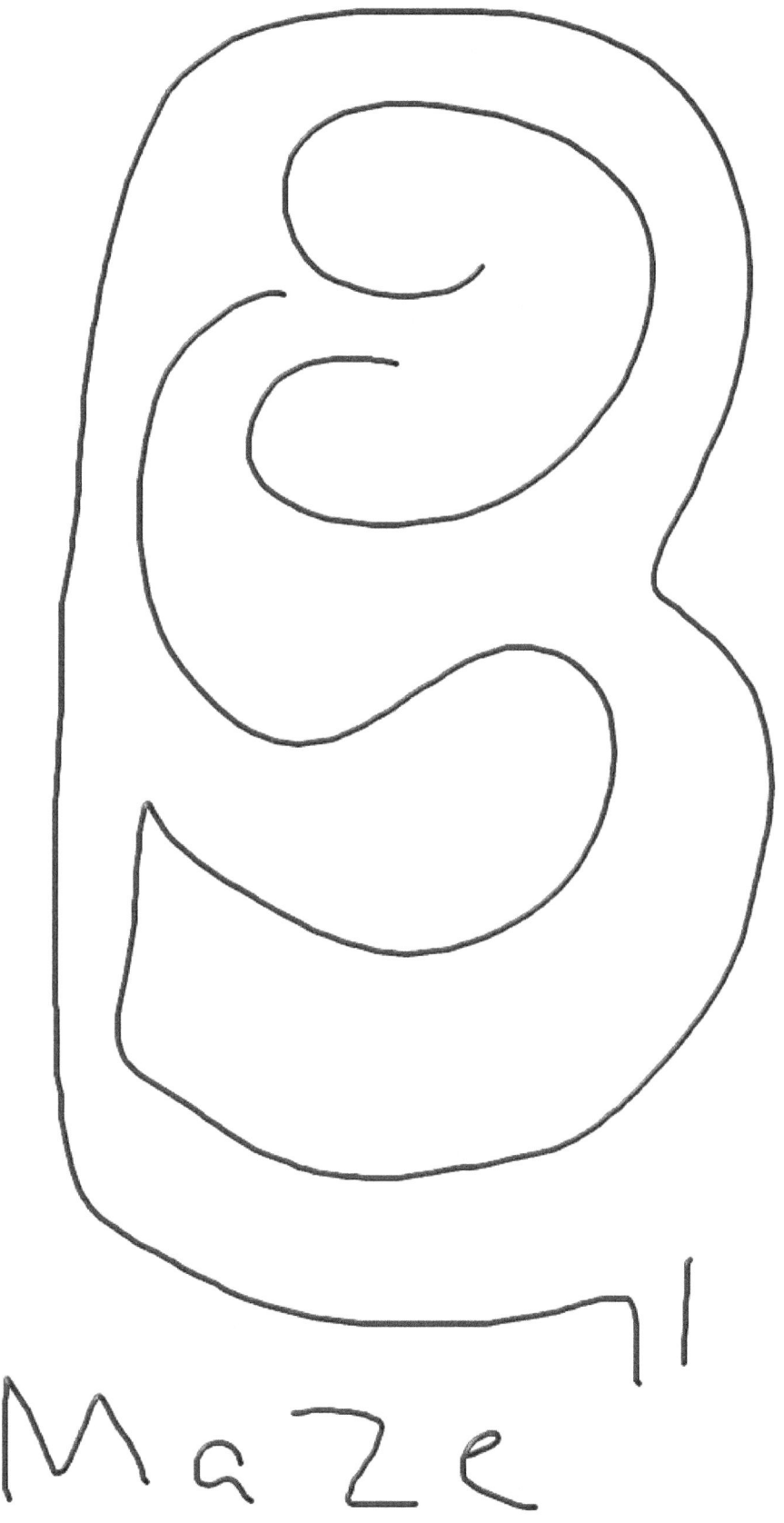

Maze

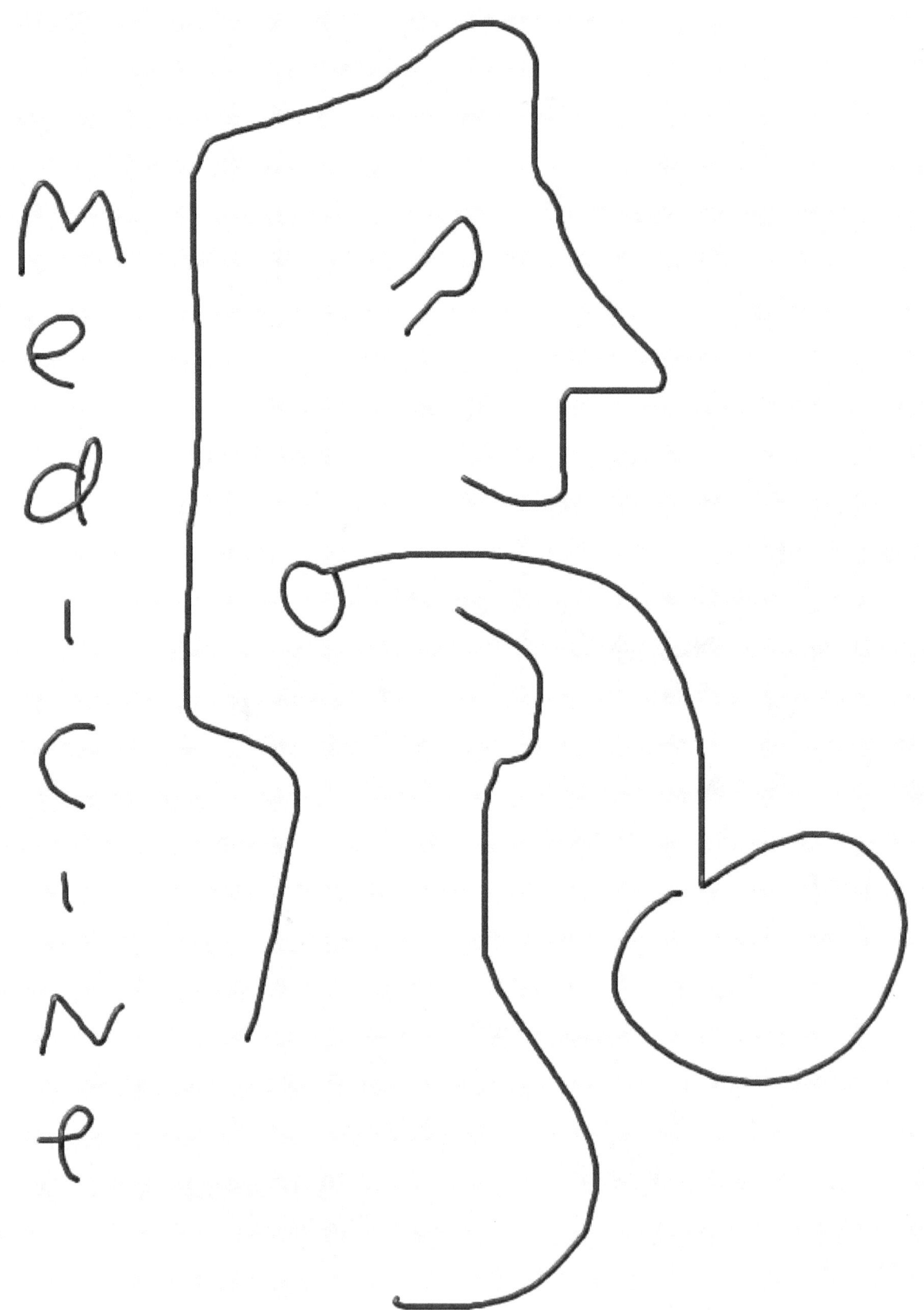

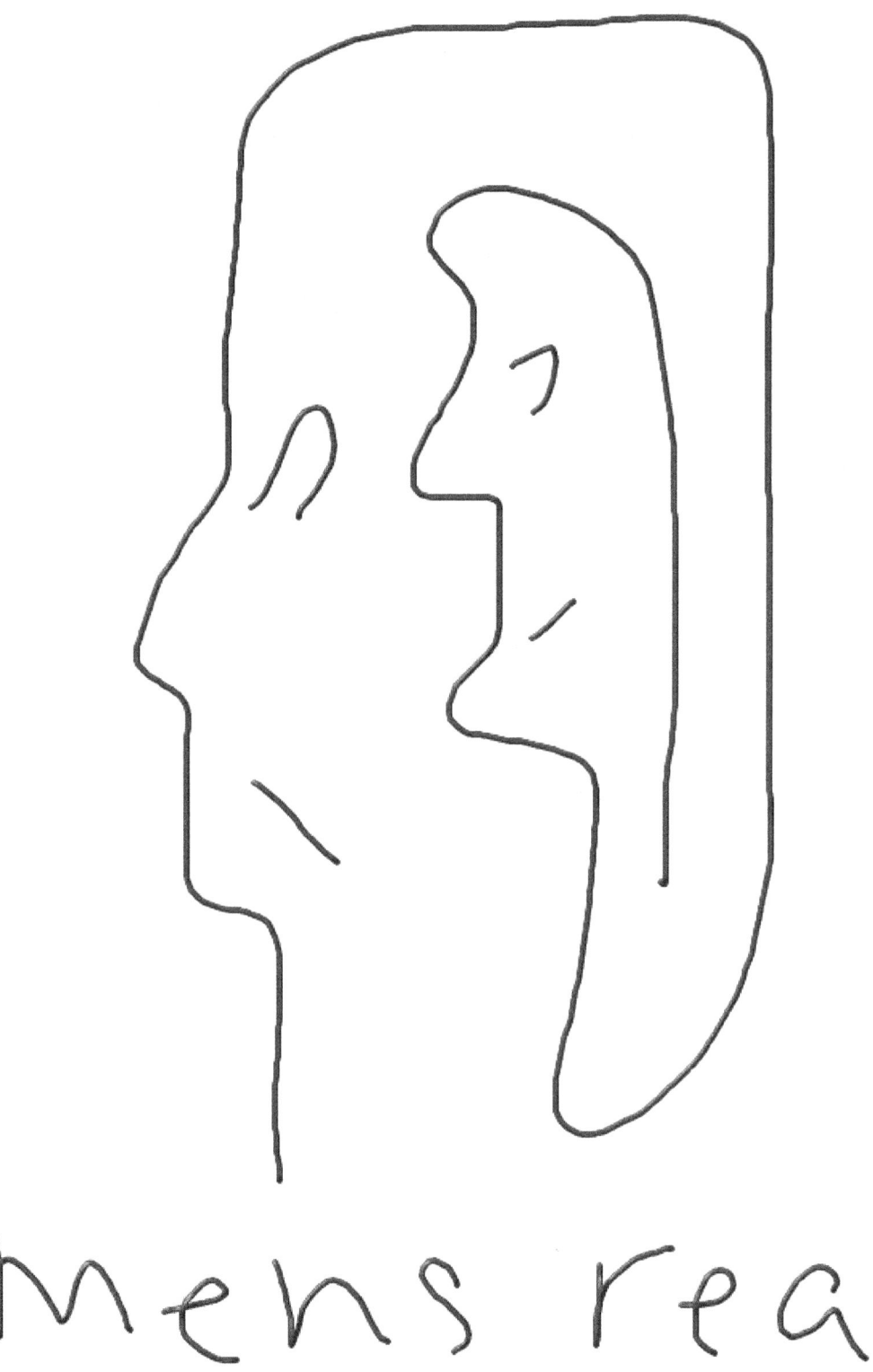

mens rea

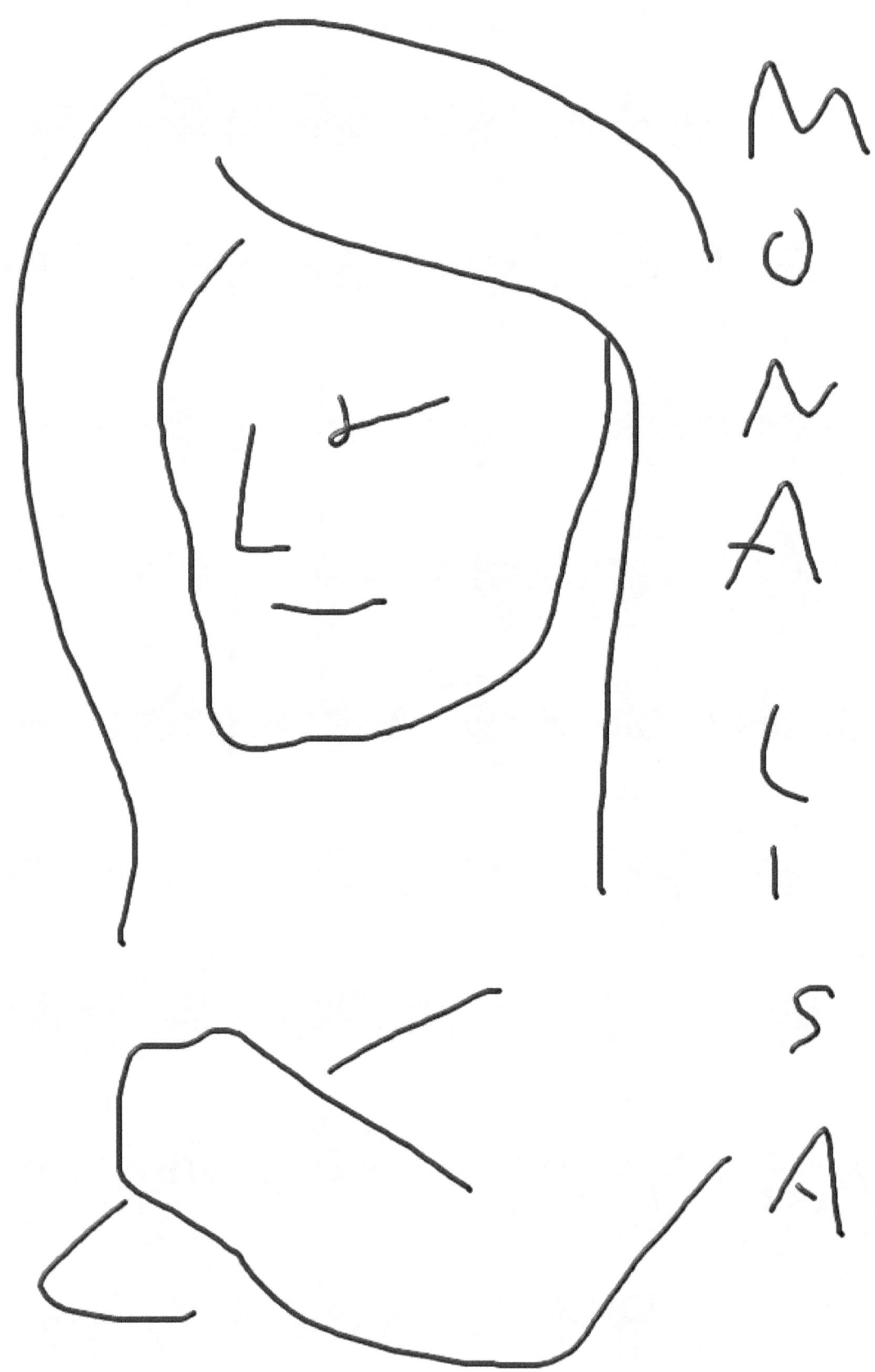

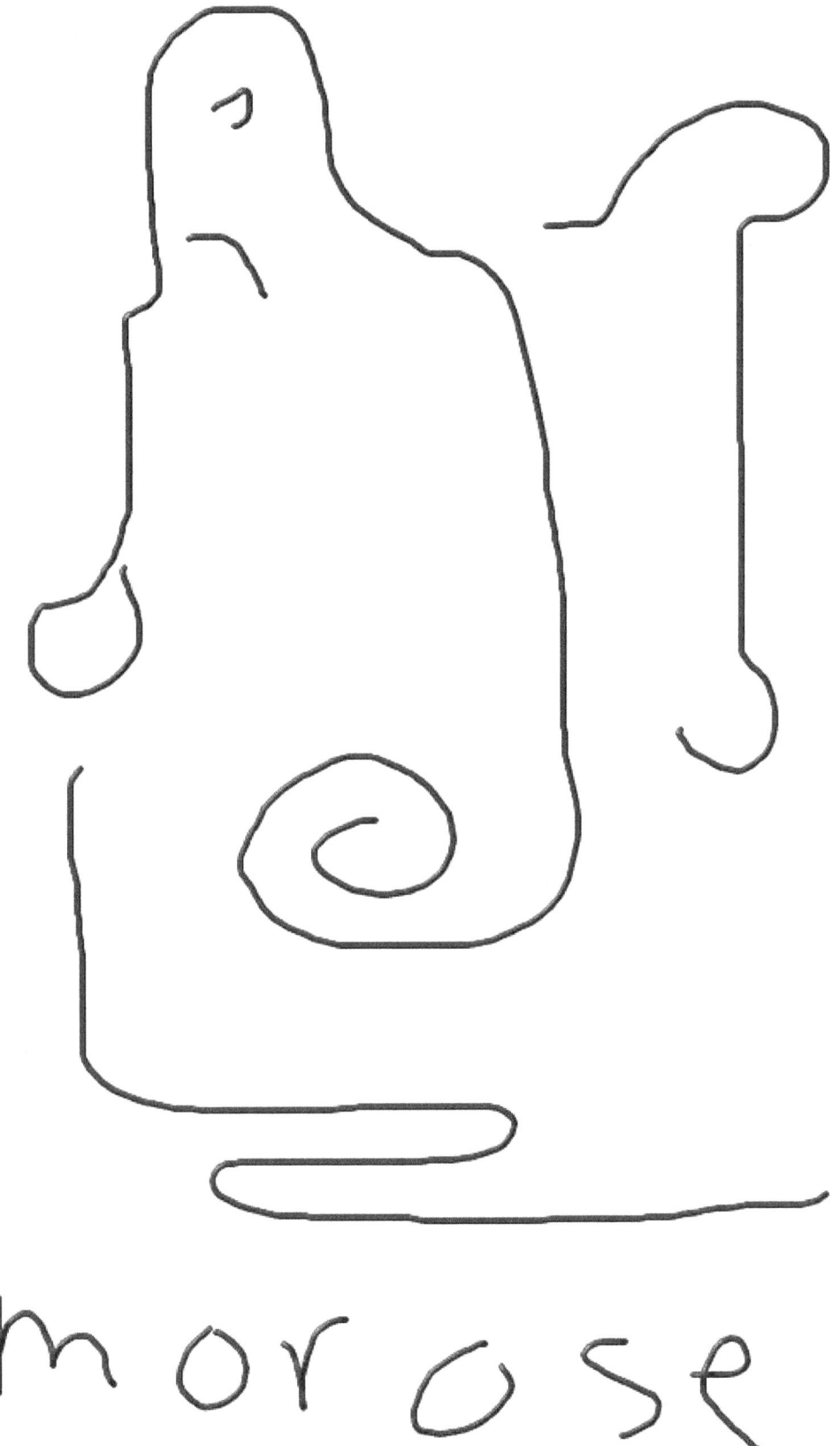

morose

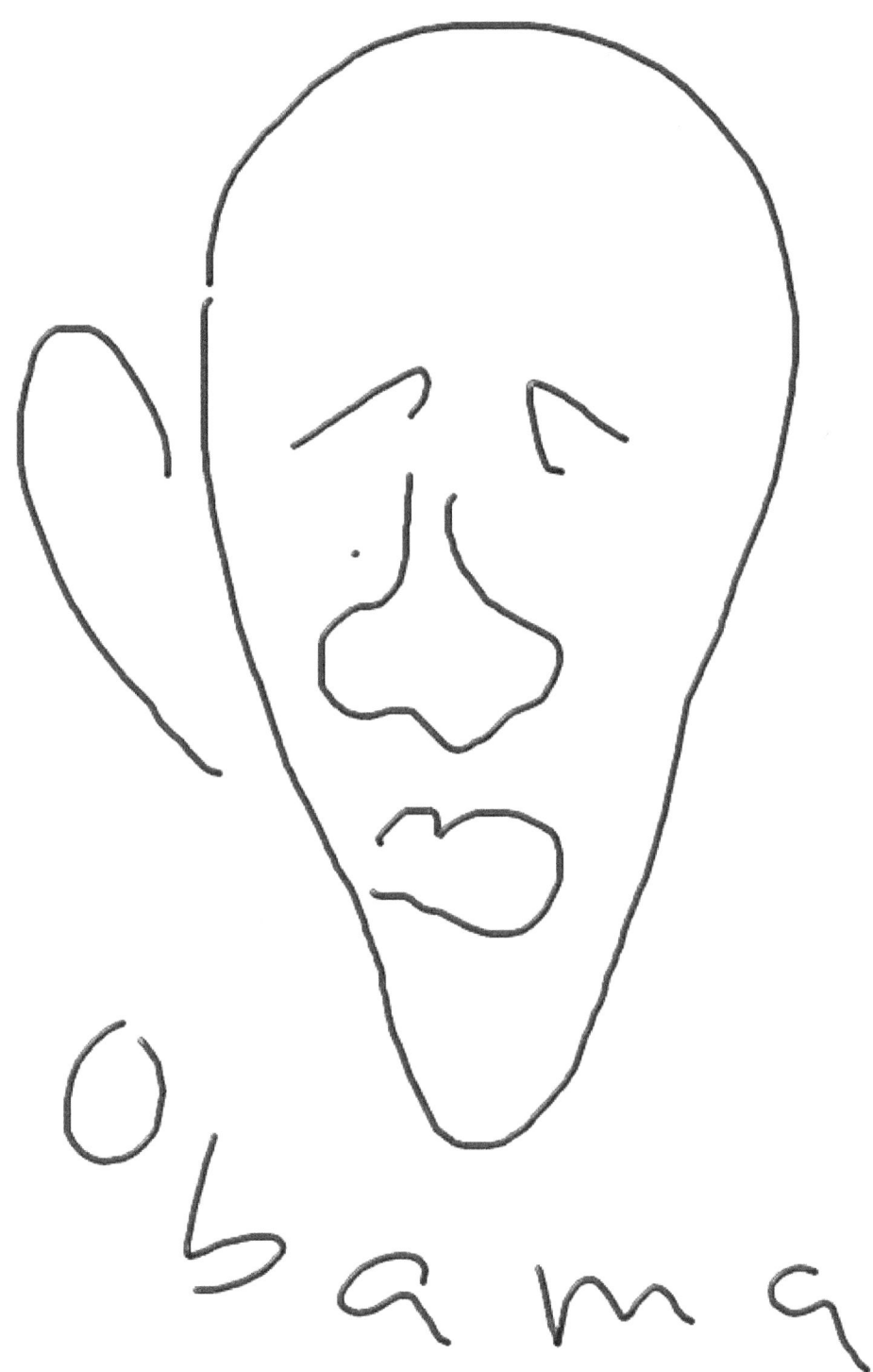

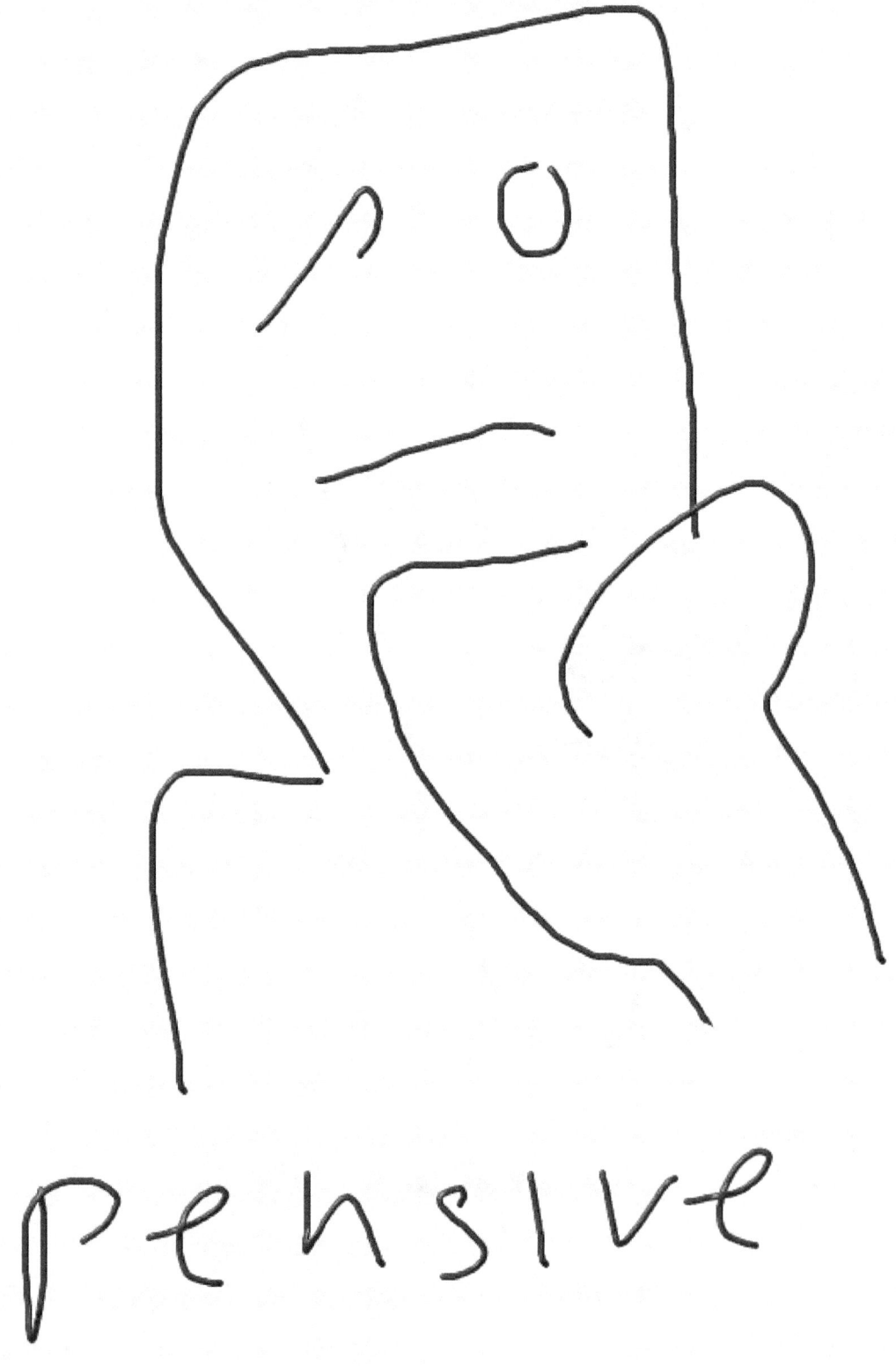

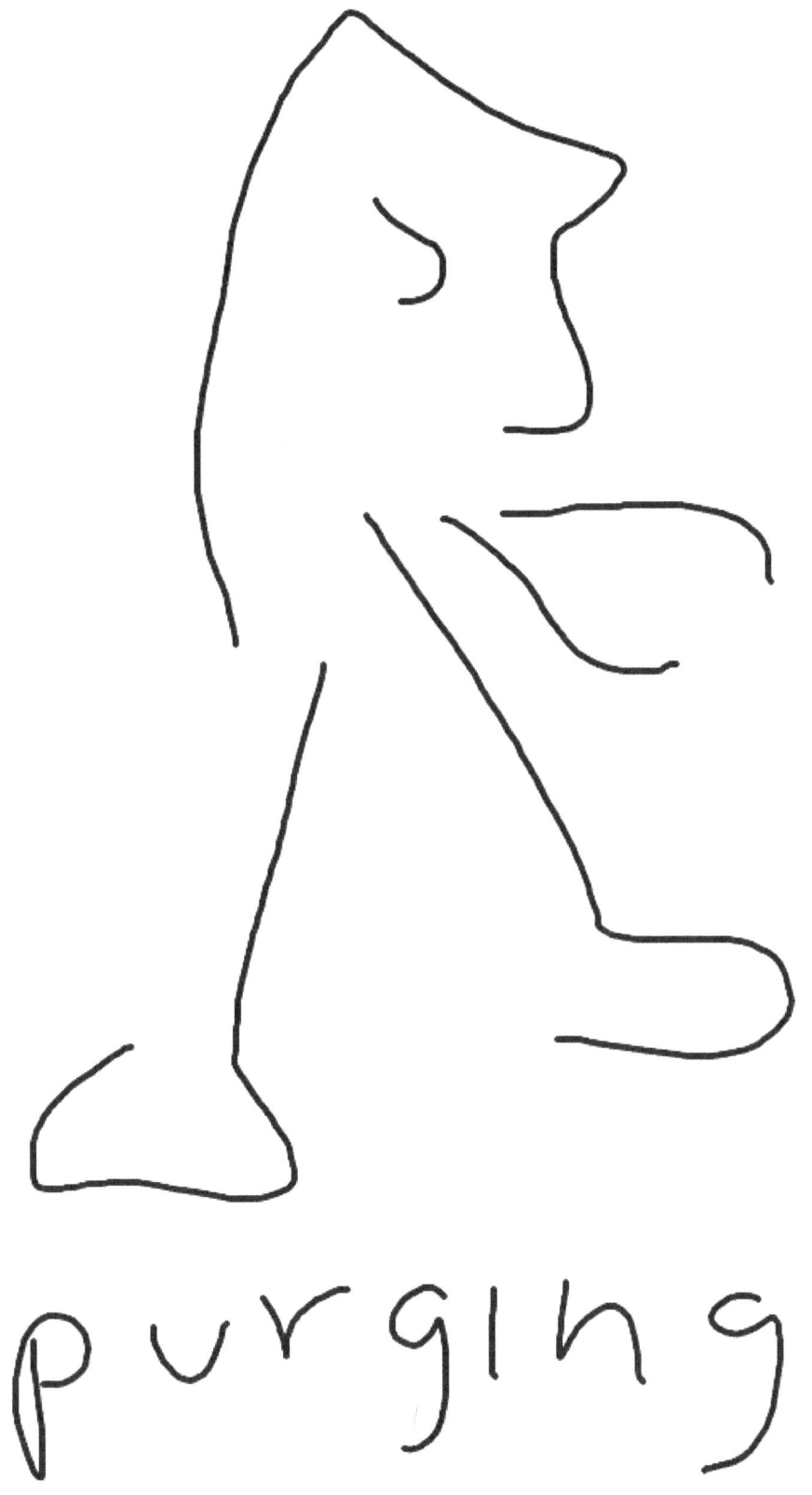
purging

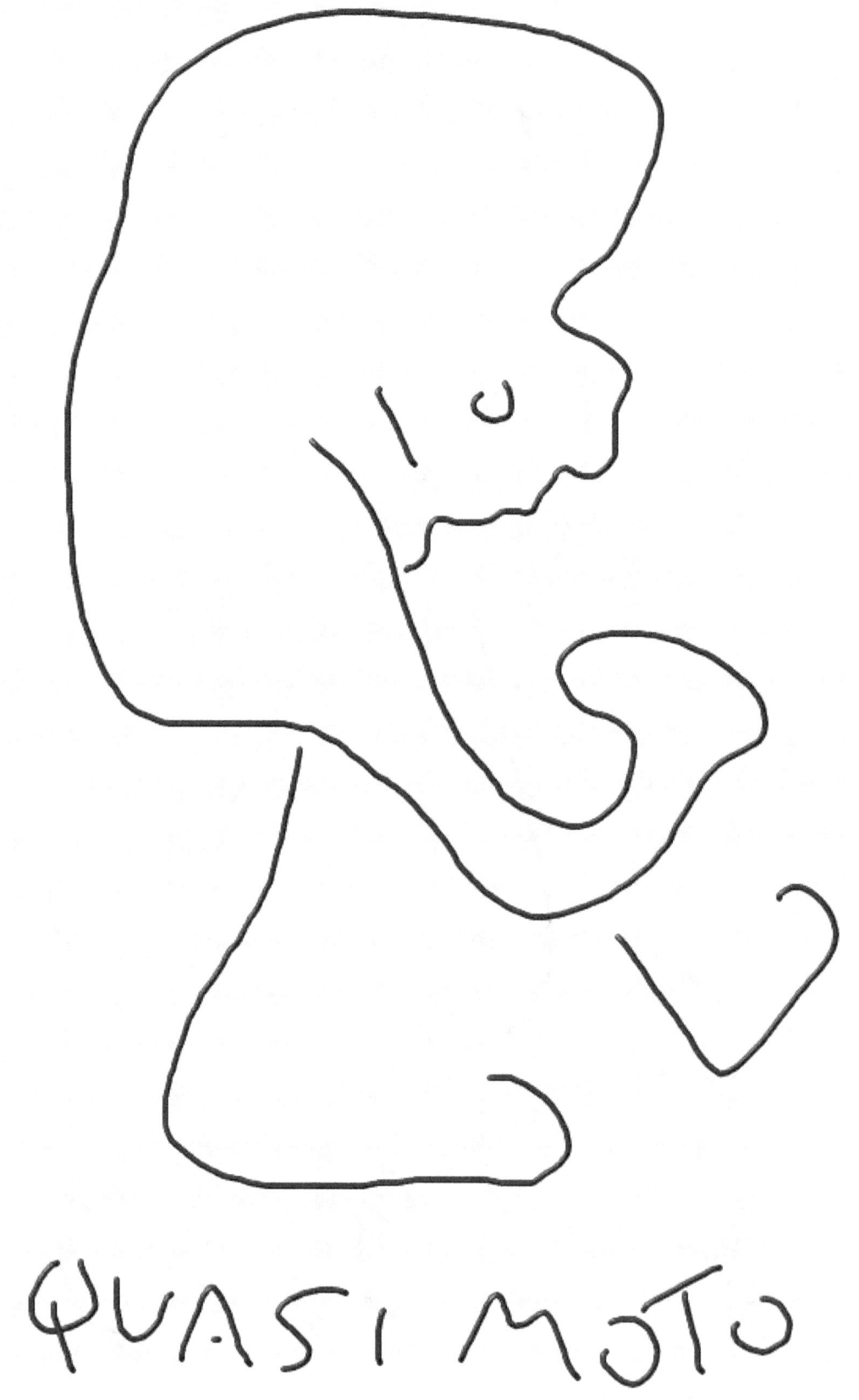

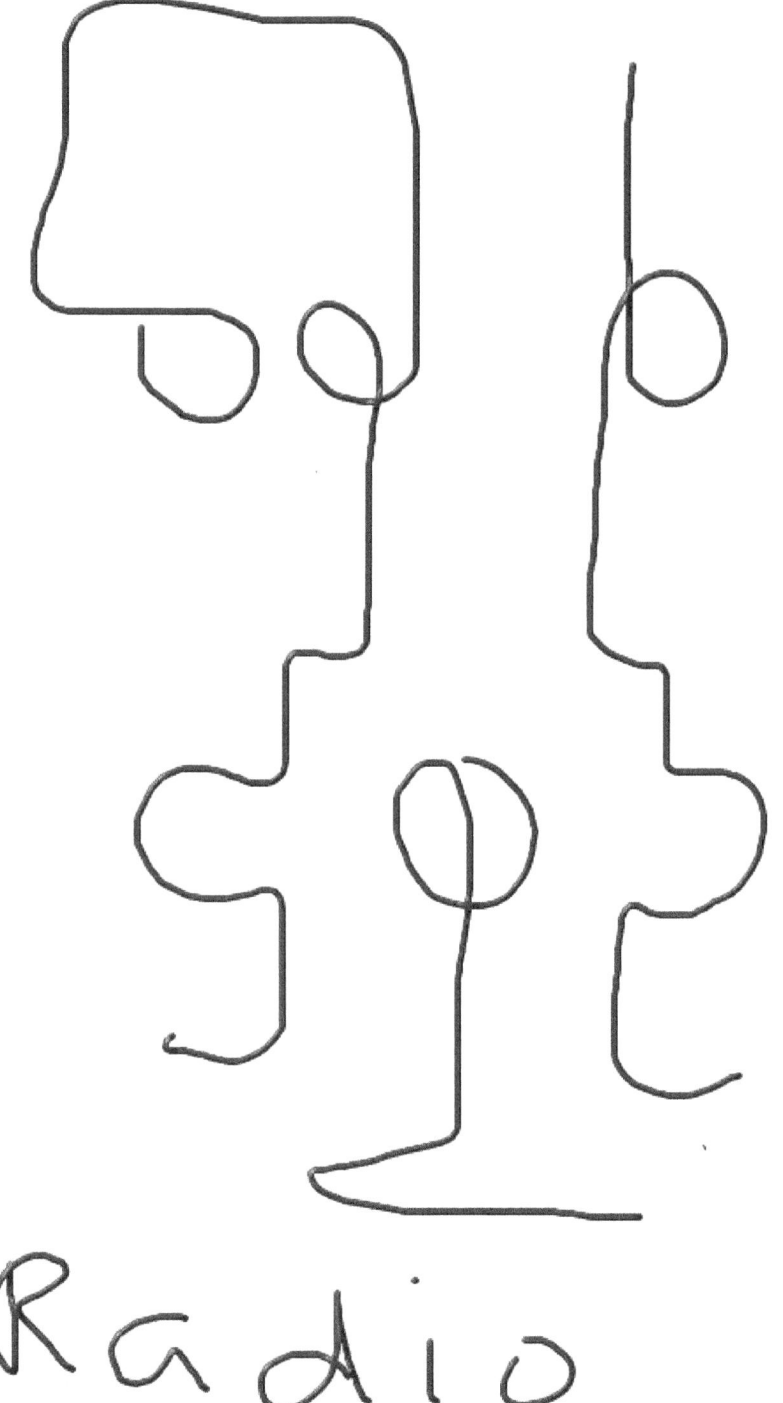
Radio

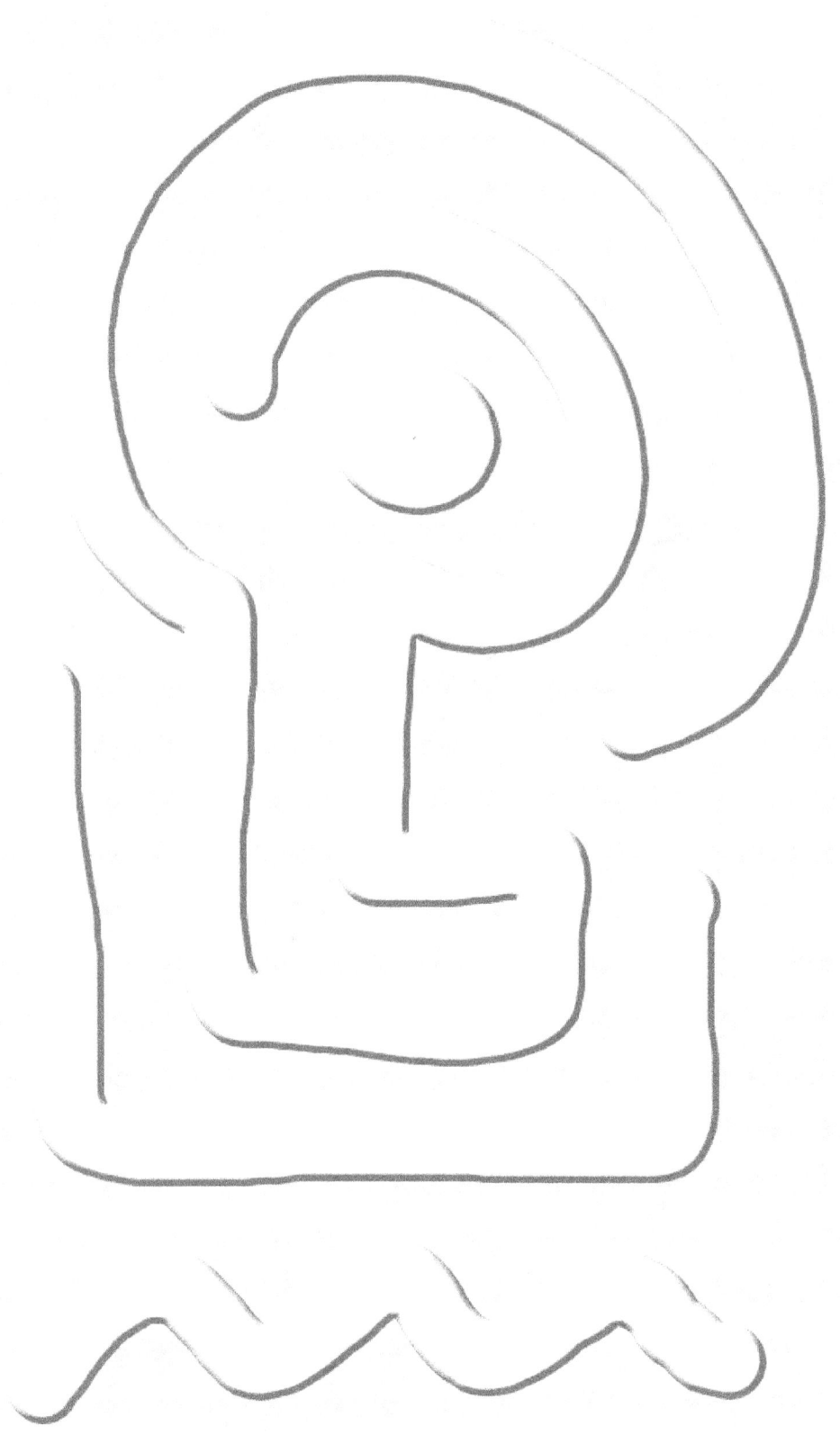

sensory

struggle

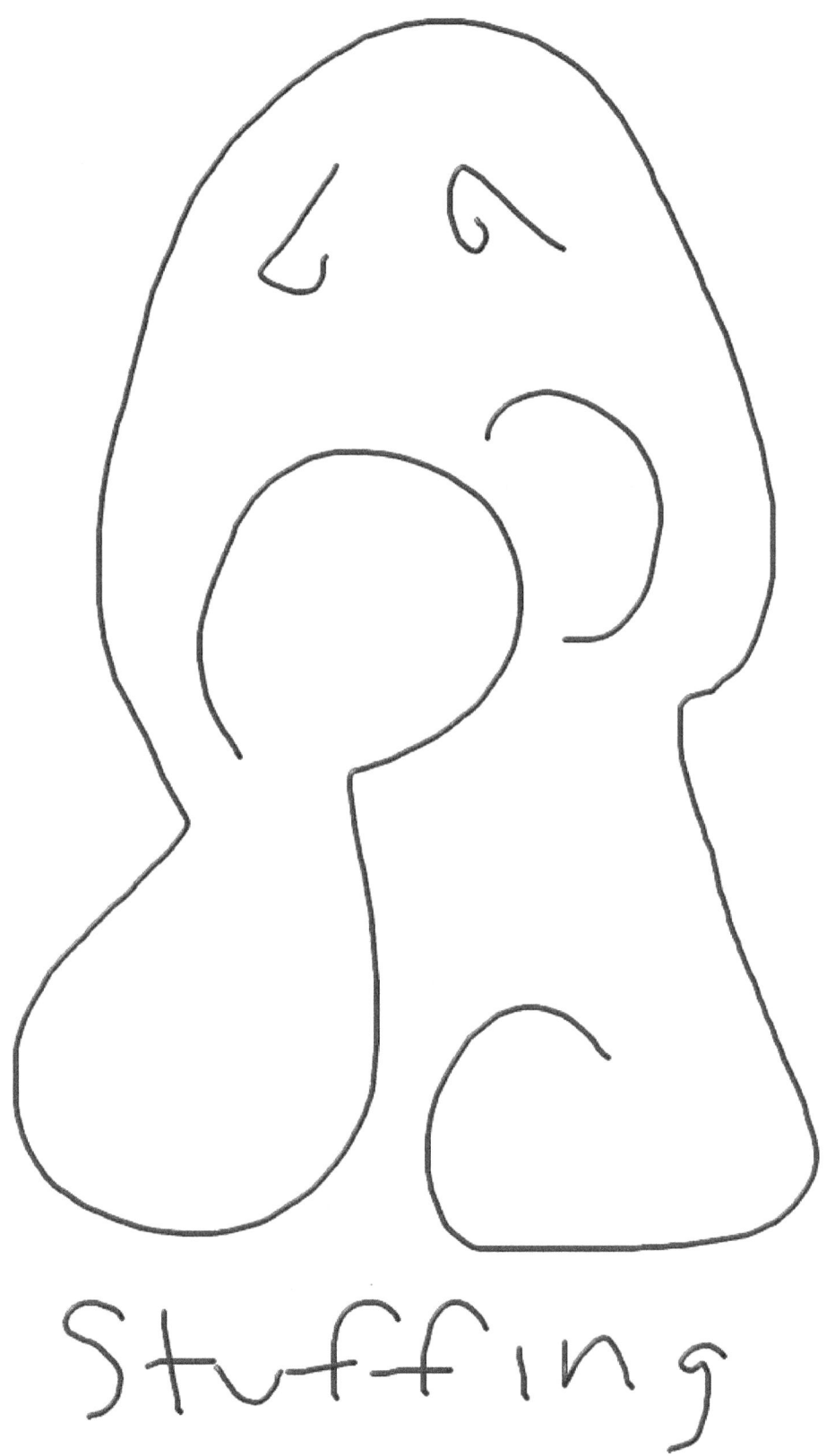

Stuffing

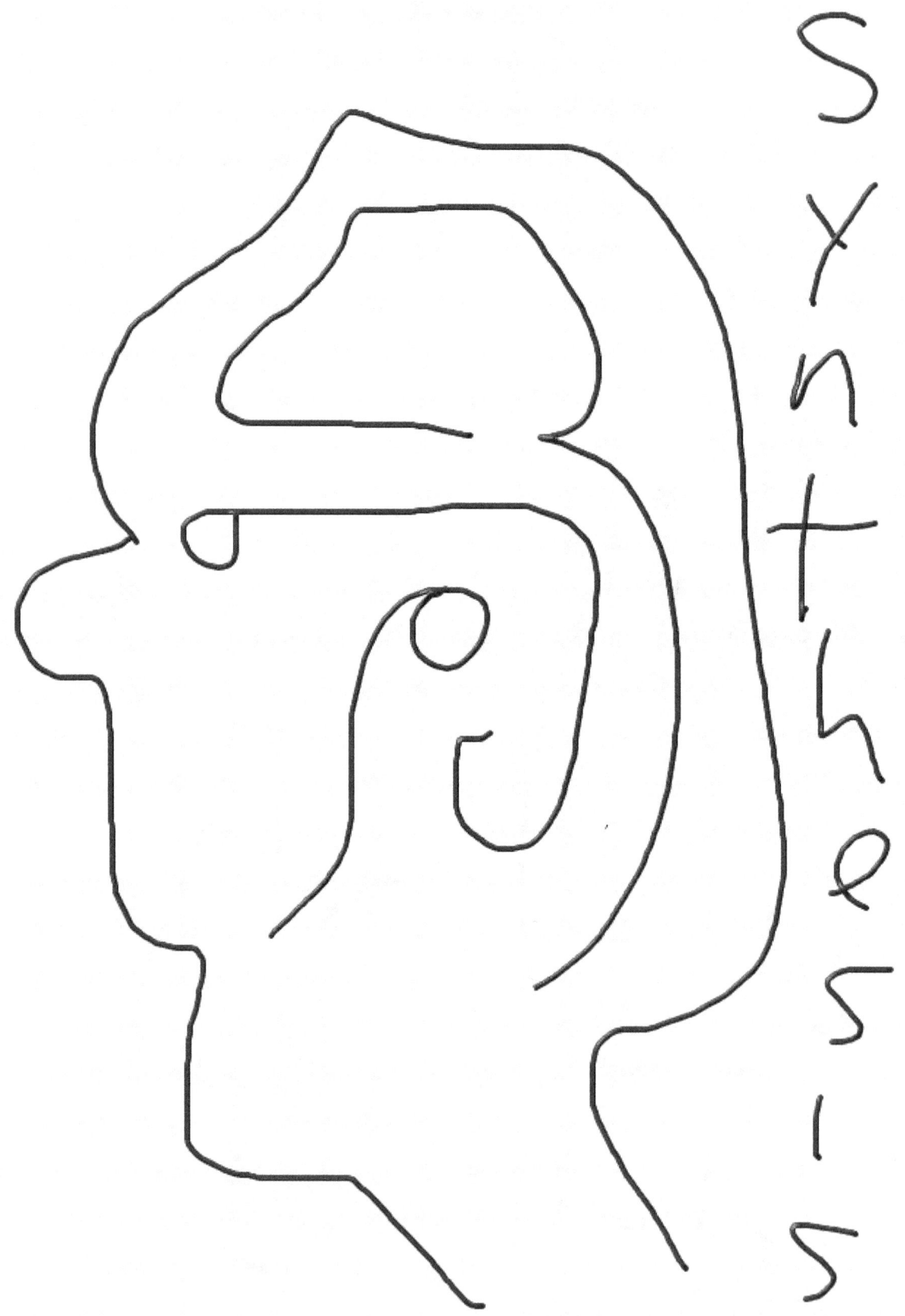

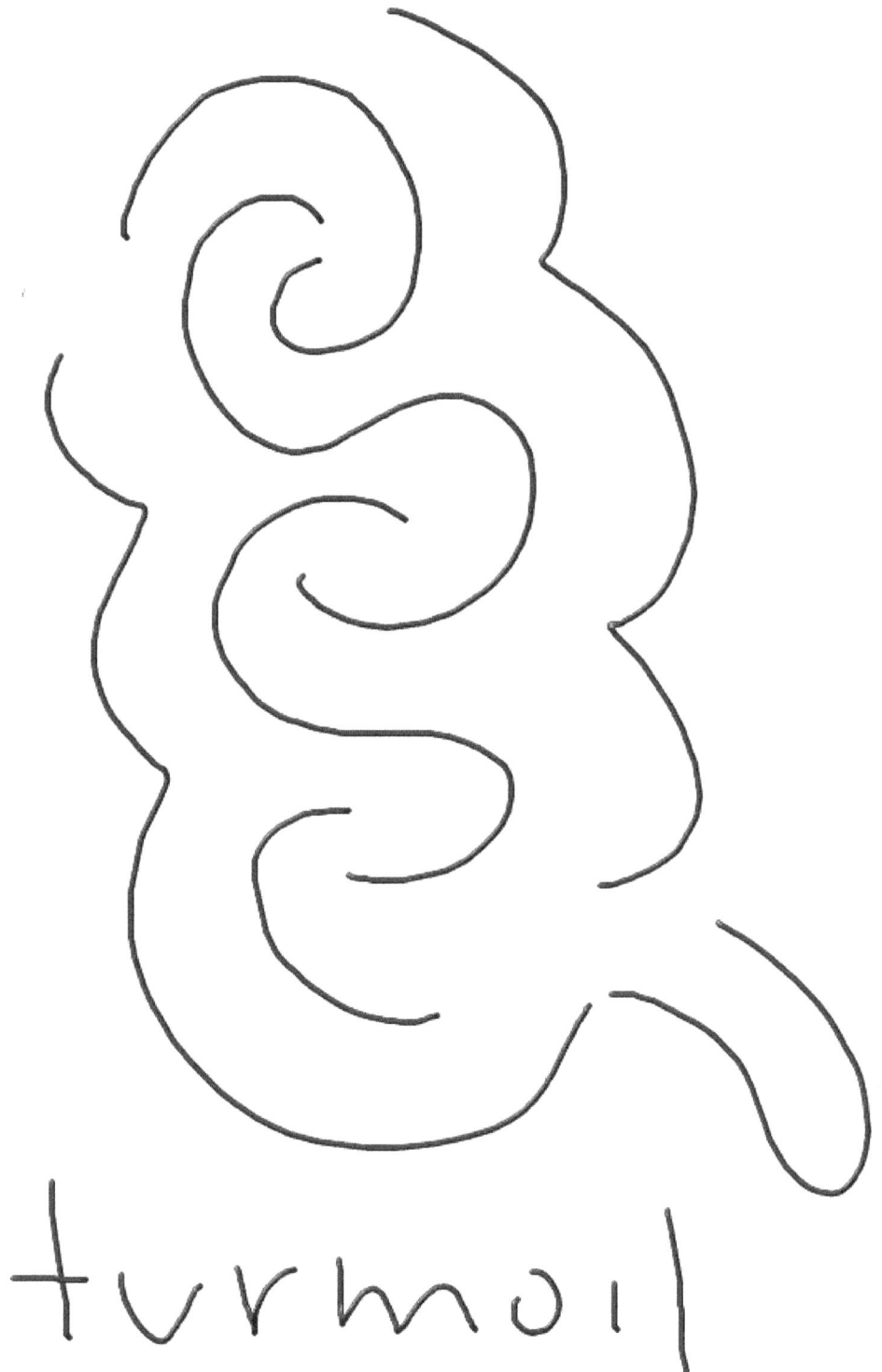

turmoil

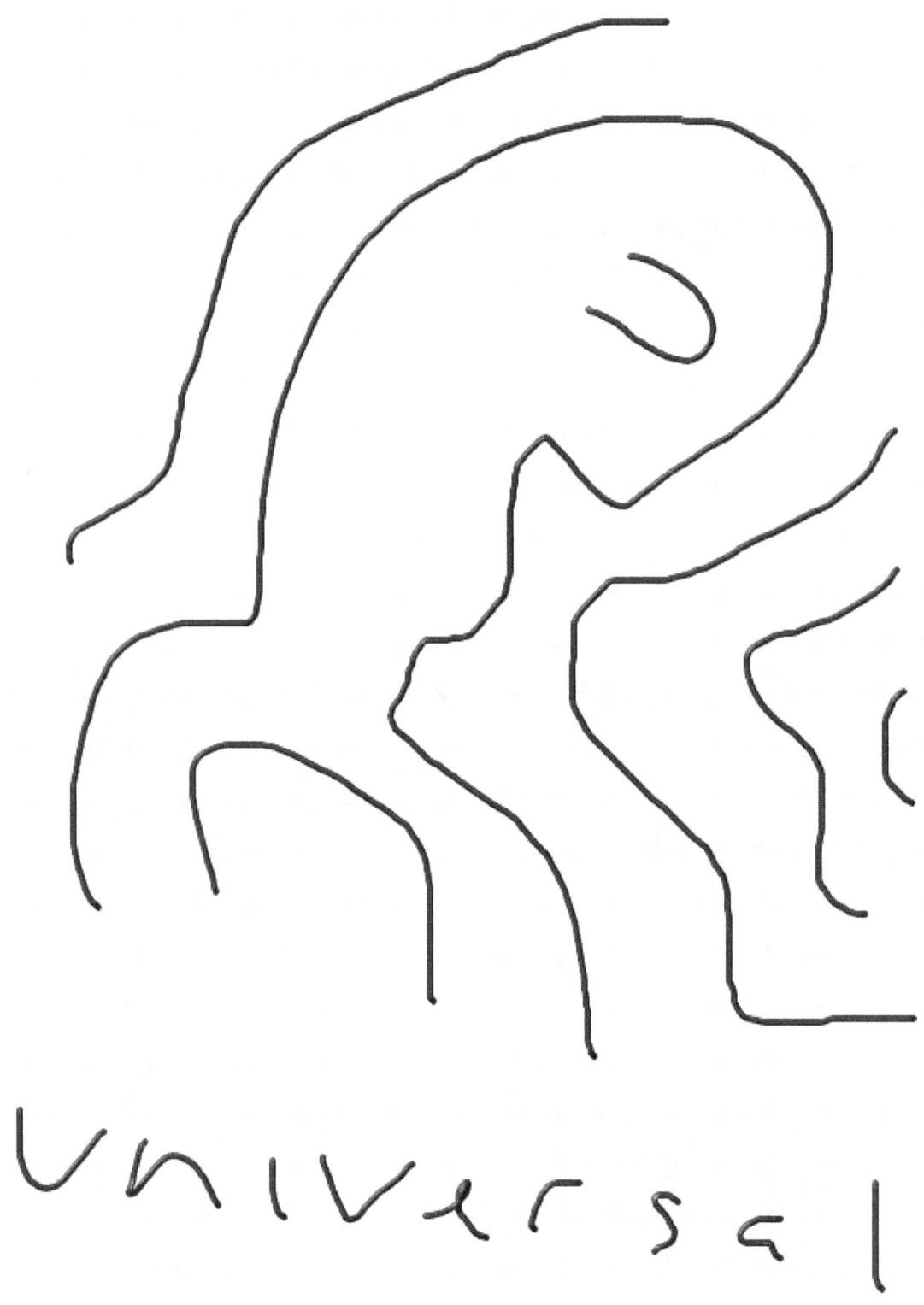

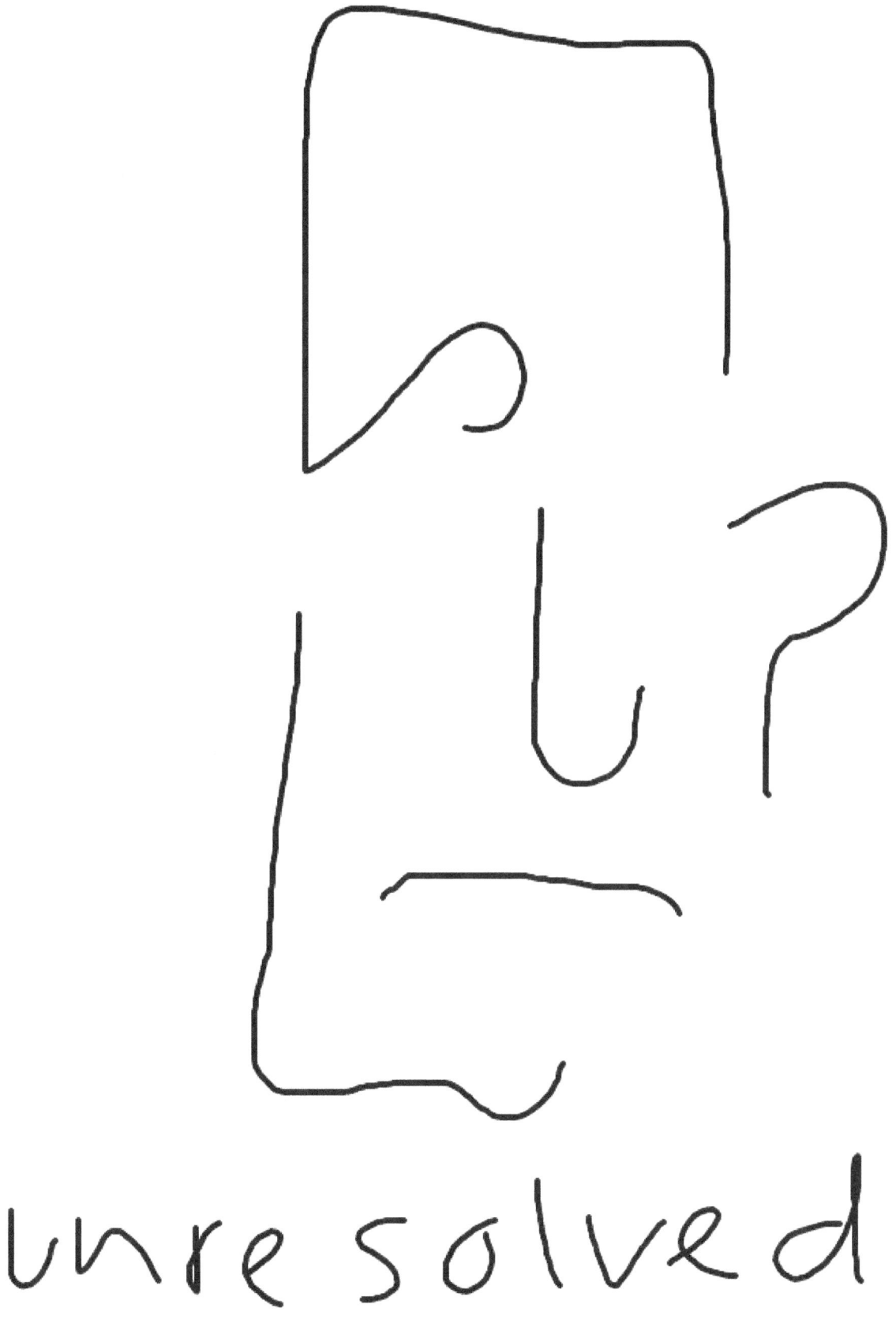

unresolved

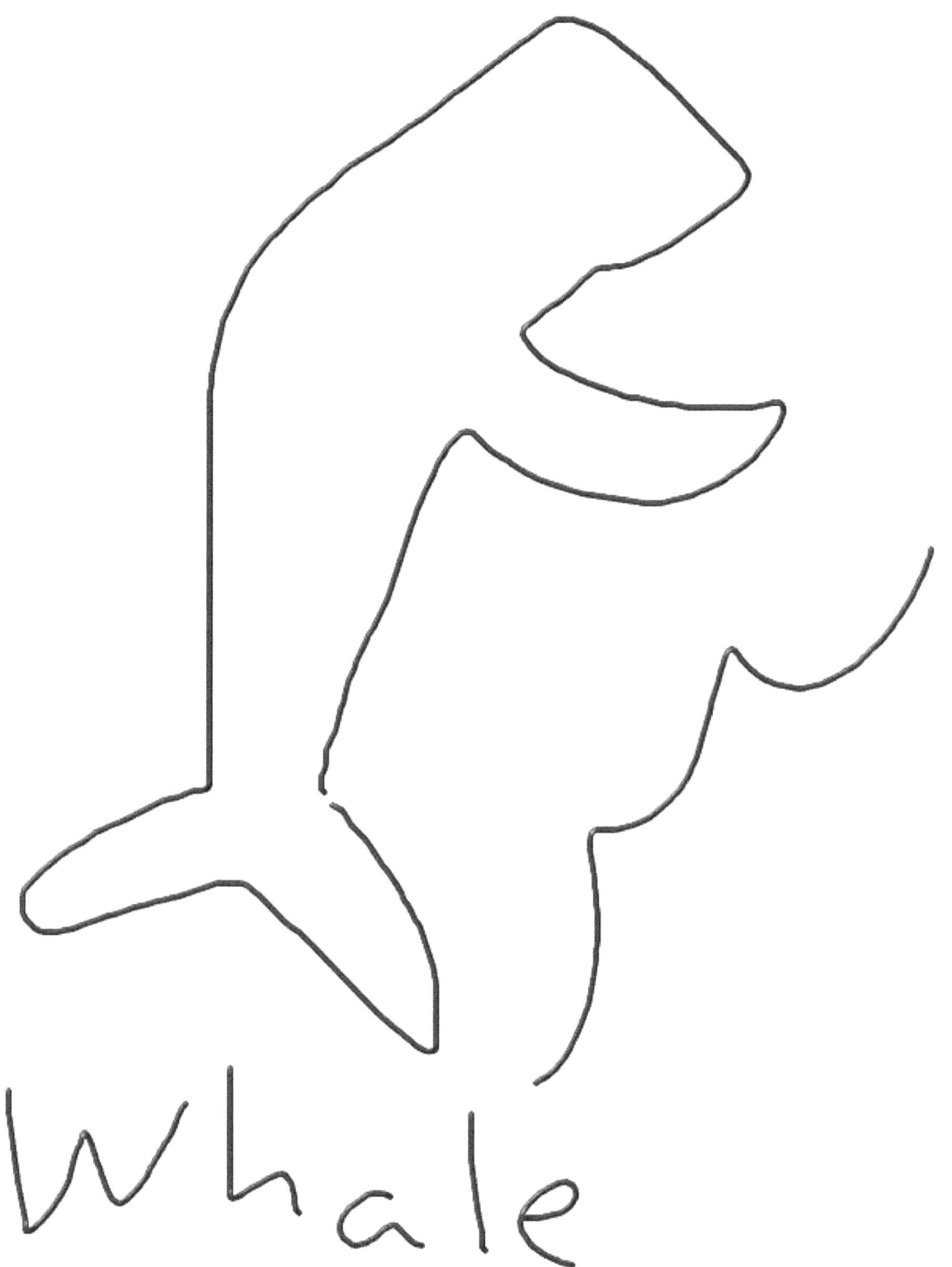
whale

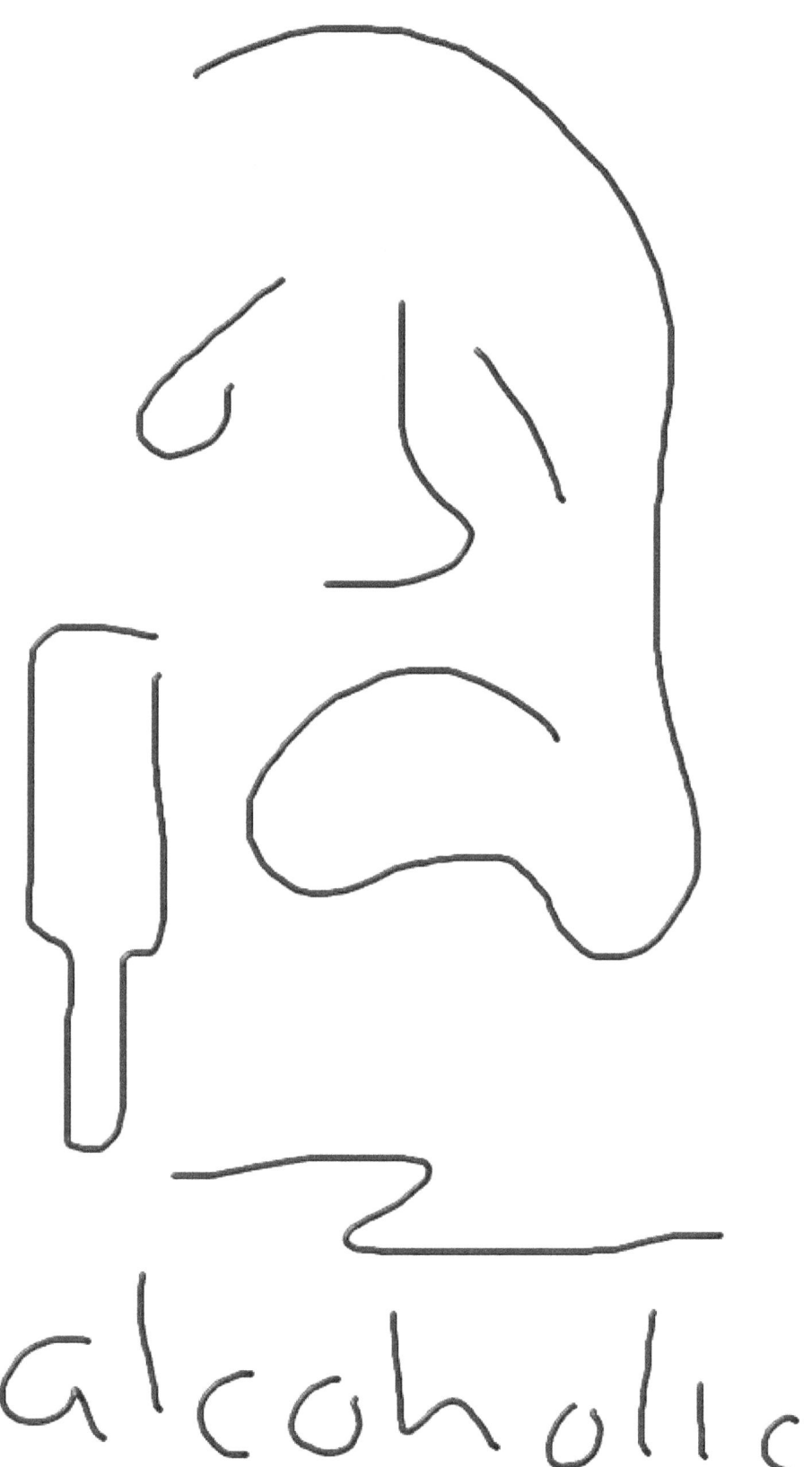

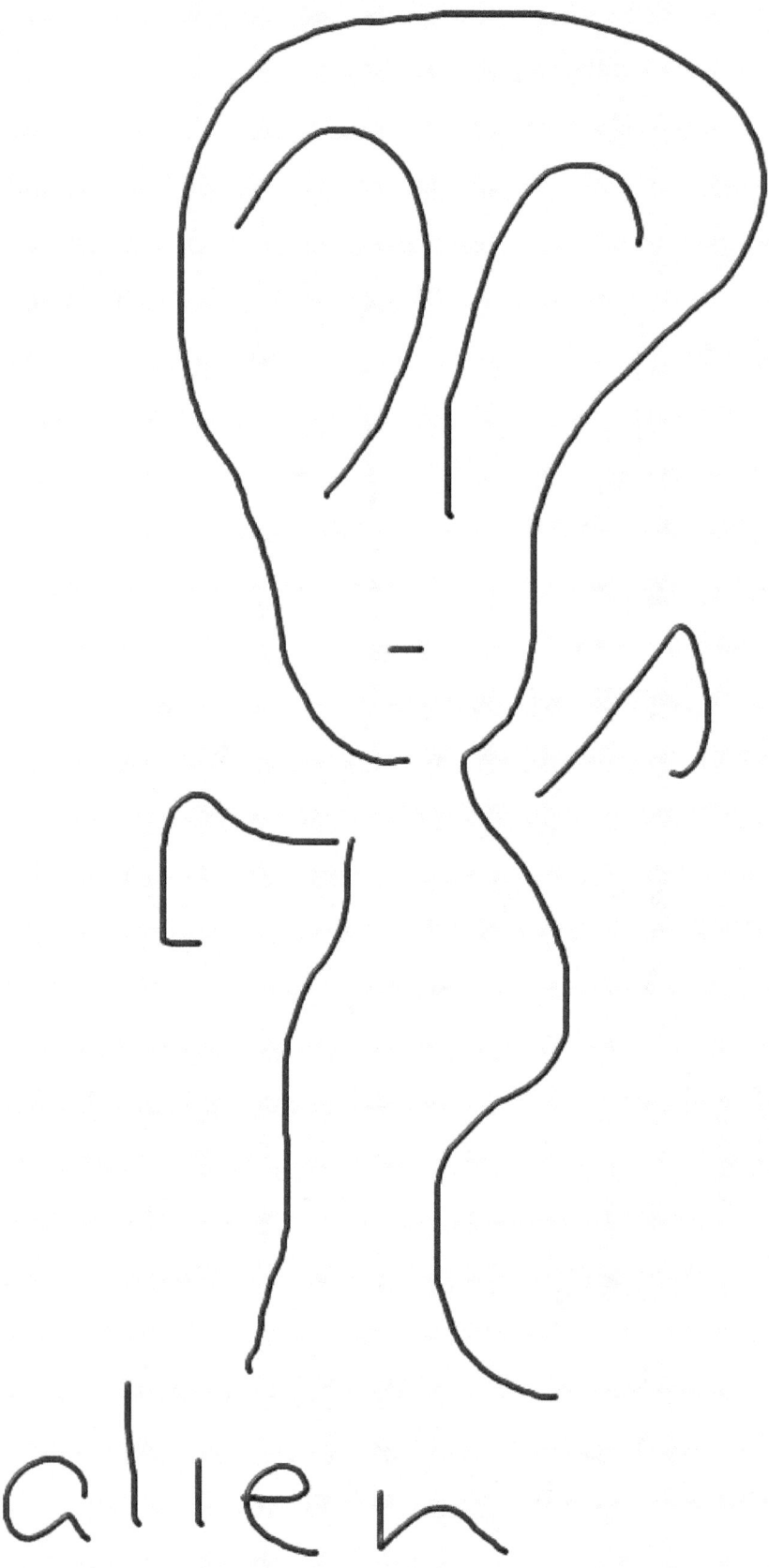

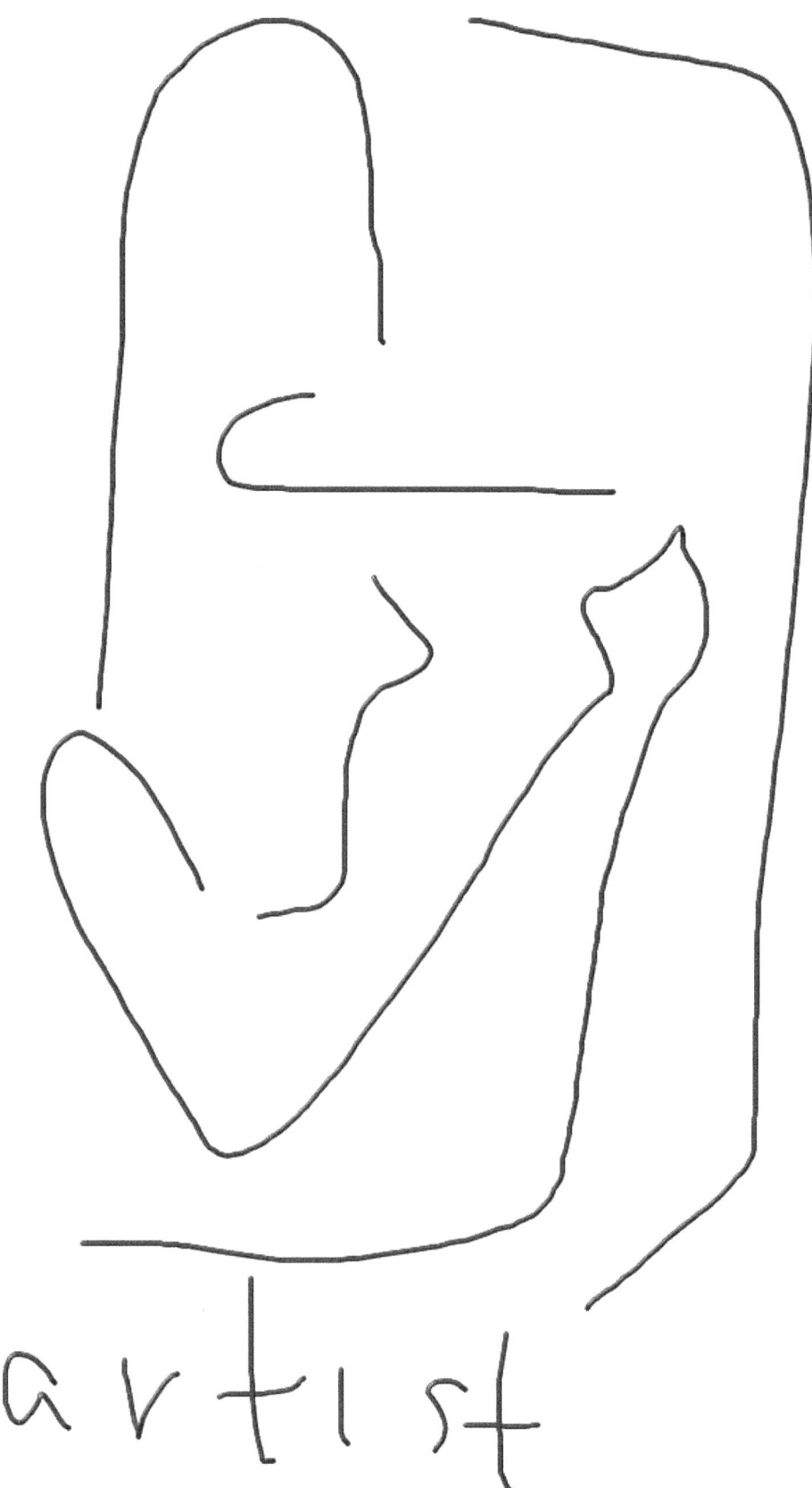

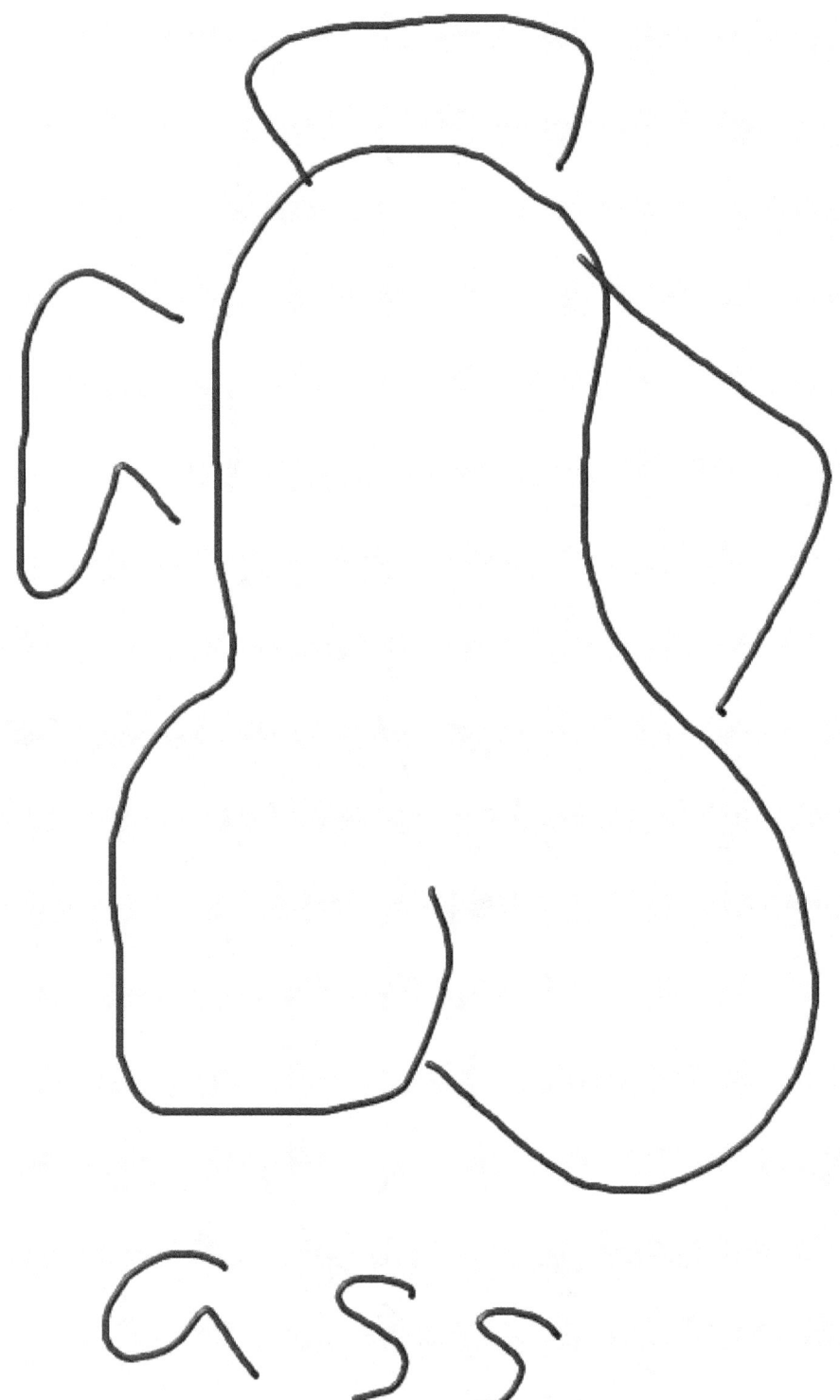
ass

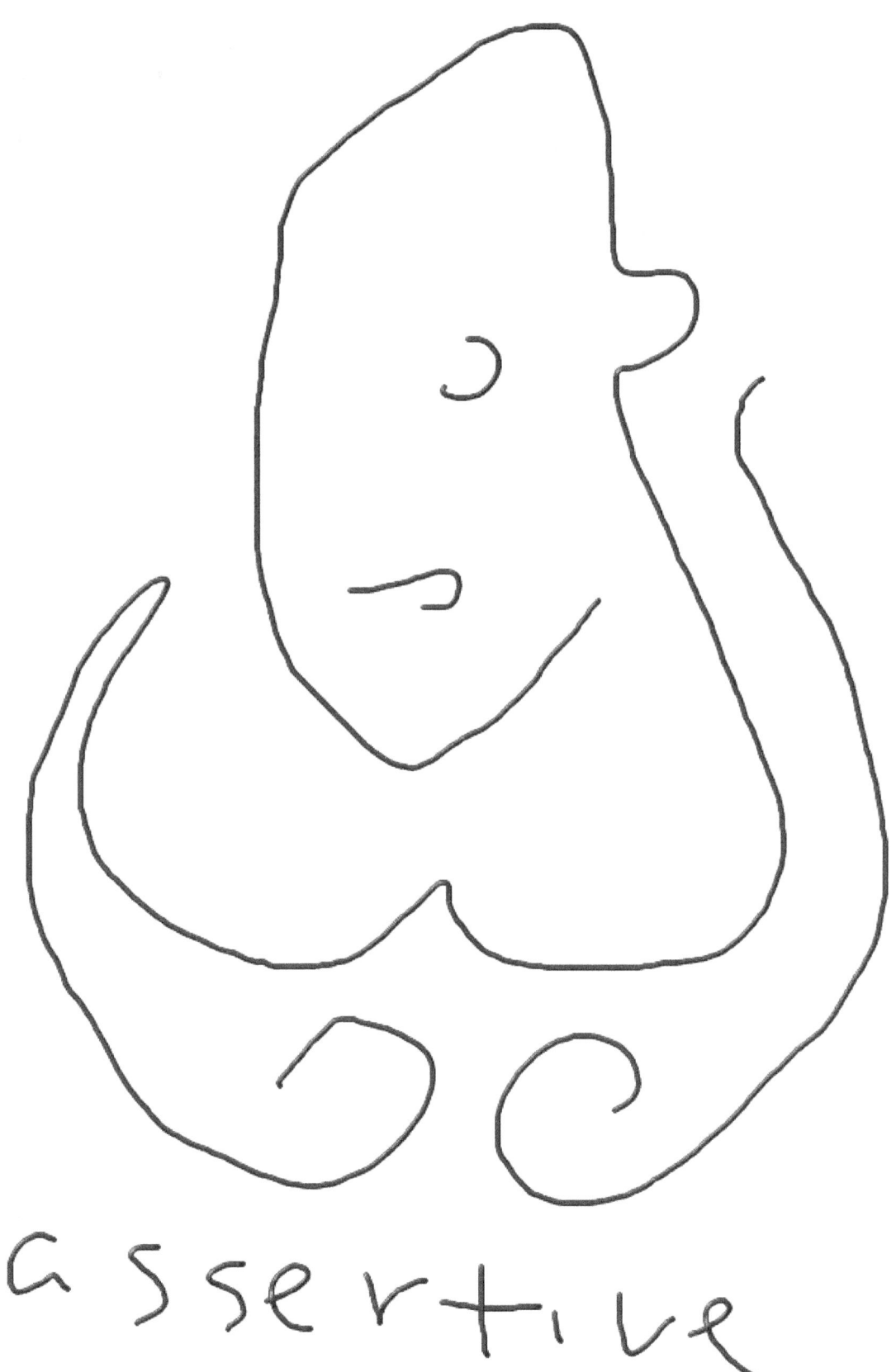

assertive

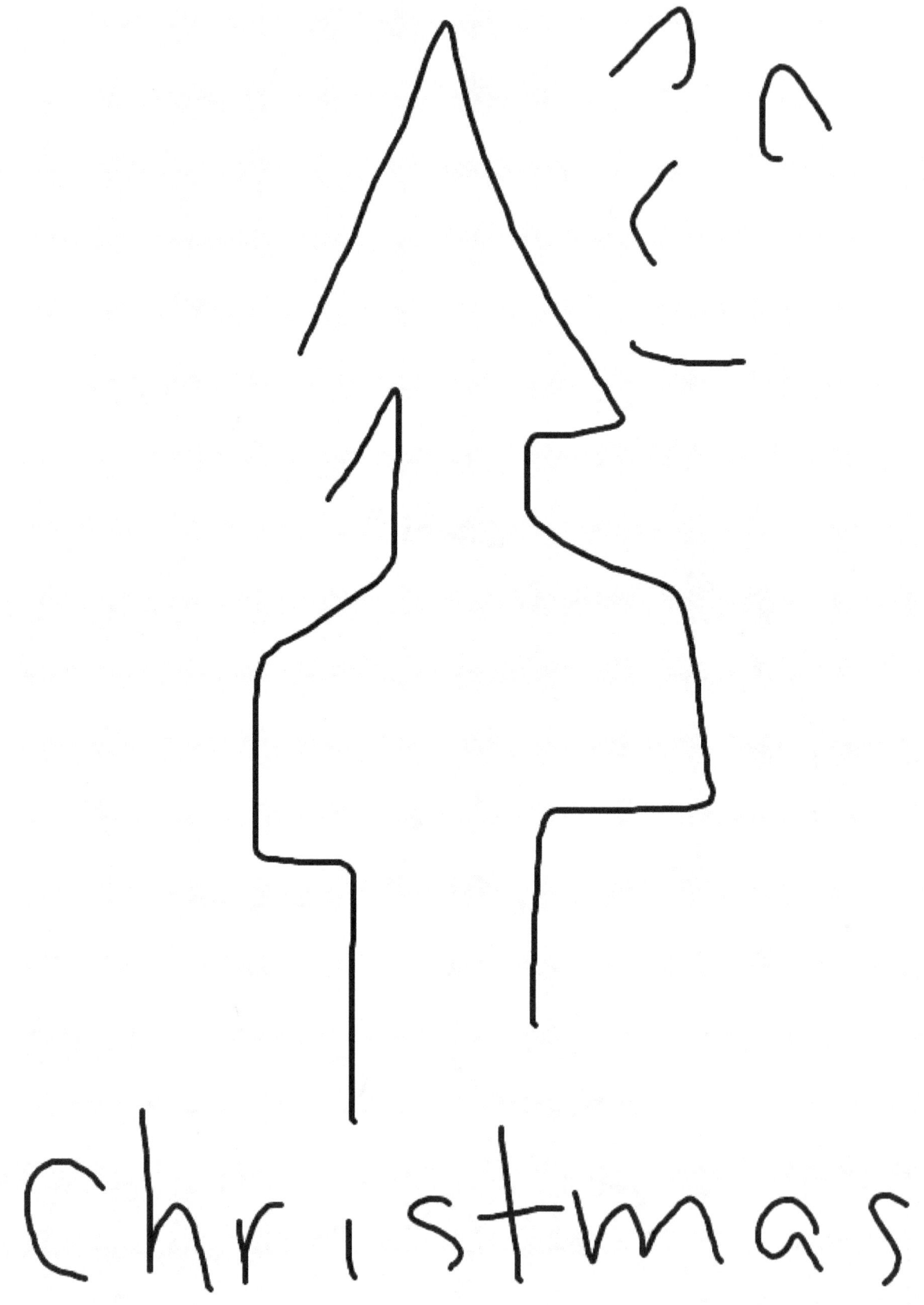

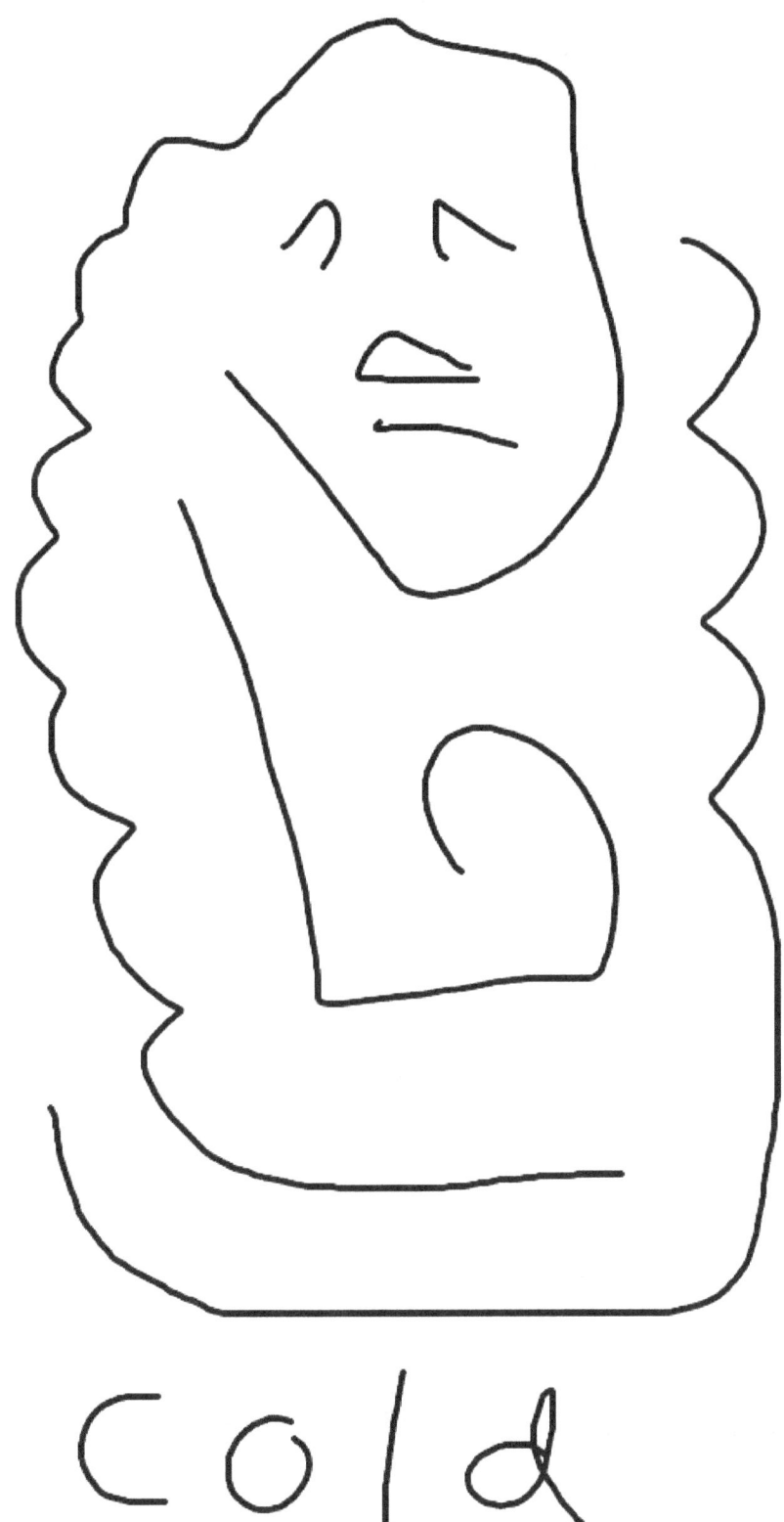

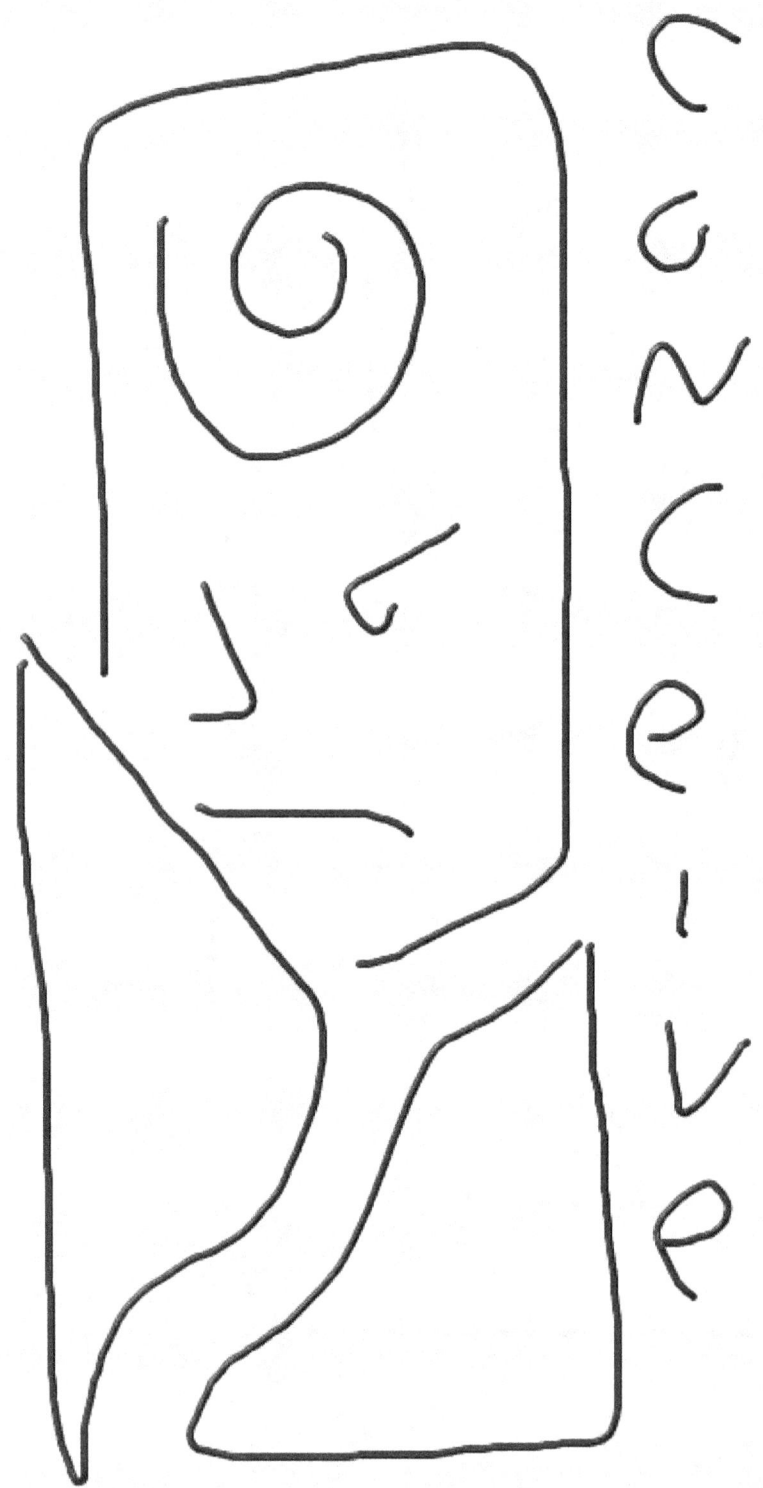

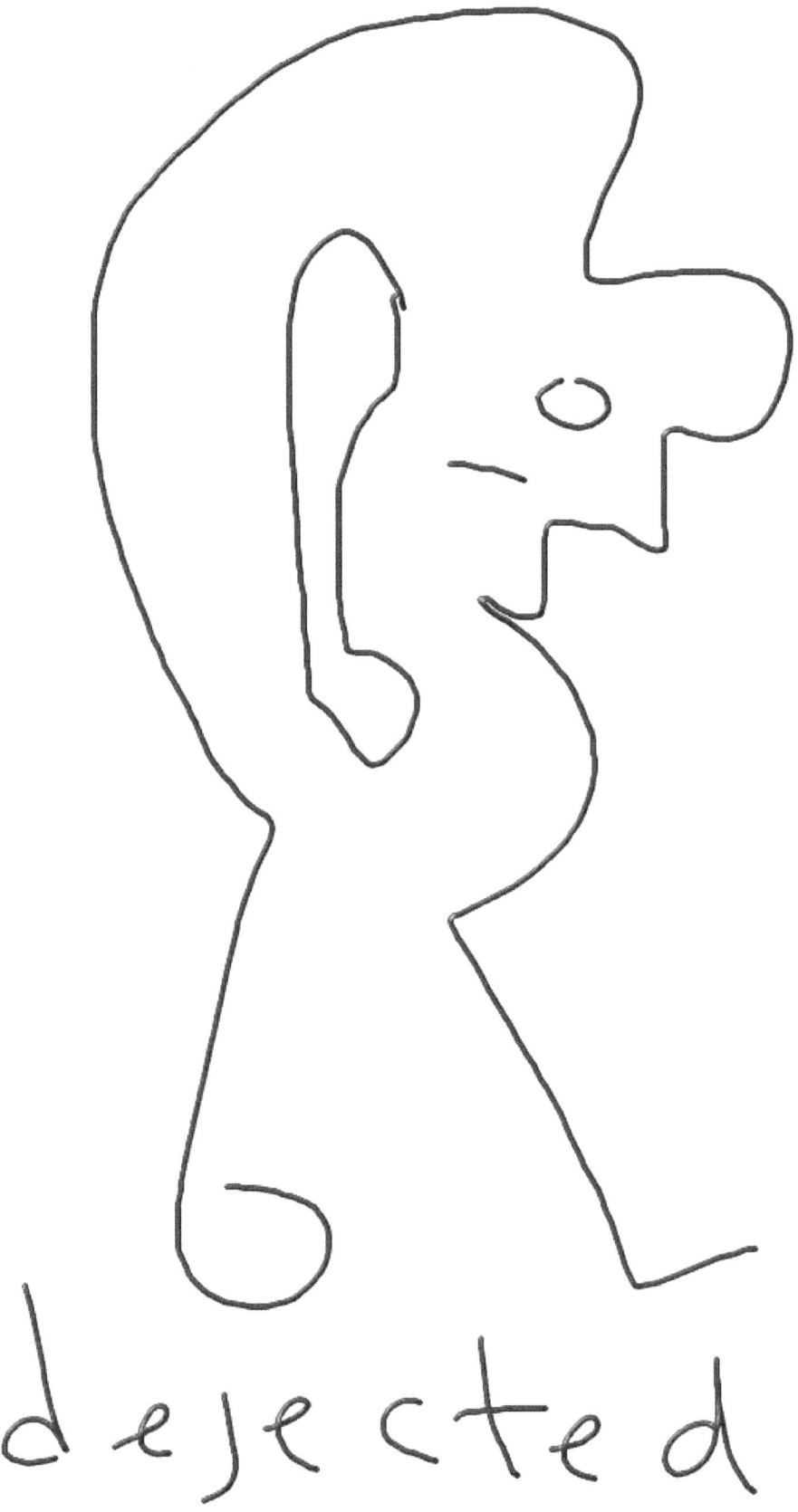

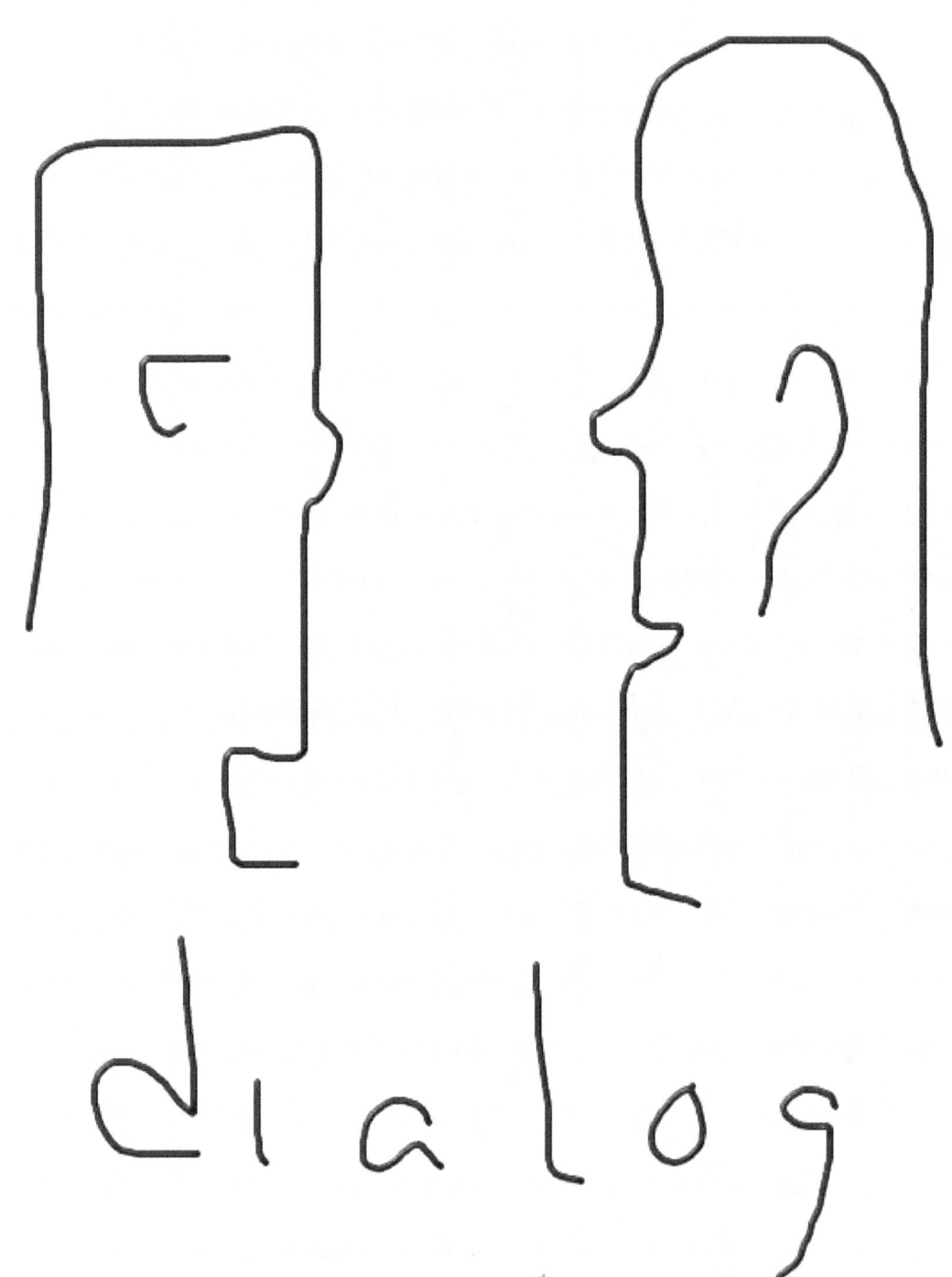

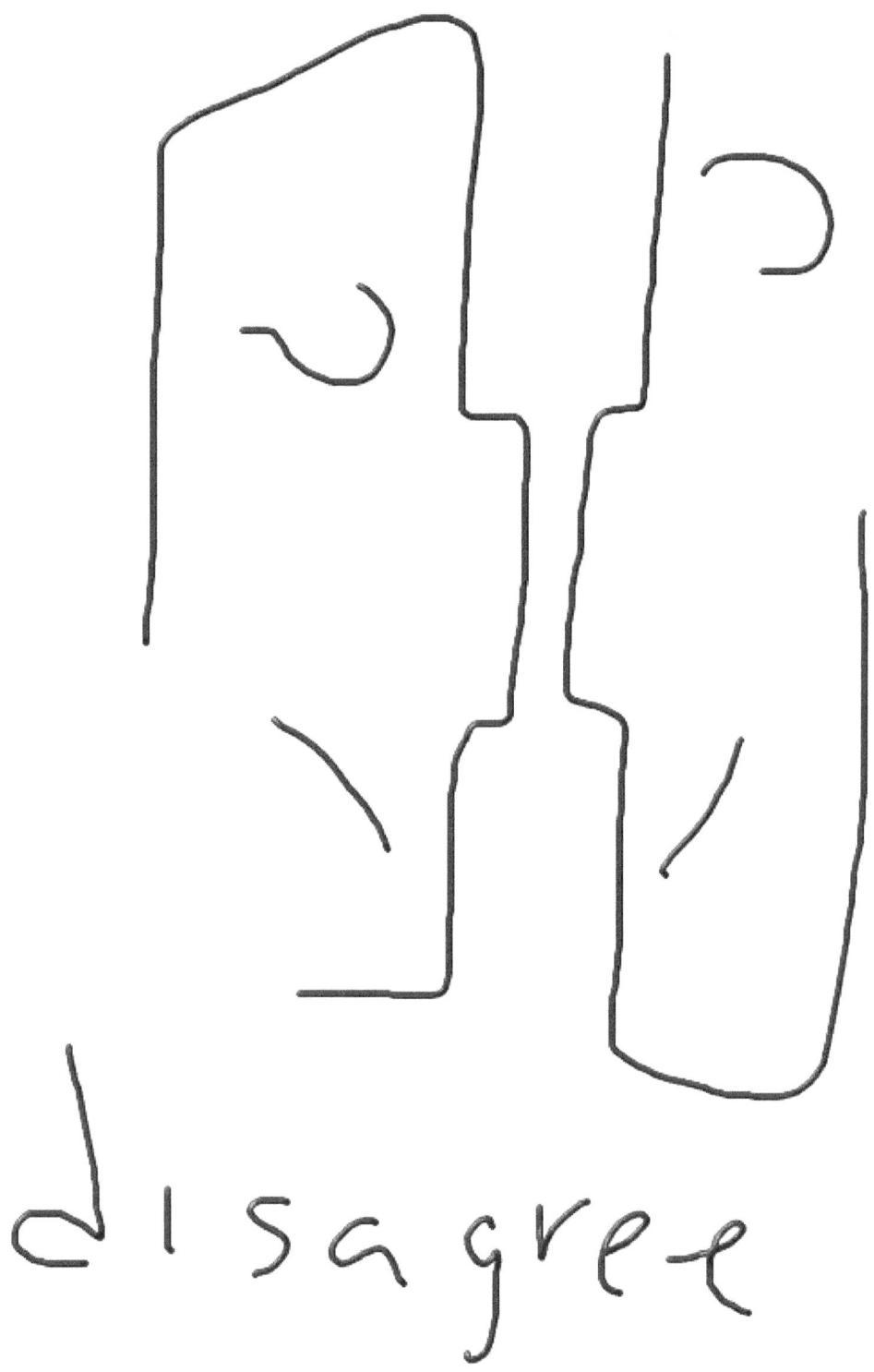

disagree

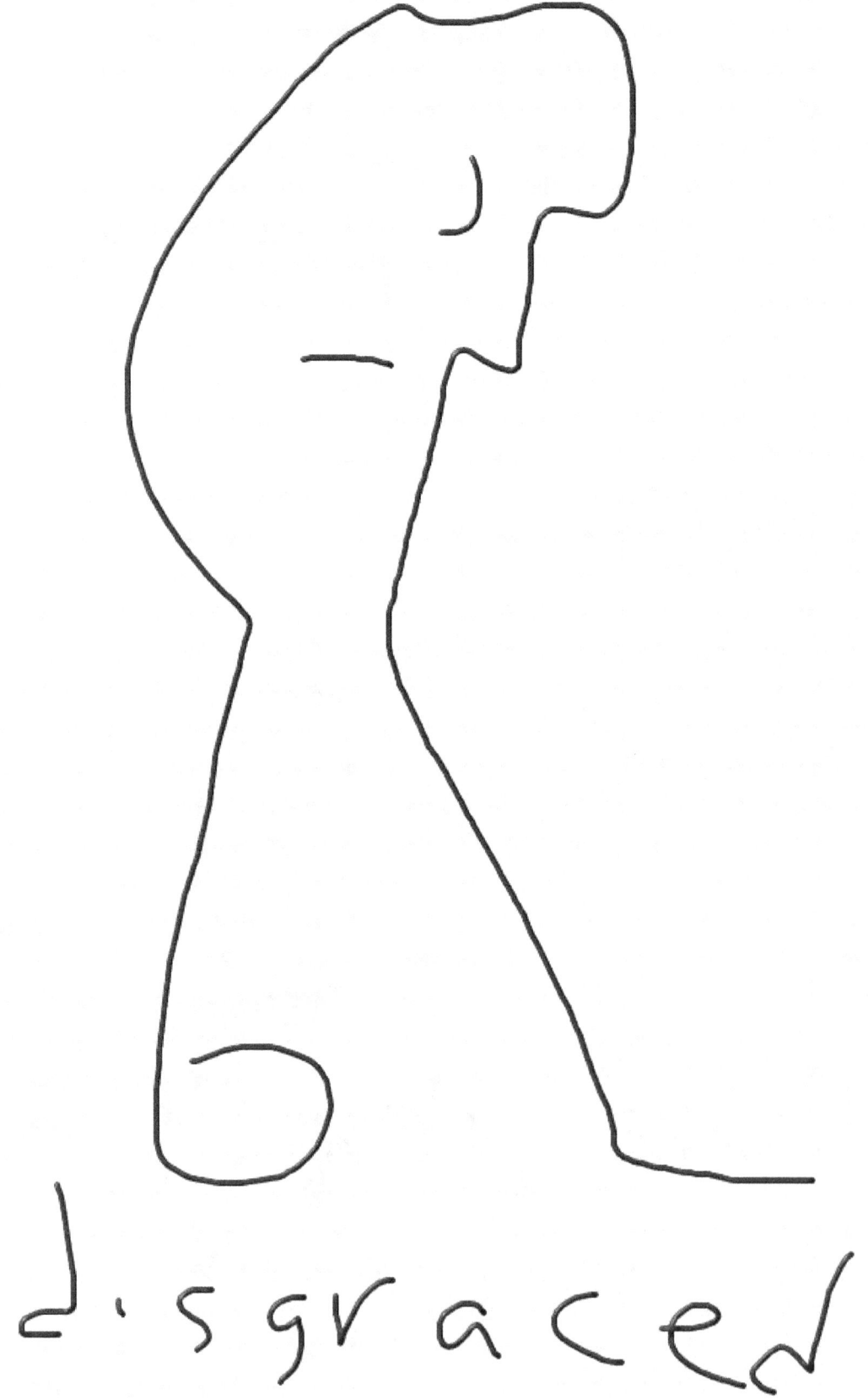

dubious

christmas

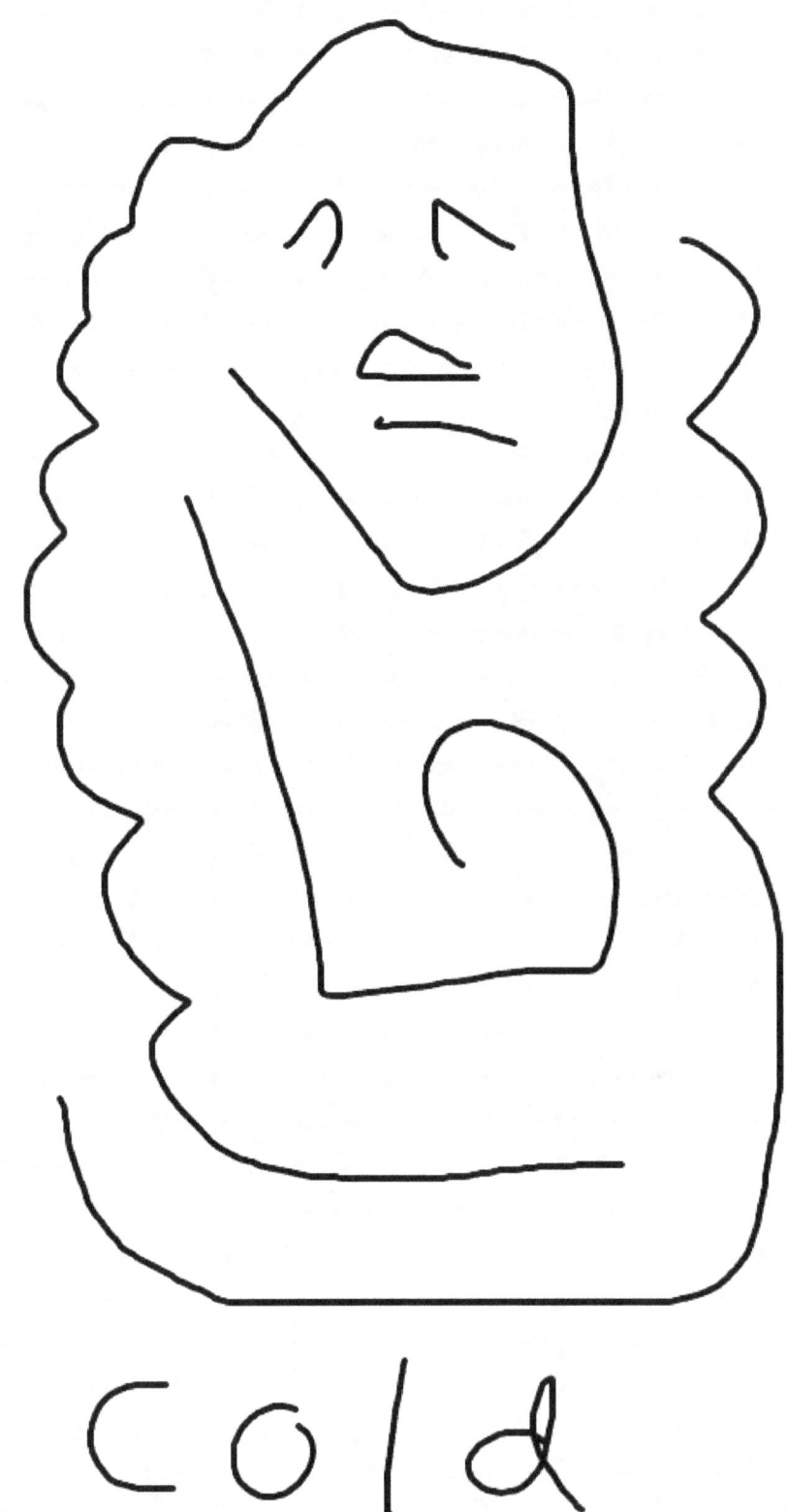

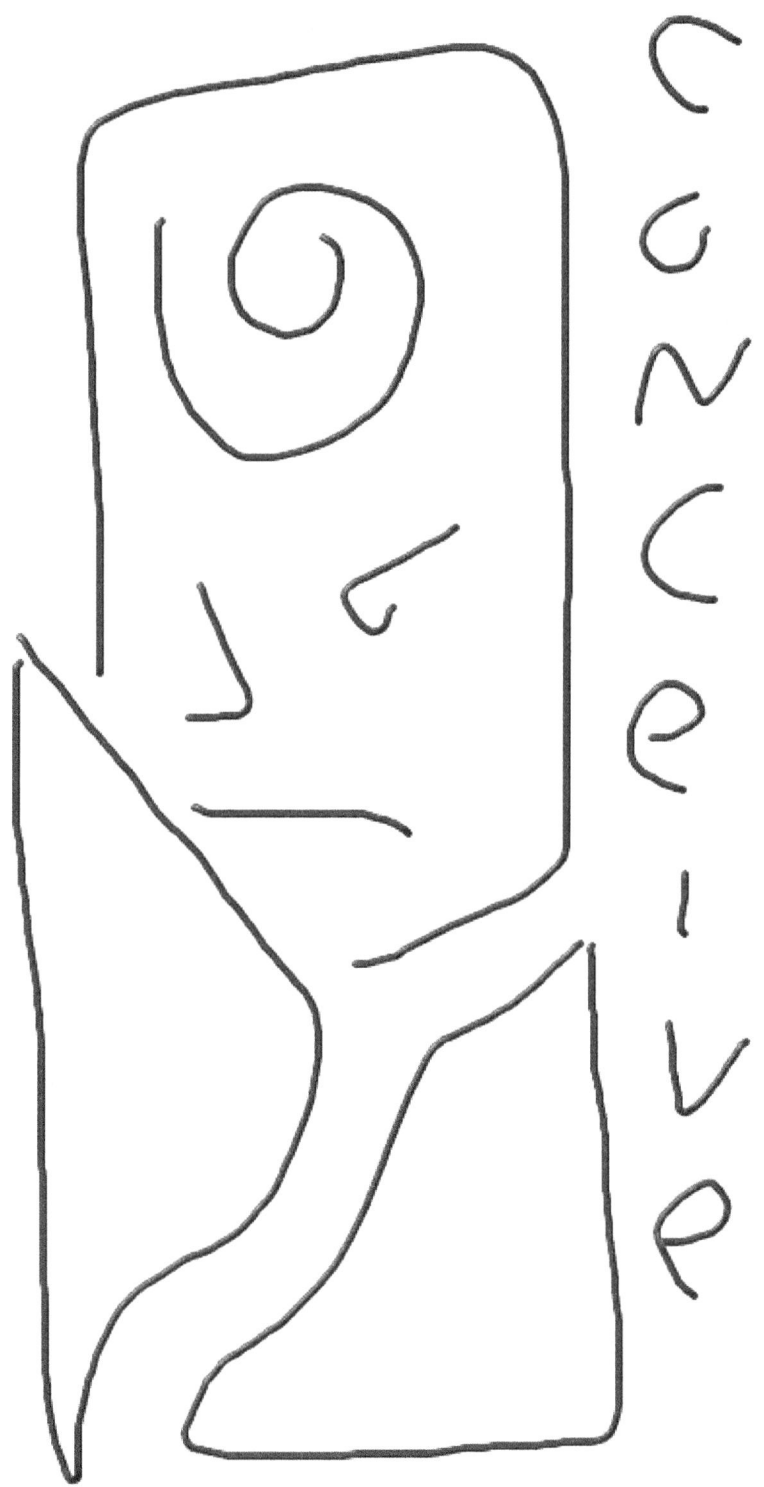

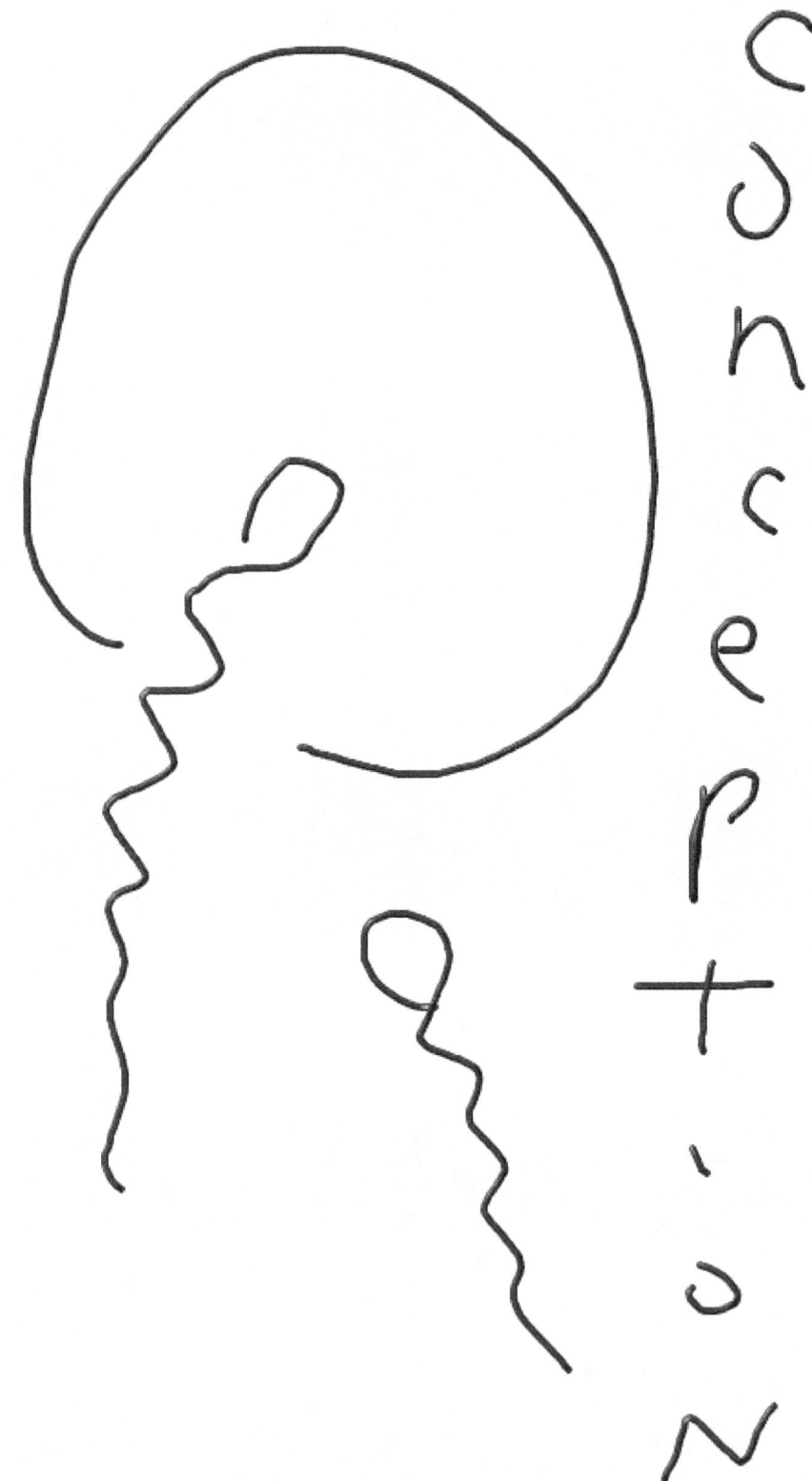

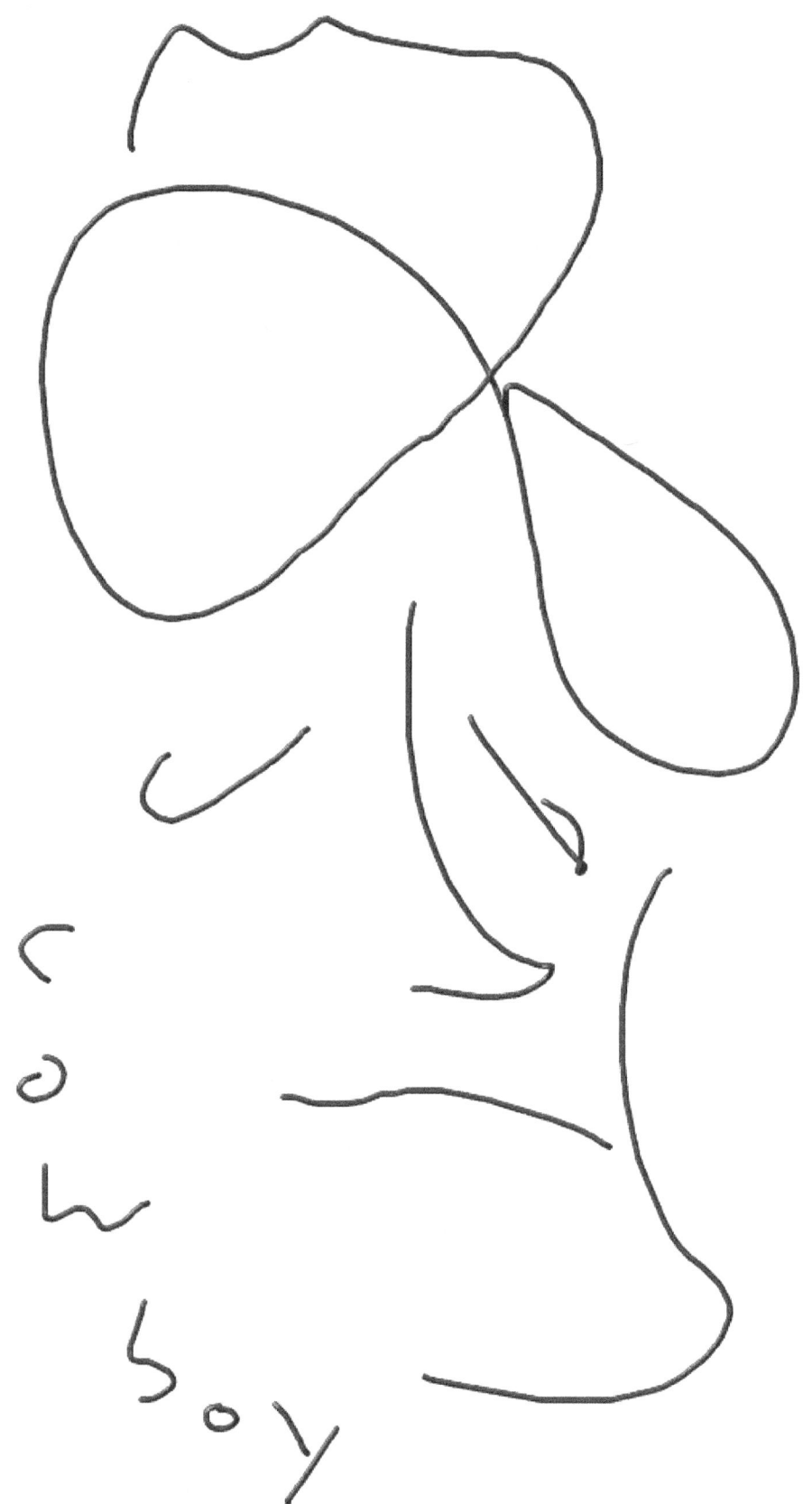

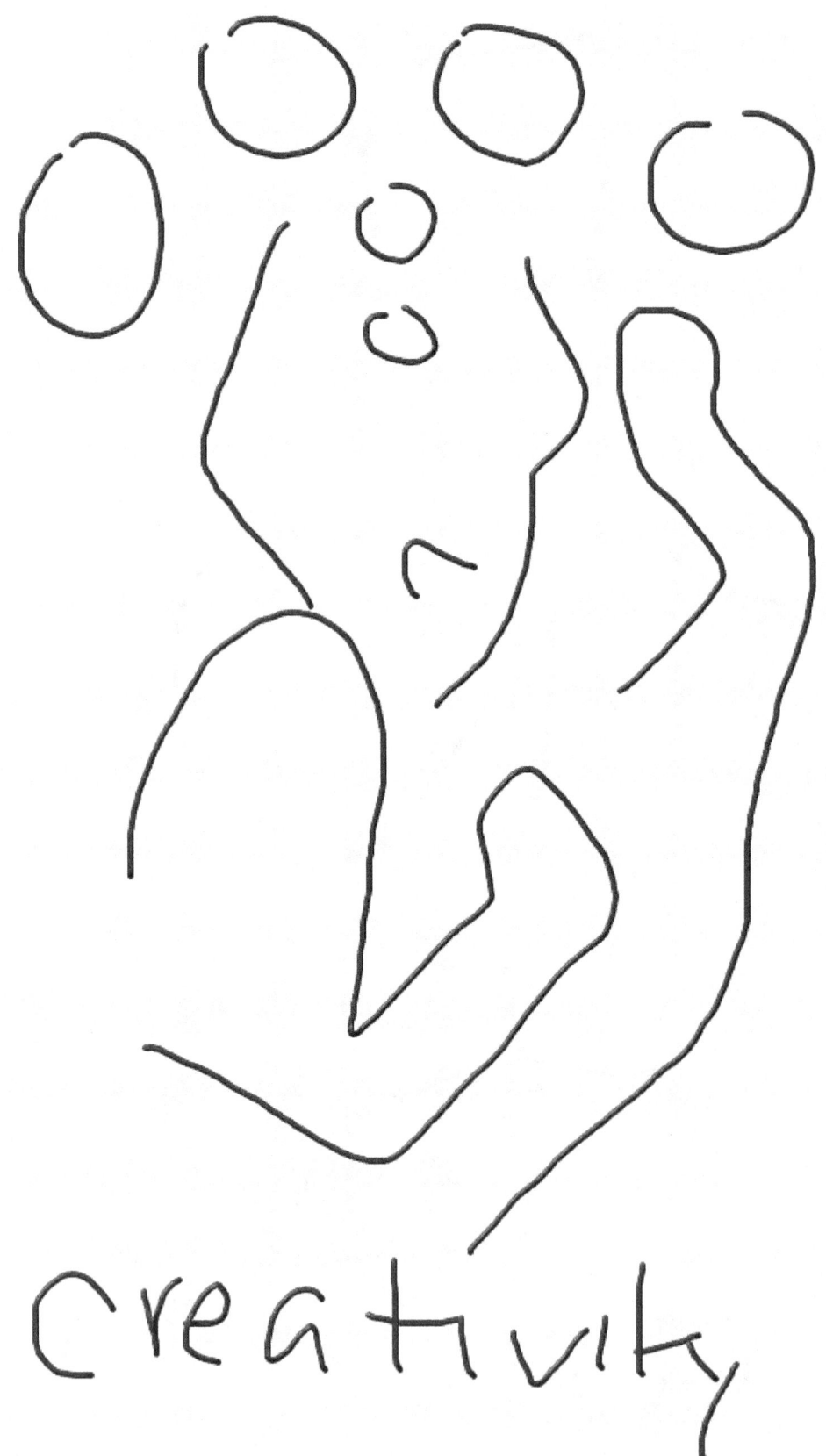

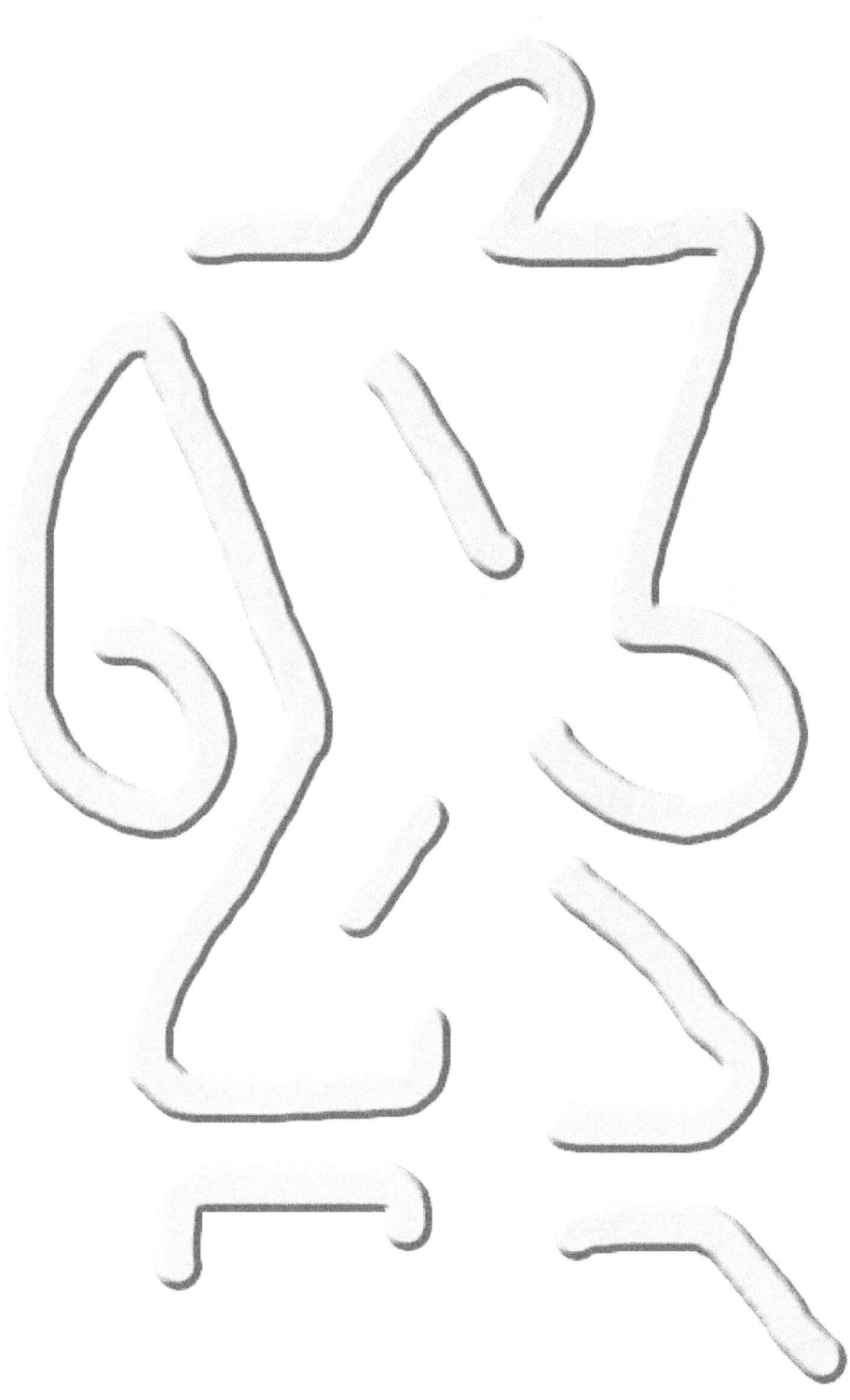

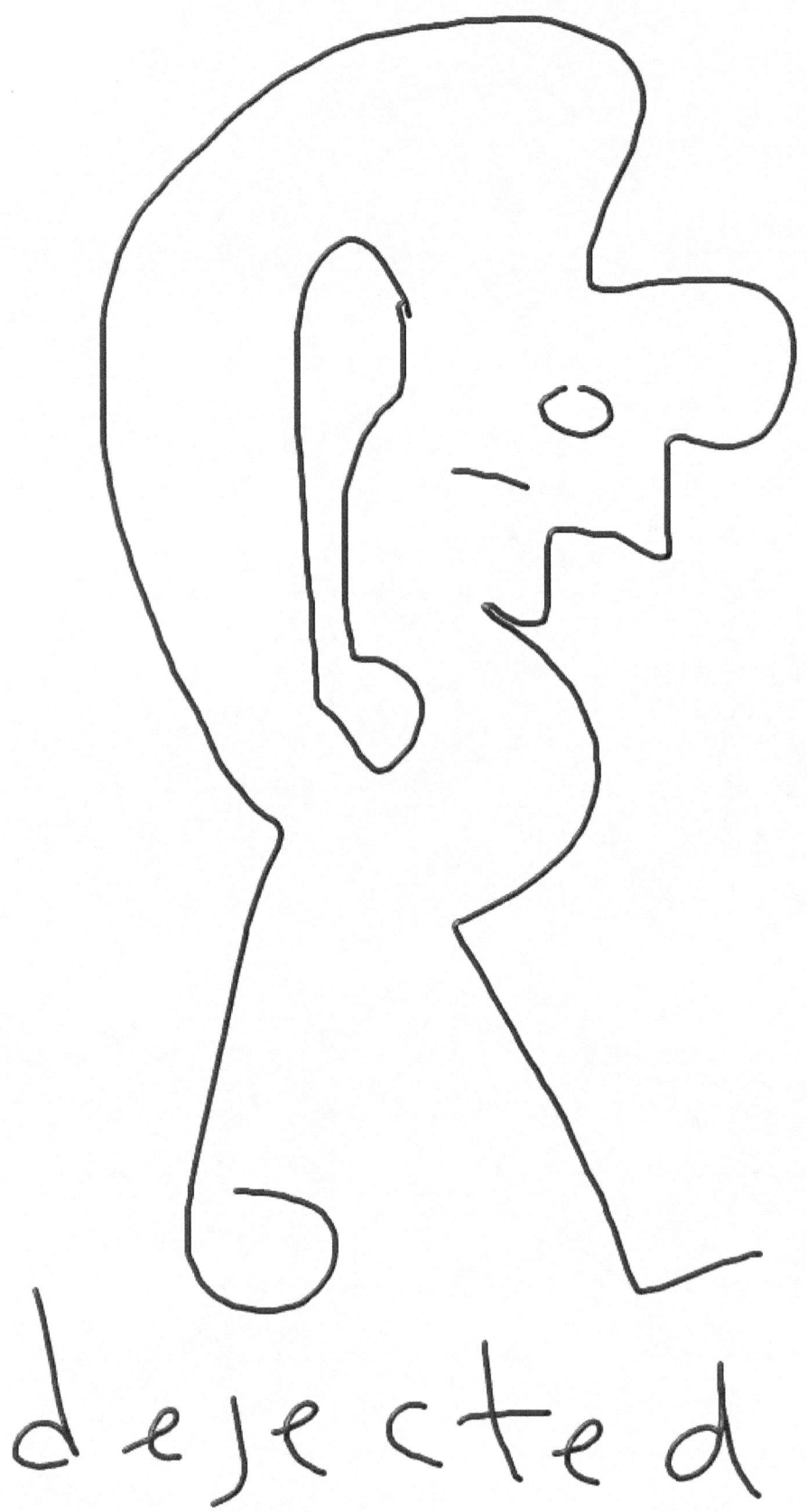

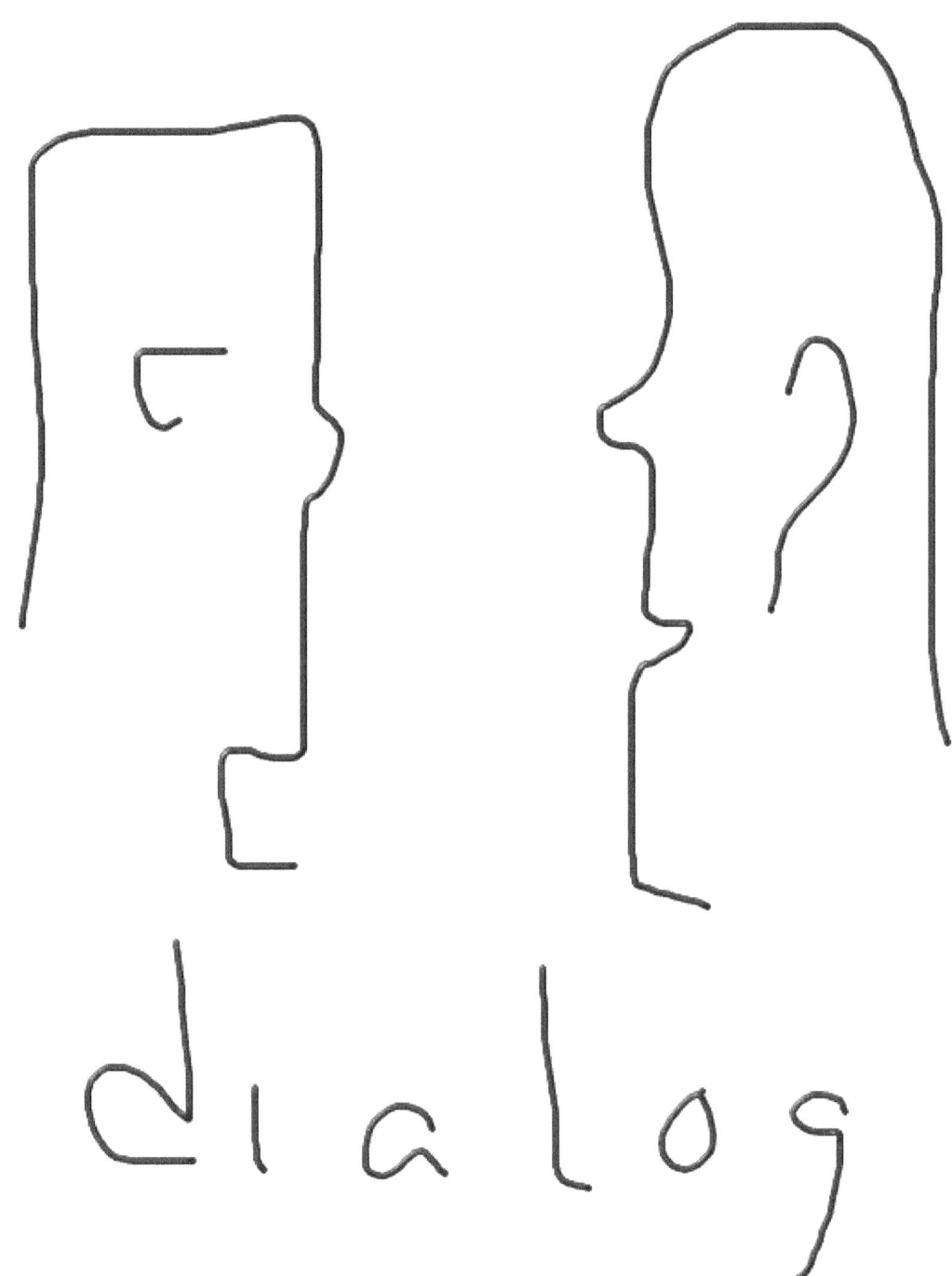

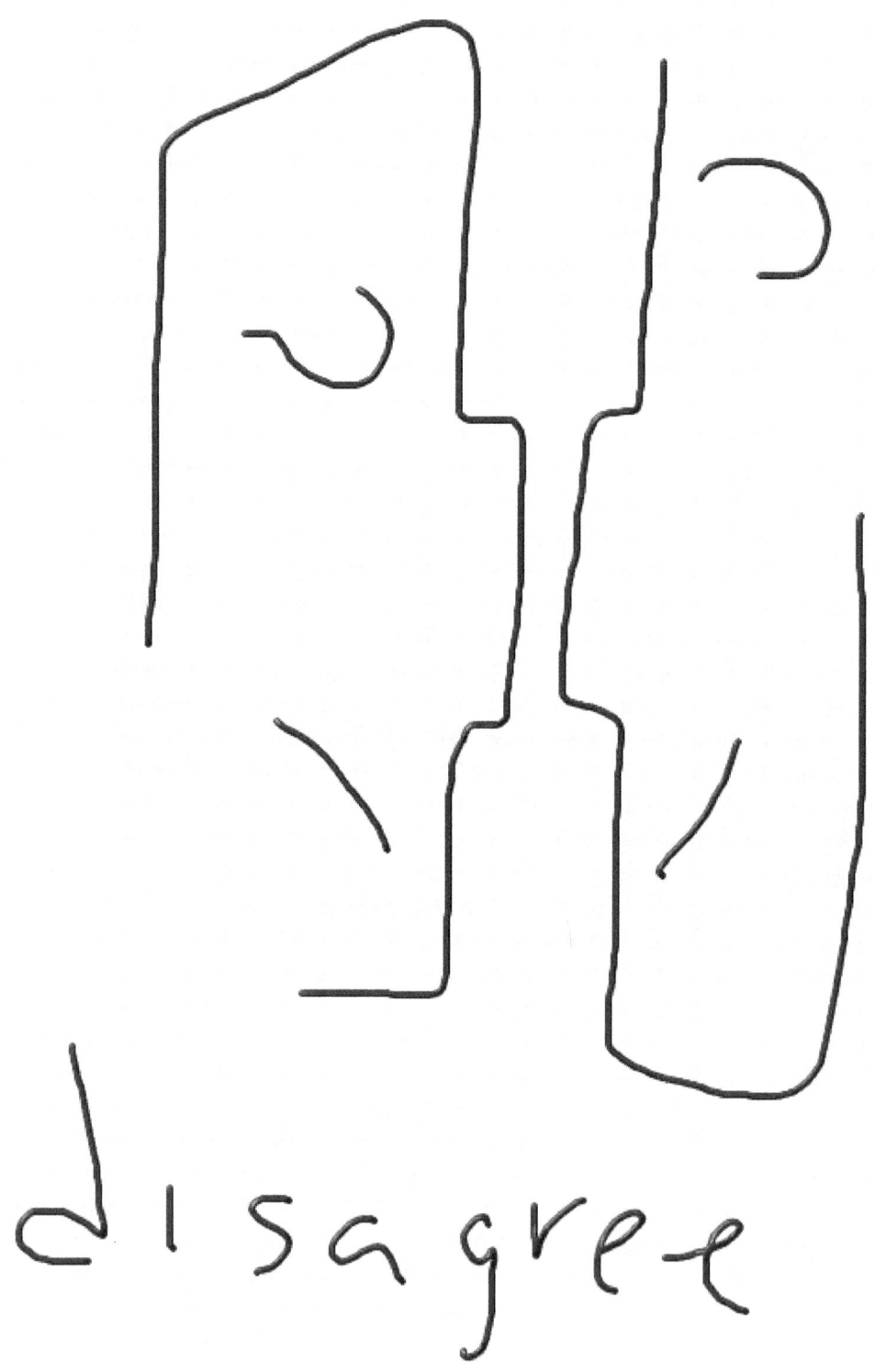

disagree

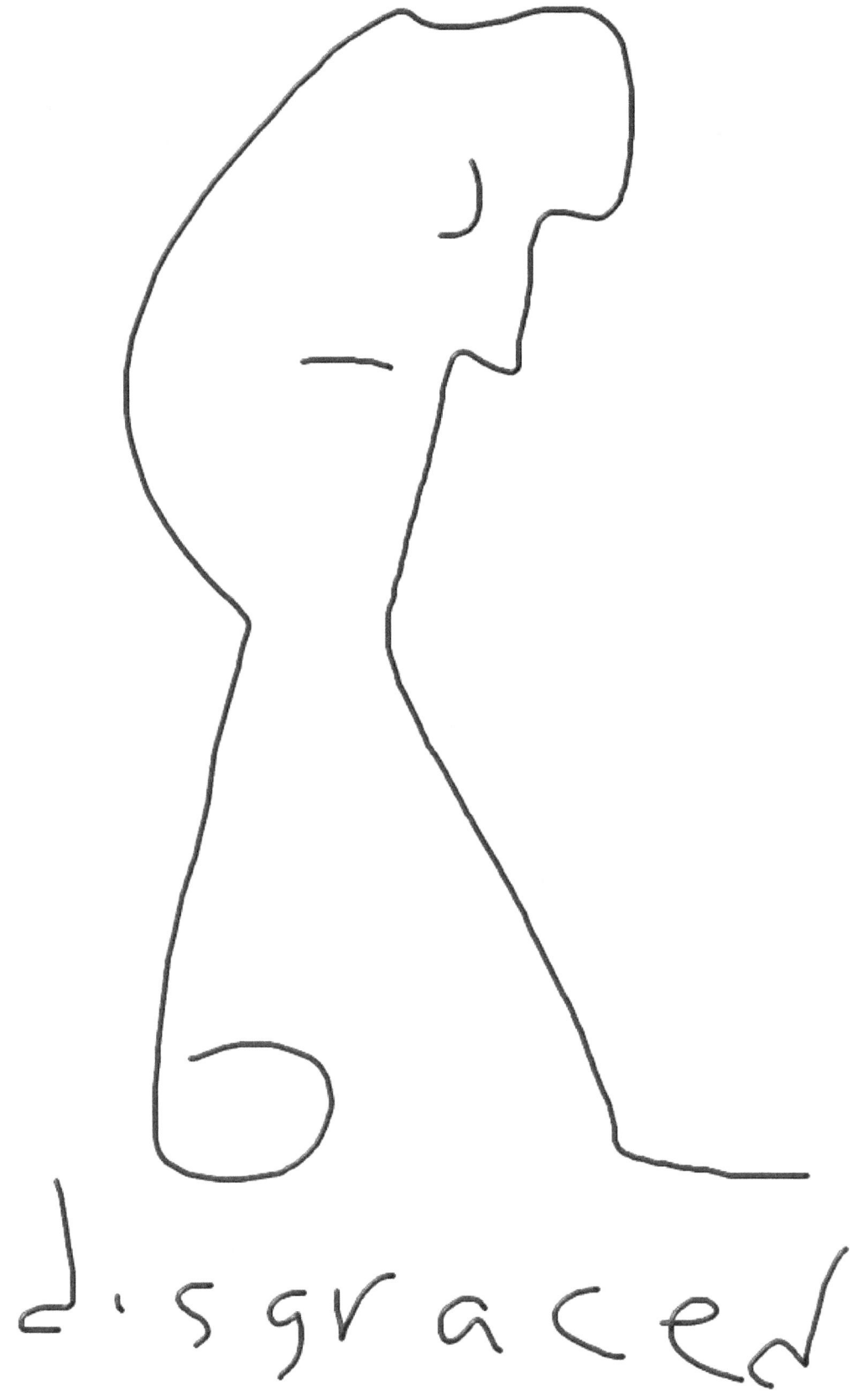

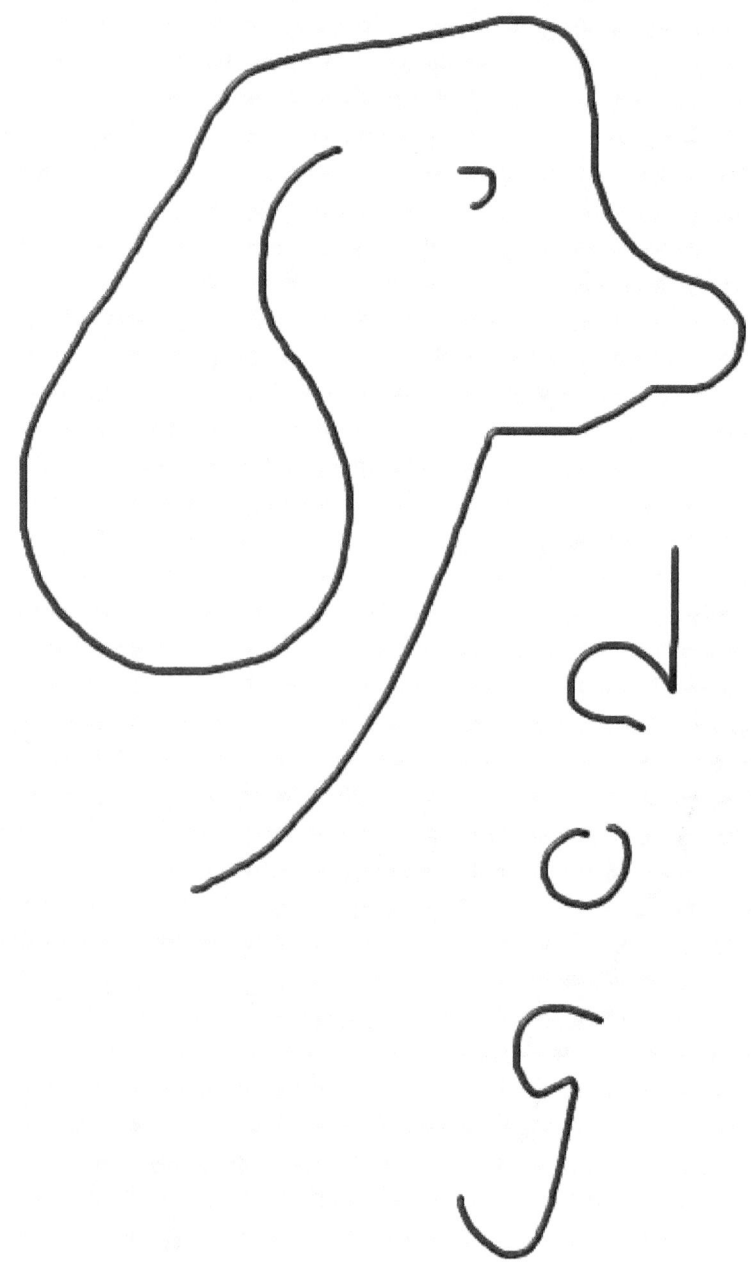

dubious

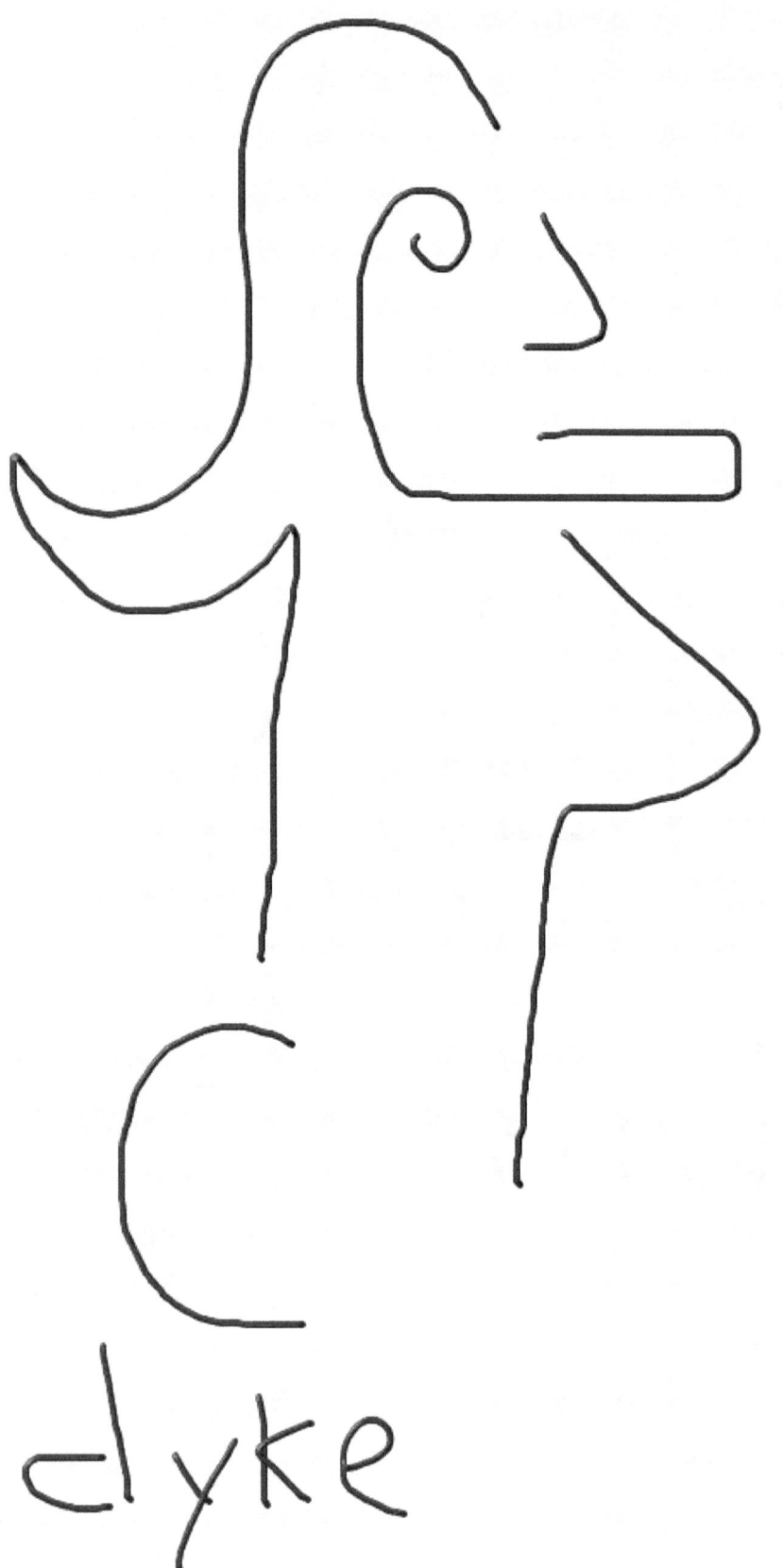

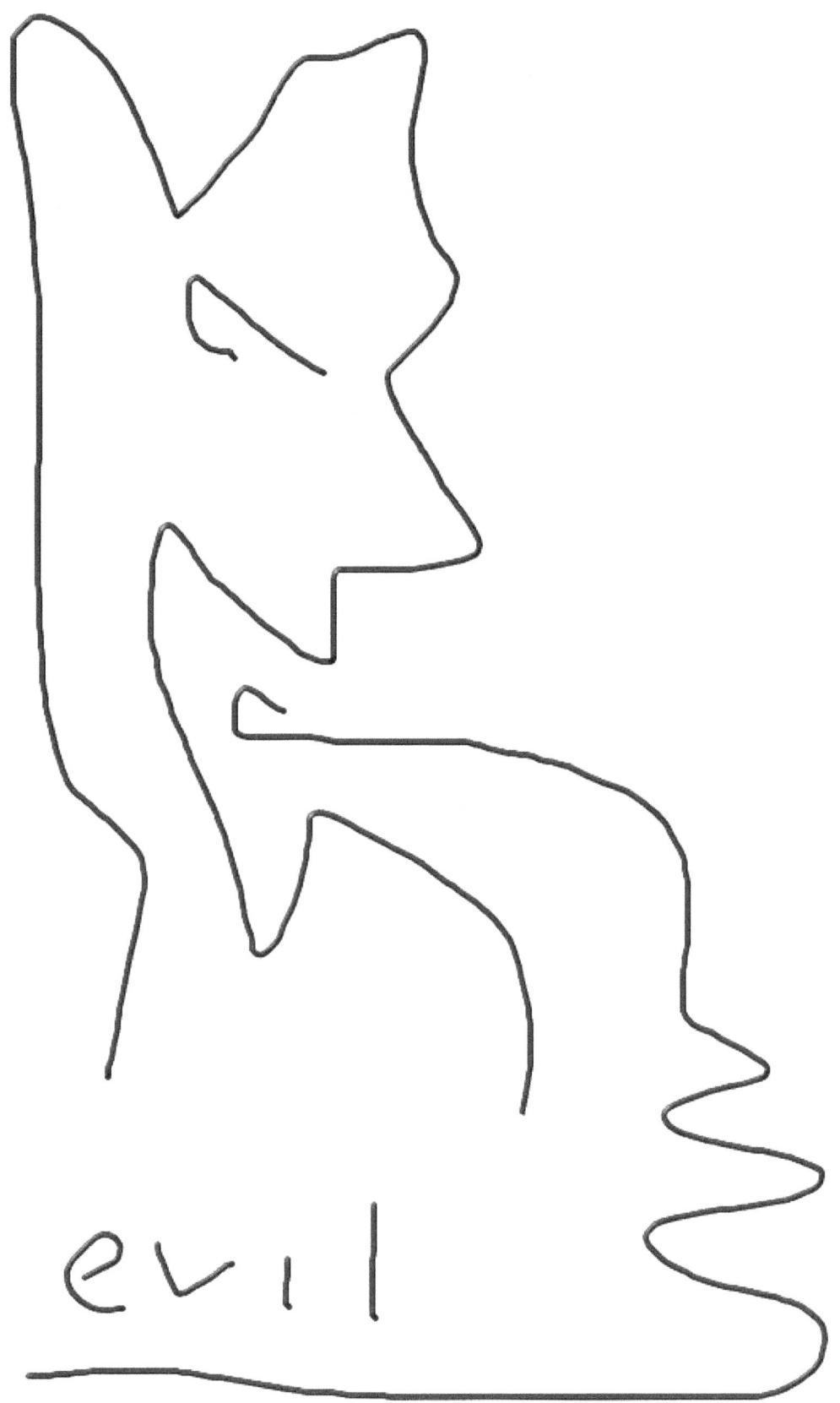

Keyes the Arist

www.ingramcontent.com/pod-product-compliance
Lightning Source LLC
Chambersburg PA
CBHW080808180526
45168CB00006B/2367